HIDDEN GEMS

HIDDEN GEMS
ROADSIDE TREASURES
OF
NEW MEXICO

DONNA BLAKE BIRCHELL

AMERICA
THROUGH TIME®
ADDING COLOR TO AMERICAN HISTORY

America Through Time is an imprint of Fonthill Media LLC
www.through-time.com
office@through-time.com

Published by Arcadia Publishing by arrangement with Fonthill Media LLC
For all general information, please contact Arcadia Publishing:
Telephone: 843-853-2070
Fax: 843-853-0044
E-mail: sales@arcadiapublishing.com
For customer service and orders:
Toll-Free 1-888-313-2665

www.arcadiapublishing.com

First published 2021

Copyright © Donna Blake Birchell 2021

ISBN 978-1-63499-280-0

Typeset in 10pt on13pt Sabon
Printed and bound in England

This book is dedicated to every citizen of New Mexico, every visitor to New Mexico, may you always keep enchantment in your heart.

"I have traveled many places but have no desire to leave New Mexico."

Rudolfo Anaya

"When I got to New Mexico, that was mine. As soon as I saw it that was my country. I'd never seen anything like it before, but it fitted to me exactly. It's something that's in the air—it's different. The sky is different, the wind is different. I shouldn't say too much about it because other people may be interested, and I don't want them interested."››»

Georgia O'Keeffe

ACKNOWLEDGMENTS

My dear friend, Samantha Villa, started this journey by believing in me, and for that I am forever grateful! Thank you, *mi querida amiga.*

The ability to continue this wonderful journey of discovery and writing is facilitated by my outstanding family, Jerry, Michael, Sherrie, Justin and Amanda, and Missy and Robert, who instill the will to keep going with their encouragement and love. It is with a loving heart that I thank you all for lifting me up when things get rough or talking through panic attacks over deadlines. A simple thank you is not enough. Much love to each of you.

Tons of gratitude to my lifelong friends, Richard and Carol Estes, for your continued, much-valued friendship and providing the transportation to the Jemez. It is always an adventure. Love you both!

To Murt Sullivan, Park Ranger extraordinaire, friend, and classmate, who is truly a hidden gem himself, I am indebted to you for the personal tour, you are a fountain of information and a huge asset to the Quarai Mission site.

A shout out to my original editor, Matthew Rodriguez, editors Kena Longabough, Jamie Hardwick, Joshua Greenland, and all those at Fonthill Media who made this book possible, my deepest gratitude.

CONTENTS

INTRODUCTION

As the forty-seventh state of the Union, entered on January 6, 1912, New Mexico has a history that spans centuries. Indigenous tribes, the Spaniards, and Anglos have called this beautiful land their home, each one leaving deep impressions on the state. New Mexico has been highly coveted and fought for, with good reason: the resources available in the state are seemingly endless. As you drive the scenic byways and tours offered in this book, you will become acquainted with the "Land of Enchantment" and realize quickly why the state holds this special moniker.

You will follow trails blazed by the Indigenous people, conquistadors, American soldiers, cowboys, ranchers, and those who traveled westward in search of gold and a better way of life. Prosperity and tragedy resulted from each cultural introduction and made New Mexico what she is today. New Mexicans of every culture are proud of their state and want to show it off at every opportunity. Despite the differences, New Mexico's people have become a melting pot and continue to live as harmoniously as possible.

Four is an extremely important number in the New Mexico heritage and culture. The state symbol is the Zia, which resembles a sun with four rays emanating from four sides. This symbol was found painted on a water jar discovered at the Zia Pueblo, displayed at the Museum of Anthropology in Santa Fe. Dr. Harry Mera, a physician and anthropologist at the museum, designed the first flag of New Mexico in 1925 using the jar as inspiration, which won a competition to replace the old flag design. Mera's design was a burgundy Zia symbol on a field of gold—it has since changed to bright red Zia on gold background.

The first official flag of New Mexico used from statehood in 1912 to 1925 had a blue background with a small American flag in the upper left corner and the number "47" in the upper right corner to indicate New Mexico being the forty-seventh state. The state seal encircled by the state motto, at that time "the Sunshine State," graced the bottom right corner, with "New Mexico" emblazoned across the center of the blue field. In 2001, the New Mexico state flag ranked number one out of a field of seventy-two American territories, states, and Canadian provinces for its distinctive and simple design, but elaborate meaning.

Back in the day when the Pledge of Allegiance was recited in every classroom in New Mexico, a pledge to the state flag was also said: "I salute the flag of the State of New Mexico and the Zia symbol of perfect friendship among united cultures."

The Zia people, or Ts'íiy'am'è, explain the Zia symbol as representing the four directions of the earth (north, east, south, west), the four times of day (sunrise, noon, evening, sunset), the four seasons of the year (spring, summer, fall, winter), and the four divisions of life (childhood, youth, adulthood, old age) all tied together in the circle of life which has no beginning or end. It is also the belief of the Zia people that humans have four sacred obligations: be strong of body, have a clear mind, pure spirit, and a devotion to the welfare of their people.

One of the most recognizable symbols of New Mexico is the roadrunner (*Geococcyx californianus*), adopted as the state bird on March 16, 1949, not quite like the Saturday morning cartoon variety which we all know, but a proud, fast, and often fierce bird that the Hopi believed provided protection against evil spirits. Related to the cuckoo bird, the roadrunner was the first state litter-control mascot and is often seen nesting in the prickly pear cactus or the branches of mesquite bushes. This majestic bird goes by several names, Chaparral, El Correcaminos, and El Paisano, and can be seen most times with a lizard or mouse in its beak rather than a coyote; it is also a notorious snake killer, including the dangerous rattlesnake. At 22 inches in length, the bird can run up to 15 miles per hour, which it prefers even though the bird is fully capable of flight.

New Mexico today is a diverse blend of many proud cultures, each lending a touch of themselves to the fabric of the state. You will be amazed by the stories of the host of anomalies that New Mexico has to offer. These include a volcano with an ice cave attached, 750-foot-deep caverns in the desert, bizarre rock formations, Native American cliff dwellings, Spanish Missions, outlaw graves, ghost towns, dinosaur footprints, frontier forts, alien crash sites, and satellite dishes listening for sounds from outer space, just to name a few.

The term "extreme volcanism" is used often to describe the formation of the New Mexico landscape. Every type of volcanic landform is found in the state, and many are landmarks as well as tourist destinations. New Mexico is proudly home to one of the greatest rift valleys on Earth, the Rio Grande Rift. This rift dissects the middle of the state and gives us the Rio Grande River, the Rio Grande Gorge near Taos, Petroglyph National Monument, the Carrizozo Lava Flow, Clayton-Raton Volcanic Field, Valley of Fires State Recreation Area, Capulin Volcano National Monument, El Malpais National Monument, Zuni Bandera Volcanic Field, Rio Puerco Volcanic Necks, Valles Caldera, and Zuni Salt Lake Crater.

The volcanic field areas are littered with over 125 composite, cinder cone, caldera, pahoehoe lava and a'a'lava as well as shield volcanos for 1,000 square miles. It is thought these volcanic fields date back 60,000 to 1 million years ago.

You must be tough to live in New Mexico—her beauty sometimes comes with a cost, triple-digit temperatures, high winds, large amounts of snow and dust, yet she is welcoming, sustaining, and amazing nonetheless. History abounds in the state, with many categories starting with the word "oldest"—such as oldest capital city, oldest wine industry (nearly 140 years before California), oldest churches, oldest cultures, and oldest dwellings. Even with all of these to her credit, New Mexico is often forgotten by the country and the world. It is my intention to do my part to put the great state of New

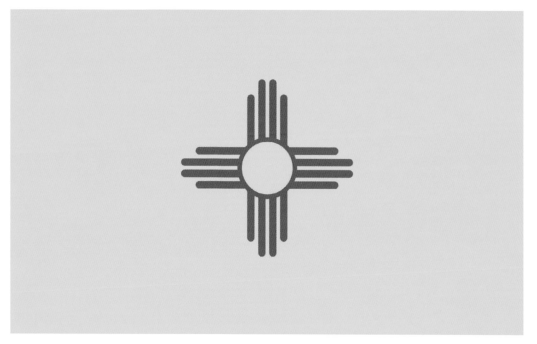

The state symbol of New Mexico is the Zia, which represents the four seasons, stages of life, times of the day, and directions that radiate out from a center sun. (*Author's collection*)

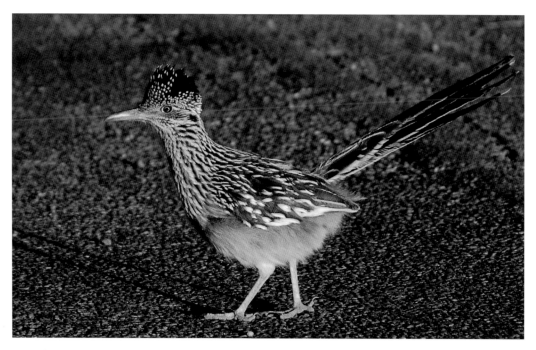

El Paisano, otherwise known as the Roadrunner, is the proud state bird of New Mexico and a proficient snake killer. (*DB*)

Mexico on the map by introducing you, the reader, to her immense charms. The United States are certainly more beautiful with the inclusion of Nuevo Mexico.

New Mexico's diverse background can be enjoyed in her full glory through the many museums which call the state home. As you travel the main arteries of the state, you will notice a direct correlation between the region's culture and what type of museum they offer. Ride along as we discover some of the most interesting and unusual museums in the United States.

As if the state was not colorful enough on its own, there is brilliant artwork everywhere you look. Murals, statuary, quirky roadside masterpieces will have you craning your neck in every town you visit. Artists have long been drawn to New Mexico, be it for the climate, the attitude, or just the sheer beauty that surrounds them. Proudly we have been home (adopted or native) to some of the most famous artists in the world, Georgia O'Keeffe, D. H. Lawrence, Joseph Henry Sharp, and Roderick Fletcher Mead to name only a few. Santa Fe and Taos are famous for their artists and both have world-famous galleries, which feature indoor and outdoor artwork. If you love art, New Mexico will not disappoint.

With the land being isolated and the population sparse, New Mexico was a perfect haven for outlaws, ruffians, and anyone who just wanted to get lost. Lawlessness ran amuck due to the fact there were so few lawmen and such a huge land to cover, which was extremely enticing to outlaws. A couple of the most well-known of these outlaws are William H. Bonney, a.k.a. Billy the Kid, and train-robber Tom "Black-Jack" Ketchum. Others, such as the Hole in the Wall Gang, with Butch Cassidy at the helm, Dave Rudabaugh, and even Bonnie and Clyde, found New Mexico to be a perfect hideaway.

Each region of the state is unique. You will encounter vast deserts, breathtaking mountain vistas, natural wonders, man-made curiosities all under some of the bluest skies you have ever seen. Be warned, Mother Nature likes to play in New Mexico and is at times a bit fickle as to what she genuinely wants. It is not uncommon to have freezing weather in the mornings and near 70 degrees by afternoon on the same day. It is a common saying in New Mexico, "if you don't like the weather, wait five minutes and it will change." So, in other words, be prepared for anything.

New Mexico's vast landscape and sparse population also enticed the United States military as a perfect spot for nuclear testing. The secret base at Los Alamos, New Mexico, developed the Manhattan Project, which saw the testing of the atom bomb in the desert at the White Sands Missile Range. The Trinity Site is still seen as a site of both wonderment and disdain. A smaller nuclear bomb test conducted in Carlsbad, New Mexico, will also be described. Nuclear energy continues to play a large part in the economy of the southeastern region of the state, with the operation of the Waste Isolation Pilot Plant (otherwise known as WIPP) between Carlsbad and Hobbs, New Mexico, which is an underground nuclear waste depository. This depository safely stores waste generated from sites ranging from medical facilities to nuclear development a half a mile underground in natural salt beds.

New Mexico is a wild land—not quite like you see in the old Western movies, but most of the vegetation, reptiles, animals, and insects will bite or sting. Give them plenty of room and they will leave you alone as well. It is suggested you bring water, a first-aid kit, and extra food with you on your journeys, as well as fuel up often due to the long distances between destinations. With twenty-four scenic byways in New Mexico for you

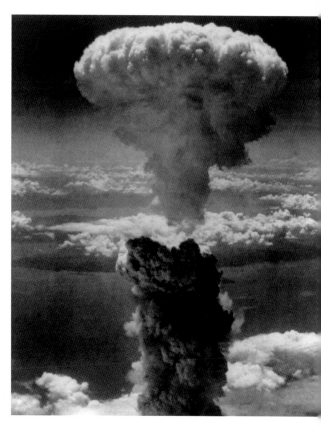

Above left: William H. Bonney, alias Billy the Kid, is one of the most famous outlaws of the Old West. Bonney's life and death are still debated, but New Mexico is proud to claim the outlaw. (*Author's collection*)

Above right: The Manhattan Project, the first atomic bomb detonation, which occurred at the Trinity Site near White Sands Missile Range, is a location that symbolizes both the success and failure of the nuclear industry and war. (*Library of Congress*)

to explore and discover the truly enchanting land of which New Mexico is comprised, I am positive you will remain captivated by her immense beauty for the rest of your life. Please be respectful of this enthralling state by keeping it clean so others will have the same experience as you. Litter, graffiti, and trash destroys the fragile environments found around the state.

This book is broken down into four regions and the major cities in the state. Some of the towns in the regions are officially considered to be in central New Mexico, but I thought it would be easier, for the reader and traveler, to divide the state into four equal quadrants. My trusty ruler and pencil provided the measurement and division—not exactly scientific, but serviceable. I beg understanding from the purists.

A special chapter on the great tastes of New Mexico will be sure to whet your appetite! The official recipe for the delicious state cookie, the Biscochito, is included. Try it at

home, it will become a favorite in your household as well. You will be introduced to the green/red chile, both a staple of the cuisine served everywhere in the state. New Mexico is famous not only for chile, but our green chile cheeseburgers—which is a delectable treat you must try at least once in your lifetime. Not to mention Wine Trails that also deliciously bisect the state.

You are encouraged to use this book as a guide as you get off the beaten path to discover some of the most fascinating destinations in New Mexico. Forge your own journeys and make a lifetime of memories in the Land of Enchantment. I have often been asked how I decide what to include, but the true question is how you decide what to leave out since the whole of New Mexico itself is a true hidden gem. Any exclusions were purely due to time and space constraints, but if I had been able, every town and attraction would have found a place between these covers.

During my extensive travels in my home state, I have been amazed by the amount of history in New Mexico and the willingness of her people to share these stories with those who travel her byways. It is my distinct pleasure to impart to you the wealth of the traditions of New Mexico through the great love of my home. Only words of warning: do not forget your camera.

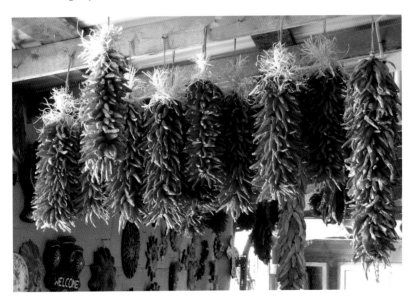

Above: The chile ristra is a staple in New Mexico cuisine and culture. (*DB*)

Left: The official state quarter for New Mexico was issued in 2008 and features the Zia symbol. (*Author's collection*)

1

NORTHWESTERN NEW MEXICO REGION

Historical Background

Aztec, New Mexico

Located a scant few miles from the New Mexico–Colorado border, the small village of Aztec, population less than 7,000, was founded in 1890, but has history dating back to the eleventh century. Today, Aztec is the seat of San Juan County and enjoys a healthy tourist trade thanks to the many attractions in and around the town.

The Animas River, which bisects the town, provides opportunities for kayaking and river rafting, as well as some of the best fly-fishing spots in the state. For those of you who enjoy staying dry, there is the Animas River Trail System to explore along the banks, over 30 miles of mountain bike trails and an eighteen-hole golf course.

Aztec received its name from the early settlers who came to the area and marveled at the architectural wonders of the pueblo great houses, which were used by the locals. Misidentified as Aztec ruins, the name stuck, and the village has embraced the name since. Aztec is proud to have seventy-eight structures on the National Register of Historic Places, as well as the New Mexico Register of Cultural Properties.

Written history of the Aztec area began in 1776 by Father Francisco Atanosio Dominguez and Father Francisco Velaz de Escalante, two Franciscan friars who unknowingly drew settlers and travelers to the San Juan Basin in their quest for a short route from Santa Fe, New Mexico, and their mission churches in California. Aztec would later be established as a trading post in 1887 to provide the local farmers and ranchers with much-needed supplies.

By 1901, the discovery of oil and gas deposits brought prosperity to Aztec, a boom in population carried through to the late 1960s. One of Aztec's most proud accomplishments is being named an "All-American City" in 1963. The community's determination and selflessness to build a two-lane highway from the city limits to the newly constructed Navajo Dam 19 miles away, shown true as they accomplished this feat in a mere three months to garner the town national media attention.

Although Aztec is famous for their camping opportunities, world-class fly-fishing spots, and outdoor activities offered in a beautiful setting, they also are famous for

Aztec, New Mexico, is known for being the home to ancient ruins and modern conveniences. (*Library of Congress*)

several wonderful wineries in which you can partake in nature's gifts. The community offers year-round goings-on to entice the visitors ranging from car races, music concerts, holiday festivals, outdoor recreation, and golf.

Move over Roswell, Aztec also reports it experienced its own alien encounter in March 1948 when an alleged spacecraft crashed in Hart Canyon, northeast of Aztec. The craft was reported to have been superbly built and rendered fourteen to sixteen charred remains of small humanoid creatures. Like Roswell, the United States government was dispatched to the site to remove any evidence of its existence.

Dulce, New Mexico

If you are into weird, controversial, or conspiracy theories, Dulce, New Mexico, might be just your cup of tea. New Mexico has always held many secrets, as you will see as you delve further into this tome. Dulce, which means "sweet" in Spanish, was founded in 1877 as a homestead by rancher, Jose Eugenio Gomez. The ranch became surrounded by the Jicarilla Apache Reservation in 1887 but is still owned by the Gomez family. With a population today of nearly 3,000 souls, nearly all Native American, Dulce is the largest community in the area and the tribal headquarters for the Jicarilla Apache Reservation.

Looming over the town of Dulce is Archuleta Mesa, home to a large array of radio antennas and communication towers; this is the long-rumored location of a huge, seven-story underground collaboration base between the U.S. government and space aliens. Yes, you read that right. No matter your beliefs on the matters, Dulce had a long history of UFO sightings and other strange activities reported over the years, which earned this small northwestern New Mexico town to be compared to Area 51 in the state of Nevada.

This facility is rumored to have underground shuttles called "tube shuttles," which allegedly take scientists and aliens alike to Los Alamos, Albuquerque, Taos, and even

18

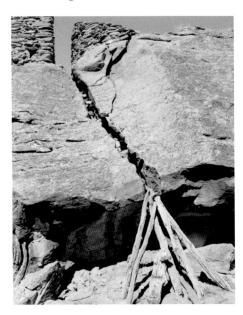

Split Rock Pueblito is built on top of a split boulder—hence the name. (*Library of Congress*)

as far south as Carlsbad—crude maps of the supposed routes also have these shuttles traveling all over the southwestern United States from Oklahoma to California and even into Mexico. The many cattle mutilations – where the organs and blood were removed by what appeared to be laser cuts—and human disappearances around the area have residents wondering and speculating as to the true causes.

Everything is purely conjecture and nothing is proven, but for UFO enthusiasts, and the curious, the rumors of Dulce, New Mexico, sure play with the imagination. The validity of the stories is up to the beholder.

Farmington, New Mexico

In the furthest northwest corner of New Mexico is the beautiful town of Farmington, which is rich in culture and oil reserves, as well as being the largest city in that part of New Mexico. You will find fly fishing in the Animas River, outdoor recreation such as four-wheel drive trails, mountain biking, hiking, hunting, nature trails, and water sports sure to pique your skill levels all while in a spectacularly beautiful setting of red sandstone hills, arches, and formations.

The four-wheel drive vehicle is extremely popular in New Mexico and Farmington hosts the World Extreme Rock Crawling Nationals, which is an entire week dedicated to the 4×4. These trails, which surround the Four Corners region, include a variety of surfaces such as sand dunes, steep rock walls, off-road trails, and slickrock, each posing its own challenges.

With over 30 miles of hiking, mountain biking, and nature trails, Farmington is home to one of the longest-running mountain biking races in the U.S., the Road Apple Rally, held the first Saturday in October. Many of these trails skirt the Animas River giving the riders beautiful scenery to enjoy as they quickly bike along the shores and there are activities for all fitness levels.

Farmington is also home to many art galleries and museums, which celebrate the beauty and history of the region surrounding them. You can try your luck at the two casinos that feature live horse racing, slot machines, poker, and live entertainment for your enjoyment. As with Aztec, you will also be able to visit the wineries of the San Juan award-winning wines. Home to numerous museums, Native trading posts, and art galleries, Farmington will surely have something for everyone.

Four Corners Monument or Four Corners Navajo Tribal Park

Nowhere else can a person be in four states and three sovereign nations at one time except for at the Four Corners Monument—part of the larger region known as the Colorado Plateau. The convergence, or quadripoint, of Utah, Colorado, Arizona, and New Mexico makes for a unique experience. This monument not only separates four states, it also serves as a boundary for two large Native American governments—the Navajo Nation and the Ute Mountain Tribe. Maintained by the Navajo Nation, the monument is visited readily by those who like to have the experience of being in four states at once, so expect lines at busy times of the year. Visitors are given a time limit and a photo limit of three at the monument since you will most likely be one of over 250,000 people who visits the site each year.

Located 60 miles northwest of Farmington on Hwy. 160, the granite and brass monument marks the auspicious local, surrounded by all four state flags as well as tribal flags and the original concrete marker was constructed in 1912. Native American vendors from the Navajo, Ute, and Ute Mountain tribes are also set up at the monument in the Demonstration Center, so you will have an excellent chance in obtaining true authentic Native-made jewelry, rugs, and food. The Four Corners Monument is not a federal park or state monument, so National Park Passes and Golden Age Passes are not accepted—it is designated as Four Corners Tribal Park. It is highly recommended to try the delicious fry bread, a local treat, while in the Navajo Nation. (This delectable dish is described in more detail in Chapter 9.)

The park is open year-round except for Thanksgiving Day, Christmas Day, and New Year's Day from 8 a.m. to 8 p.m. (Mountain Time) from May 1 to September 30, and 8 a.m. to 5 p.m. from October 1 to April 30 and will cost you $5 to enter the gate for ages seven to adult, children six and under are free, but please have cash available, in case the credit card machine loses connection or they charge a courtesy fee for use.

Dogs are only welcome in the parking lot—except for service animals. Also be aware there is no running water or electricity at the site, so bring water with you and a hat is also recommended as you may be standing in line for a while. Fuel up your vehicle before leaving Farmington since the closest convenience store is 6 miles from the monument in Teec Nos Pos, Arizona. Directions: Travel 60 miles northwest of Farmington on Hwy. 160 through breathtaking scenery.

For more information concerning weather conditions at the Park, please contact Navajo Parks and Recreation at (928) 871-6647 or go to www.discovernavajo.com.

Gallup, New Mexico

Known as the "Heart of Indian Country", Gallup, New Mexico, has a rich history of Native culture dating back to 2500 B.C. with the Ancient Puebloan People. The Navajo (Dinè), Zuni, and Hopi peoples call the northwestern region of New Mexico home and

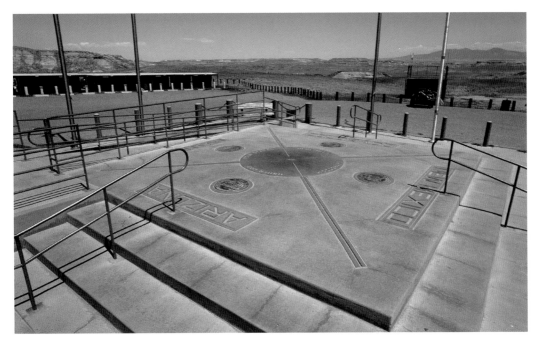

Four Corners Monument is the only place in the U.S. that you can be in four states at once. (*Author's collection*)

celebrate their traditions by holding nightly Indian dances during the summertime as they represent and preserve the culture of 43 percent of the population.

Founded in 1881 as a railhead for the Atlantic & Pacific Railroad, the western town was named in honor of the railroad's paymaster, David Gallup. Na'níhoozi, the Navajo name for the town, is located on Interstate 40 between Albuquerque, New Mexico, and Flagstaff, Arizona, on the famed Route 66. Another highway now known as U.S. Route 491, which ends in Gallup from Monticello, Utah, was once called the "Devil's Highway" since its numerical name was Highway 666. The Beast, as it was called by locals, has many reports of unexplained phenomenon that happened along this route, earning it the moniker of a haunted highway. The Devil's Highway was renamed in 2003 to the relief of residents.

Although Gallup grew because of the mining and railroad industries, it is the unequalled jewelry making and weaving skills of most of its residents that have put the town on the map. Silver and turquoise jewelry is long associated with the Navajo (Diné) People, even though jewelry was made by the tribe prior, the first known combination of silver and turquoise was not recorded until 1880. The Navajo Nation is the place to go if you want authentic "Indian" jewelry. Many shops in town carry a huge variety of modern and old pawn jewelry to choose from, as well as woven rugs/blankets, pottery, and sand paintings—all of exceptional quality.

With its picturesque landscape, Gallup has been the backdrop for many Hollywood movies such as *The Grapes of Wrath*, *Escape from Fort Bravo*, and *Ace in the Hole* to name a few, which starred greats such as John Wayne, Kirk Douglas, and Gregory Peck.

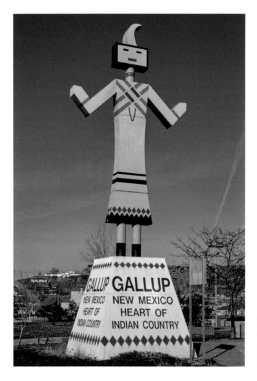

Gallup, New Mexico, is known as the "Indian Capital of New Mexico" and one of the best cities in the state to find authentic Native American art and jewelry. (*Author's collection*)

If you are looking for the ultimate outdoor experience, Gallup is for you. Activities include biking, ballooning, hiking, climbing, hunting, fishing, shooting, horseback riding, and motorsports aplenty.

Jemez Springs, New Mexico

Beauty surrounds this quiet mountain community of less than 400 "laid-back, unjudgmental" souls. Only a short distance from the hustle and bustle of Albuquerque, Jemez (pronounced HAY-maze) Springs offers a welcomed respite from city life and traffic. Nestled in the Santa Fe National Forest, on the banks of the Jemez River, Jemez Springs offers unique shopping, eateries, and hot springs in which to let all your troubles melt away.

The waters of the hot springs are said to have healing powers by the several spas and resorts located in the small village. These waters were also used by members of the Guisewa Pueblo, (which means "place at boiling water") now Jemez Springs, for healing over 3,000 years ago. It is said one of the hot springs produced a geyser in 1860, the townsfolk built a rock wall around the pool, which formed from the spewing water and a tourist attraction was formed. People would come to the town from miles around to "take the waters."

Today, the original geyser is housed in the 130-year-old Jemez Springs Bath House, where you can lower yourself in heavenly waters ranging from 154 to 186 degrees in temperature for a nominal fee. These waters are chlorine and chemical free, and, thankfully, release no rotten egg smell as some hot springs can. Be warned this is a bathing suit optional bath house with private bath sections and people fourteen years

of age and older are welcome. Mineral wraps and massage therapy are also available for additional fees.

Jemez Springs today looks much like it did in the 1800s and was given the honor of the "All-American City" Award by the National Civic League in 1995—one of the smallest municipalities to receive this honor. Jemez Springs is also home to the Bigfoot Festival held in 2017 after strange sounds, tracks, and sightings occurred near the village. Promoters pointed out that whether you believe in the existence of the hairy manlike beast, there was fun for everyone just to enjoy the day with live music and great food.

Bigfoot has long been rumored to live in the nearby Valles Caldera and Jemez Mountains. A nighttime thermal image of a large being was featured on the *Animal Planet* in 2011 during the New Mexico episode, giving small credence to the actual existence, but many locals swear to have seen or heard Bigfoot over the years. New Mexico was described on the episode as "super squatchy" and one of the "Sasquatchiest places in the country" with over twenty-four sightings reported in the state—be sure to check out the t-shirt vendors in town who feature Bigfoot on their creations. The large herds of elk in the Jemez mountains has long been speculated as the main reason for the supposed Bigfoot to enjoy the area. This mystery ranks right up there with the Roswell Incident in many minds.

Quaint shops, cafes, and art galleries line the short street of Jemez Springs. (*DB*)

For those of you who fish, the Jemez River is one of the most beautiful places in the state to dip a pole, since Rainbow Trout are routinely stocked in the winding river. Several beautiful cottonwood populated outlets are available along the narrow Highway 4, which takes you into Jemez Springs, no better way to spend a lazy Sunday afternoon. The local cafes and brewery have wonderful food to offer you as you sit back, relax, and breathe in the clear high desert air.

Los Alamos, New Mexico

Referred to as "The Hill" by those who worked there, Los Alamos is home to one of the most secretive laboratories outside of the famous "Area 51" in the state of Nevada. As you drive by the highly secured Los Alamos National Laboratory facility, you will notice signs on the fences warning you are under surveillance and the fact explosives are in use. At the center of the nuclear industry in the U.S. during World War II, the Cold War, and today, the laboratory is responsible, in conjunction with many government agencies, for the development of weapons, environmental management, cyber security, and counterterrorism systems to protect the U.S. from imminent threats.

Los Alamos, which means "The Cottonwoods" is Spanish, has been home to the Ancient Puebloan People, Spanish explorers, Native tribes, and homesteaders throughout its history. The isolated and picturesque location seized interest from the U.S. government as perfect setting in which to develop the atomic bomb, otherwise known as the "Manhattan Project," and the location was referred to as "Project Y." So highly secretive was this spot that incoming loads of equipment and supplies were trucked in under false names and labels. The only address known to the world for Los Alamos in the 1940s was a post office box.

Spies, engineers, scientists, and military officials inhabited the tiny town that was developed under a cloak of secrets. It was not until the bombing of Hiroshima and Nagasaki that information about the existence of nuclear weapons was revealed. Known as Los Alamos National Laboratory today, the necessity for housing close to the lab facilitated the building of nearby town of Los Alamos.

Situated in some of the most magnificent countryside in New Mexico, Los Alamos sits upon a high plateau—it is said it was placed there to inspire the scientists to "think bigger." Although the bombs developed at this site are controversial now, you must put yourself in the timeframe in which they were made. It is noted due to what the world saw in the horrible aftermath, another bomb of this magnitude has not been used in war since.

In May 2000, a controlled burn became a raging wildfire and resulted in the loss of over 400 homes and 150,000 acres burned in and around Los Alamos, including some structures at Los Alamos National Laboratory. The Cerro Grande Fire was not determined to be extinguished until July 20, 2000. The conifer forest that surrounds the town and lab were prime for a major fire due to drought conditions—it was driven by high winds that blew embers ahead of the prescribed burn lines and straight into the town causing over $1 billion of damage. Cerro Grande has gone down as the largest, most destructive fire in New Mexico history to date.

Los Alamos has recovered and rebuilt and the countryside bears but a few scars to show the tragedy that occurred. Today, the town is a shining example of perseverance and still houses some of the most brilliant minds in the world.

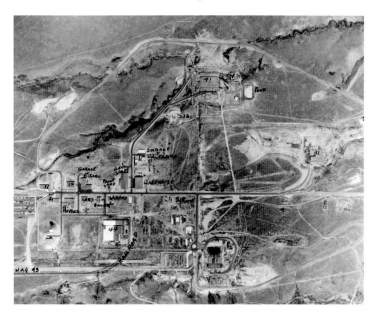

Once a secret city, Los Alamos is home to some of the most brilliant scientific minds in the world. (*Library of Congress*)

Makes You Go ... Hmmm

Los Lunas Mystery Stone

Carved on to a basalt boulder west of Los Lunas, New Mexico, in the Manzaño Mountains, is a Paleo-Hebrew script version of the Ten Commandments. Speculation on how the etching got on to the stone and who the people were who carved them remains a debated subject since the first known use of the Paleo-Hebrew language is the Gezer Calendar, which dates to the tenth century B.C. This stone is referred to by researchers, theologians, and academics as the Los Lunas Decalogue Stone because it has an abbreviated version of the Ten Commandments written on the 80–100-ton boulder and was known to locals in the 1850s. Reportedly, there is a Tamarisk tree planted near the rock—this is the same type of tree species native to the Middle East and the same as the one Abraham planted in Beersheba when he called upon the name of the Lord.

In 1933, Frank C. Hibben, an archaeologist for the University of New Mexico, was said to have discovered the stone with guidance from a person who had seen the stone in the 1880s, proclaiming it was over 100 years old at the time. Hibben suffered accusations of the stone being his own creation and therefore a hoax, but he maintained his stance on the validity of the stone until his death in 2002.

Skeptics argue the stone is a fake, mostly due to there being an absence of ancient Hebrew communities in the New World, especially the southwestern portion. Others believe the stone represents the arrival of ancient Jewish people in New Mexico, but errors in some of the words on the stone point to the possibility of it being written more recently than during the Paleo-Hebrew era. These writings are mainly of Jewish origin, but also contain Greek letters as well, which gives greater mystery to the origins of the writing on the stone.

The Decalogue Stone is surrounded by ancient Native American petroglyphs carved on boulders as well. A little higher up from the Mystery Stone are more Hebrew

carvings, which read: "Jehovah our Mighty One" mixed in with the Native carvings of constellations. One of the carvings possibly depicts constellation symbols and that of the zodiac such as a scorpion and a solar eclipse. Researchers say this astrological event took place in 107 B.C., which could possibly date these petroglyphs to 2,000 years ago.

One theory states the carvings may have been done by a bored soldier from the Mormon Battalion who was in the area during the Mexican-American War, but the writing was done at a 40-degree angle, which suggests the boulder was moved since the inscription was done. Whatever your belief on the origins of the writings on the stone, it is an interesting spot to visit.

The land on which the stone rests is on a 400-foot mesa located on Hidden Mountain, which is a dormant volcano, on New Mexico trust land and can only be accessed by obtaining a permit from the New Mexico State Land Office first. Unfortunately, the first line of the Mystery Stone was vandalized in 2006, most likely because it is only 16 miles from the town of Los Lunas and is highly visited.

Directions: A 2-mile hike off Highway 6 and Interstate 25. You can drive only part way; once you reach the dump area, you must park your vehicle and hike the rest of the way. A sandy trail leads up to the Mystery Stone, which is about half-way up the mountain side. There will be two turnstile gates to navigate, a fence line to follow and a rather steep incline towards the end and is not handicap friendly. The land office will instruct you to stay on the trail, not pick up rocks, and to take out your trash. You will also be given a map to the site.

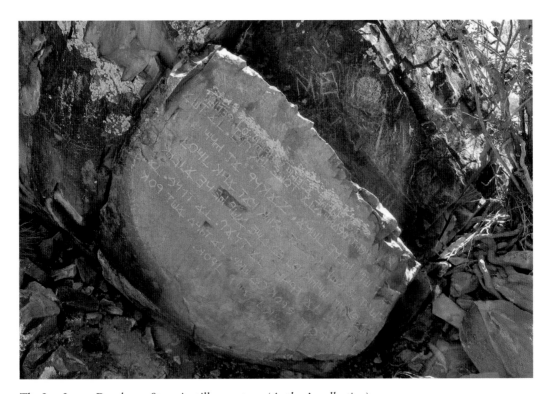

The Los Lunas Decalogue Stone is still a mystery. (*Author's collection*)

Not Your Ordinary Museum

B-Square Ranch

Housed on the B-Square Ranch are three unique museums, which are a must see in the Farmington area. The Bolack Museum of Fish and Wildlife features over 2,500 mounted animals and fish from five continents and gives the visitor a chance to see up-close the many species of creatures they would most likely never get the opportunity to see. This massive collection is the largest of its type in the world. The museum is quick to point out that these examples of nature are preserved specimens which died from old age. Free tours are given by appointment by ranch owner Tommy Bolack.

Also located on the B-Square Ranch is the Electromechanical Museum and B-Square Ranch and Experimental Farm, which provide visitors a glimpse into the early days and equipment of electricity. Switchboards, insulators, and electric meters are just a few of the items on display. There is also a functioning radio station and early television equipment on the site as well. Address: 3901 Bloomfield Highway, Farmington, New Mexico 87401. Tours can be booked by calling (505) 325-4275, or by visiting www.bolackmuseums.com or www.b-squareranch.com.

Belen Harvey House Museum

The 1870s saw the arrival of the railroad to the New Mexico Territory and connected the vast west with civilization in the east. New businesses sprang up to accommodate the industry with one of them being the Harvey Houses. As an immigrant from England, Fred Harvey started his life in America washing dishes at a restaurant, but soon was able to form a partnership with the Atchison, Topeka, and Santa Fe Railroad to operate lunchrooms and hotels along the route.

Harvey only employed single women in his Harvey House's as servers. These young women, called Harvey Girls, had to live up to extremely high standards, wear spotless uniforms, be chaperoned (dating was discouraged), all for $17.50 a month wage. The Harvey Girls of New Mexico were sent to Vaughn to receive training in the fine art of serving and then scattered throughout the state. Most of the Harvey Houses had dormitories upstairs where the girls would live along with a dorm mother and office manager. There were bed checks at 10 p.m., and anyone not there would have to sneak past the rooms of the dorm mother and manager. Harvey's girls were not called waitresses since he felt that was a demeaning term, they were known as Harvey Girls and anyone who disrespected them would be immediately removed from the premises.

Fred Harvey was a stickler to how the Harvey Houses were run and perceived. Tables were set with English china, Irish linen, and crystal and silverware. The passengers of the incoming train sent their orders ahead by telegraph and the meals were prepared and waiting when they arrived. As a refueling stop in Belen, the passengers only had thirty minutes to eat and re-board the train, so the operation had to work like a well-oiled machine.

The Belen Harvey House Museum was open as a Harvey House from 1910 to 1939. During World War II, many of the Harvey Houses reopened to serve the troop trains that were running on the rails. The museum building fell into disrepair and was nearly demolished if not for the efforts of the citizens of Belen. Today, the museum specializes in railroad, Harvey House, and southwest history and includes many of the original items used by the Harvey Girls.

Closed Monday and Tuesday, the Belen Harvey House Museum, which is located at the railroad track, is open from 12 p.m. to 5 p.m. every day except Saturday when it is open 10 a.m. to 5 p.m. Address: 104 North First Street, Belen, New Mexico 87002. You can contact via (505) 861-0581.

Bradbury Science Museum

Have you ever wondered how Los Alamos National Laboratory works? Although you will not be allowed in the sensitive areas of the laboratory, you can experience scientific and technological concepts such as life sciences, supercomputers, and energy at the Bradbury Science Museum in downtown Los Alamos for free. Named for Laboratory Director Norris Bradbury, the museum began to store weapons-research artifacts. All the exhibits are declassified and are a huge part of the fascinating history of the Laboratory's weapons program. The original museum was housed in the old icehouse in Los Alamos and was already equipped with a vault in which sensitive, classified documents were preserved.

Hands-on demonstrations and exhibits are geared towards the education about nuclear science and research of the Manhattan Project and its importance to national security and scientific development. This is a fascinating tour through the history of the atomic age of Los Alamos and truly gives you an insight on how the industry began. The museum is proud to report they are visited by over 80,000 visitors each year with many of these numbers being students ranging from elementary to college age.

Address: 1350 Central Avenue, Los Alamos, New Mexico 87544. The Visitor Center can be contacted at (505) 667-4444, Visiting hours are Sunday and Monday, open from 1 p.m. to 5 p.m., and Tuesday through Saturday, open from 10 a.m. to 5 p.m.; it is open every day except Thanksgiving Day, Christmas Day, and New Year's Day.

National Navajo Code Talkers' Museum and Veterans' Center

At the height of World War II, a group of unlikely men from the Gallup area accomplished what few thought they could, but the fate of the entire free world rested on their shoulders. Sound like a perfect plot for a Hollywood movie? This was better, it was true.

The German war machine was having no trouble in breaking the strategic codes used by the Allied armies; consequently, it was looking a bit rough for the good guys. At Fort Wingate near Gallup, New Mexico, the Navajo language was discouraged by the U.S. government to be spoken, but as Japan also became more successful in breaking the codes using the normal dialects and languages, the government came to the door of the Navajo Nation to sign up twenty-nine young men as Code Talkers. This unique program used the difficult dialects and inflections of the Navajo to send secret messages to other troops, proudly without ever being broken.

Over 10,000 Native Americans fought in World War I, without being considered citizens. It was through their efforts that the Citizenship Act of 1919 was enacted by Congress and granted citizenship to all Native American veterans of World War I in 1924. World War II would see over 40,000 Native Americans serving in the ranks.

It can truly be said that without the brave Navajo Code Talkers, the U.S. would not have won the war. What makes the dedication of the Navajo even more astounding is they were only sixty-three years out on one of the most tragic "experiments" in military history. In 1855, the Navajo and Mescalero Apache tribes in northwestern and central

New Mexico were rounded up and made to walk up to 500 miles from their homeland to Fort Sumner, New Mexico. The brutality of this "Long Walk" left a permanent strain between the Native Americans and the Anglos who ordered the march.

The National Navajo Code Talkers' Museum and Veterans' Center pays homage to these people who overlooked a great grievance to their ancestors to help the country they formed. Even with their willingness to participate, the U.S. government still did not fully trust them as they were guarded by other American soldiers during their service. In this small celebration exhibit of the World War II contribution of the Navajos, there are wartime articles and equipment used by the Code Talkers.

Address: 106 W. Historic Route 66, Gallup, New Mexico 87301. Contact details: (505) 722-2228. Closed Saturday and Sunday.

San Juan County Museum at Salmon Ruins and Heritage Park

Located in Bloomfield, New Mexico, the eleventh-century ruins, A.D. 1064 be exact, are related to the Chaco Canyon Culture. Being over 2 acres in size, the pueblo saw two occupations and has produced some of the best artifact examples of these cultures.

After the second occupation ceased in A.D. 1250, the pueblo remained untouched until people began moving westward to settle. It was in 1877 when Peter Milton Salmon homesteaded the land next to the ruins; his son, George, later acquired the land on which the ruins were located, and the tract remained in the Salmon family until 1956. The San Juan County Museum Association was lucky enough to be able to lease the land in 1964 for $1 a year for 100 years.

Between 1964 and 1970, two-thirds of the pueblo had been excavated, resulting in an astounding 1.5 million artifacts, many of which are displayed in the museum. Archaeological digs are continually being conducted at the ruins providing an excellent site for students and researchers to do field studies. Stabilization of the ruins with the addition of fresh mortar and stone cutting helps to maintain the centuries-old structures. Both are labor intensive, often back-breaking jobs, but do so much to preserve the history and culture of the area.

To raise funds in the continuance their operation at Salmon Ruins, the staff hosts one of the longest-running craft fairs in the region. As the largest fundraiser for the organization with eighty-one booths, the fair features local artisans to show and sell their wares. The craft fair is a great opportunity to purchase handmade items while supporting the museum.

Address: 6131 U.S. Hwy. 64, Bloomfield, NM. Contact number: (505) 632-2013.

Outdoor Adventure

Ah-Shi-Sle-Pah Wilderness

Encompassing over 26 square miles of wilderness remarkably like the Bistí Badlands, the Ah-Shi-Sle-Pah Wilderness Study Area features banded sandstone, mudstone, petrified wood, and, most distinctly, dinosaur bone fossils. There are over 280 specimen fossils from this wilderness area on display at the New Mexico Museum of History and Science in Albuquerque, which include fossilized leaves and fossils of ancient crocodile and turtle bones.

This highly photographed landscape was found by Charles Hazelius Sternberg as he was hunting dinosaur fossils near Chaco Canyon by Farmington, New Mexico. Do not rely on your GPS, the way to the wilderness area will be nearly 15 miles of unpaved roads. Highly eroded rock formations known as "Hoodoos" form the "Hoodoo City" and are a perfect example as to why New Mexico is called the Land of Enchantment.

Directions: From U.S. Hwy. 550, travel 7.5 miles northwest of Nageezi, New Mexico (44.5 miles northwest of Cuba, New Mexico), turn left on to NM 57. Drive south to southwest approximately 13.5 miles where you will find that NM 57 forms the boundary of the Wilderness Study Area, which will be on your right for the next 5 miles.

Angel Peak Scenic Area

Blink and you might miss the turn-off to the San Juan Basin Badlands of Angel Peak, 15 miles outside of Bloomington, New Mexico. The graded dirt road from U.S. 550/ NM 44 is deceiving and you will wonder if you took a wrong turn as you pass a waste facility plant. Travel slowly or the rumble strip ruts left by the road equipment will make your vehicle jump all over the 6-mile-long road.

Angel Peak rises 6,988 feet from the desert floor to beckon you to explore the over 10,000 acres of the Angel Peak Scenic Area. Once you arrive at the Kutz Canyon badland's rim, you will be amazed by the almost alien-in-appearance landscape before you. Pastel-colored striations ring the formations along the canyon floor, with the occasional element-carved hoodoo begging you to take a photo, jetting up throughout the terrain. The vast canyon is painted with greys, yellows, pinks, and purples in hues only the Creator could master.

This phenomenon is caused by the erosion of the three strata found in the area, Kirtland Shale, San Jose Formation, and the Nacimiento Formation. There are also examples of blue-grey petrified wood scattered across the landscape as well. The rugged formations are comprised of mainly sandstone, siltstone, and mudstone—all easily sculpted by the wind and rain. These formations are not visible from the highway, so it is a pleasant surprise when they reveal themselves as you approach the rim.

Angel Peak is known to the Navajo Nation who call it "the dwelling place of the sacred ones." You can certainly see why as you sit at the canyon's rim with only the occasional screech of a raven to break the eerie silence.

Nine concrete pad campsites are available for tents—each include a covered picnic table and fire grates. Although there are no electrical outlets, water and two restroom facilities are available. You must bring your own firewood should you desire to make a fire or cook. Angel Peak Scenic Area is stark and barren, but wildlife still calls this home. Please be aware of the presence of rattlesnakes on your hikes, and it is suggested you bring plenty of water.

Since this is a Bureau of Land Management site, firearms are not allowed, nor is the collection of fossils and artifacts. Please stay away from the oil well pads and equipment that are in the depths of the canyon and along the rim since the scenic area is open year-round.

Address: County Road 7175 off Highway 550, South of Bloomfield, NM.

Aztec Natural Arches

An amazing assortment of sandstone arches, windows, and bridges lie within an hour's drive of the town of Aztec. Sculpted by Mother Nature's artistic tools of wind and

Right: Rising 7,000 feet out of the Kutz Canyon badlands of New Mexico is the pastel hued Angel Peak. The recreational area offers over 10,000 acres to explore. (*DB*)

Below: You will get a great view of the Castle Rock formation from one of the three overlooks along the rim road. (*DB*)

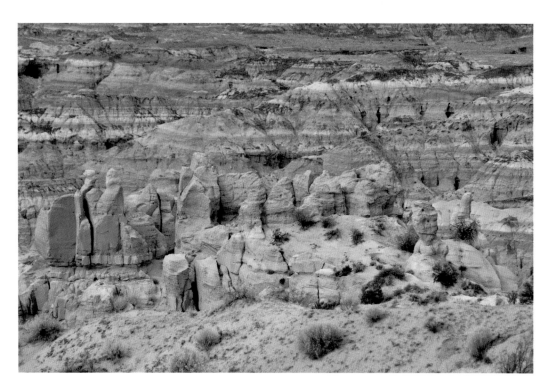

rain, the massive, yet delicate formations are a sight to behold. In fact, there have been approximately 300 arches and windows discovered in the twenty-six canyons inventoried in the region so far, with new discoveries made continuously. Anasazi Arch in Cox Canyon is the largest and one of the best examples of sandstone arches in the park, carved by the natural forces of water and holds the majority of the 500 known natural arches in the state.

As reported by the Natural Arch and Bridge Society, "a natural arch is a rock exposure that has a hole completely through it formed by the natural, selective removal of rock, leaving a relatively intact frame." Some of the arches and bridges appear so fragile and perched at such angles, it is a wonder they do not collapse upon themselves.

Many of the formations were used by ancient people to record everyday life in the form of petroglyphs. Remnants of these mysterious carvings can be found throughout the dry canyons which are tributaries of the San Juan River. Unfortunately, some of these priceless artifacts have been damaged due to vandalism, but there are still many to discover in your trek.

Battleship Rock National Recreation Area

Jetting up 200 feet from the canyon floor, the basalt cliff known as Battleship Rock is a sight to behold. Its resemblance to the prow of a Navy ship garnered the formation the name and is peppered with veins of obsidian—a black glasslike volcanic stone. There are three hiking trail opportunities from either the Day Use parking lot. A slight right turn off of Highway 4 at mile marker 24 towards the picnic area, will cost a $5 entrance fee, but you will have use of the parking/picnic grounds all day, or the free parking lot directly on Highway 4 will give you safe entrance to the hiking trails, but your vehicle will be easier accessed from the highway since it is only 5 miles from the town of Jemez Springs.

If you follow Trail 137, which hugs the east side of the Jemez River, you will be rewarded with McCauley Warm Springs after 0.5-mile moderate hike. The other two trails are more strenuous and are best for seasoned climbers/hikers—you can climb all the way to the top of Battleship Rock for a spectacular view. Personal climbing gear, water, good hiking/climbing boots, and a helmet are recommended for the trip to the tip of the prow.

The picnic area at Battleship Rock has four gas grills, drinking water, wood shelter, and toilets and is strictly day use only—no overnight camping is allowed, but there are beautiful camping grounds available just 10 miles down the road. The best seasons suggested for visiting this landmark are spring, fall, and winter. Although it is in a mountainous region, temperatures can climb in the summer.

Spence Hot Springs, a couple of miles up from Battleship Rock on Highway 4 can be accessed from a free parking lot along a well-worn trail that crosses the Jemez River and continues up to several pools with hot springs water. Due to the volcanic activity still occurring under the surface, many of the streams and pools range from warm to hot in temperature. Leashed pets are welcome; please be courteous to other hikers and remove any solid waste generated by your pet from the area.

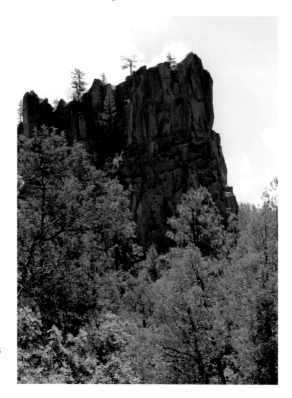

As you round a bend on Highway 4, the rugged basalt facade of Battleship Rock is a surprise and is a favorite for hikers and rock climbers alike. (*DB*)

Bistí Badlands/Da-Na-Zin Wilderness

One of the most alien landscapes in New Mexico lies along Highway 550 between Farmington and Cuba. The Bistí (Bis-tie) Badlands, also known as the De-Na-Zin (Deh-Nah-Zin) Wilderness, is the result of violent volcanic activity that left a beauty not found anywhere else. Forests of massive, tall formations, "dragon eggs," flat stone lily pads, and natural arches all give the impression of entering a wonderland formed out of soft clay, interbedded sandstone, shale, mudstone, coal, and silt. Bistí is the Navajo word meaning "a large area of shale hills" and encompasses approximately 45,000 acres of wilderness in the San Juan Basin. De-Na-Zin translates from the Navajo word meaning "cranes." These badlands are one of the most photographed, yet largely unknown wilderness areas in northwestern New Mexico.

You will be amazed at the sights you will see in the wilderness zone. Hoodoo (conical tent-like formations), other eroded rock formations in the shapes of cranes, wings, and even dinosaur bones are found in the area. One notable site is the 100-foot-long petrified wood log in the De-Na-Zin Wilderness. Be aware there are no true trails and it is easy to get lost—do not hike by yourself, bring plenty of water and supplies since there are none at the site, and always know your location. There are orange-colored mounds scattered throughout the landscape that can be use as landmarks if necessary.

Once a coastal swamp of an inland sea, the Bistí Badlands contained an environment completely different to the one seen today, it included dinosaurs, large trees, and reptiles—a far cry from the desert landscape you will experience on your visit. Be sure

to be mindful of the birds and wildlife that live in Bisti, which is listed as one of the top ten most scenic areas in the west.

Bistí is accessed generally from Hwy. 371 from Farmington, New Mexico, along a gravel and dirt road, which, by the way, can become treacherous after a rain. The likelihood of getting your vehicle stuck in the slimy mud or the possibility of a flash flood after a rain is high, so plan your trip accordingly. The Bureau of Land Management maintains the wilderness area; therefore you cannot pick up, take, or destroy any fossils, formations, petrified wood, or any other artifacts of the region.

The Alamo Wash area will take you to some of the favorite formations in the Badlands, the Rock Garden, and the Cracked Eggs. It will be hard to remember you are still on Earth while witnessing the unusual formations and shapes before you. Many of the formations seem gravity-defying as huge boulders will be perched precariously on top of tall sandstone pillars giving the impression they will topple at any time. Please use caution and care while exploring this fabulous wilderness as the formations are fragile and irreplaceable.

Due to the heat factor in the open plains of the Badlands, the best time to visit is fall or spring when the weather is more tolerable. This is the ultimate photographer's playground, and it is recommended that the best times to capture some stunning images is during the "Blue Hours"—the hours before dawn and after sunset. The colors of the rock formations are amazing and range from deep blues, whites, reds, purples, and greens.

Directions: There are two ways of accessing the Badlands—each with their own unique formations. First access point: Bistí Access Parking. To reach the Bistí Access Parking Area, Drive NM 371 just under 36 miles south of Farmington (from the San Juan River crossing) or just under 45 miles north of Crownpoint, New Mexico (from the intersection of 371 and Navajo Service Route 9), and turn east on Road 7297 (a gravel road). Drive Road 7297 for approximately 2 miles to a T-intersection and turn left. Drive just under a mile to the Bistí Access Parking Area, which is just south of a broad wash on the east side of the road. There is another, smaller parking area a quarter mile further north. Second access point: De-Na-Zin Trailhead. To reach the De-Na-Zin access, Drive NM 371 approximately 43¾ miles south of Farmington (from the San Juan River crossing) or approximately 37¼ miles north of Crownpoint, New Mexico (from the intersection of 371 and Navajo Service Route 9), and turn east on County Road 7500. Drive approximately 13¼ miles on Road 7500 to the De-Na-Zin parking area (on the left side of the road). Alternatively, drive U.S. 550, 4 miles north of NM 57, and turn west on to County Road 7500. Drive approximately 11¼ miles to the De-Na-Zin parking area (on the right side of the road). A trail leads from the parking area approximately three-quarters of a mile to the De-Na-Zin Wash.

Gilman Tunnels

You say you have never heard of Gilman Tunnels; well, because of their stunning good looks, you may have seen them in their roles as locations for movies such as *3:10 to Yuma*, *Scorch Trials*, or, more recently, *The Lone Ranger*. The red rock cliff walls, rushing river, and waterfall of Rio Guadalupe Box Canyon are worth the trip by themselves.

These historic tunnels started life in the 1920s as access points blasted out of the hard rock of the canyon by the Santa Fe Northwestern Railroad, to move Ponderosa pine

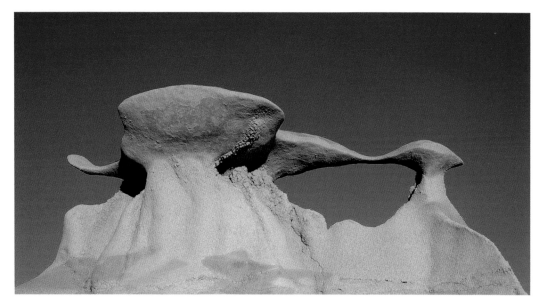

The strange, near-alien landscape of the Bisti Badlands will have you wondering if you are still on Planet Earth. (*Author's collection*)

logs and mining ore more efficiently. Today's road is the paved portion of what was once railroad track used by the train to haul the loads of timber through mountain, thus the reason for it being so narrow.

Named for the company's vice-president, William H. Gilman, the Gilman tunnels were in operation until 1941 and were reverted to use as a roadway after that time. There is no record as to when the tracks were taken up, but it is speculated it could have been during World War II when many other little used tracks were destroyed for the war efforts.

The swift-moving water in the Rio Guadalupe Box Canyon varies in intensity by how much snow run-off the state is getting at that time. People have been known to have pulled wild brown trout out of the raging waters which were 10–14 inches in length.

Directions: Although the attraction is a total of 4 miles long, Gilman Tunnels is worth the drive on State Road 485 (NM 485) off Highway 4 to view. Be aware, there is no sign stating "Gilman Tunnels" and State Road 485 comes up quickly and is easily passed. The turn-off will be on the left-hand side as you travel towards Jemez Springs and will take a sharp downward turn. One hour from Albuquerque, the road starts out as a narrow two-lane road, then narrows even more to one lane as you get to the tunnels. The road winds through the canyon and has many blind curves, but it is paved with moderate grades. This is where you must practice courtesy to others on the road and proceed slowly, as the drop-off into Rio Guadalupe Box Canyon below is rocky and an awfully long way down. Use one of the bump-outs to turn around to get back to Highway 4 to Jemez Springs. The tunnels are closed during the winter months, generally starting in November due to poor road conditions. Truly a must-see at least once.

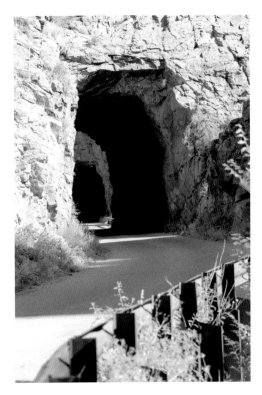

Blasted out of the mountain for a narrow-gauge logging railroad, the Gilman Tunnels have been popular as a backdrop for many Hollywood movies. (*DB*)

Jemez Falls

Known as the highest falls in the Jemez Mountains at 70 feet tall, Jemez Falls Overlook is a short quarter-mile hike from the Highway 4 campground and good for all skill levels. Although this hike is good all year, summer is recommended as the best time to visit Jemez Falls, but there is no available drinking water, so bring plenty of your own and expect the trails to be busy. Leashed dogs are allowed at the trailhead and on the trail.

This beautiful feature amidst the Ponderosa Pine trees of the Santa Fe National Forest, is at an elevation of 7,880 feet above sea level and can get cool at night, even in the summer months. Most of the trail to the falls are solid dirt, but there are some rocks to contend with as well. Also, there are several trails to the falls, each with their own degree of difficulty, so choose to your skill level.

Another cool feature about the Jemez Falls hike is you get to experience three beautiful waterfalls in one trip. The two smaller falls have wading pools in which to enjoy and relax.

Red Rock Park

Red Rock Park is a multi-faceted recreational park serving the Gallup, New Mexico, community and is called the "crown jewel of Gallup's parks and recreational system" by New Mexico True©. Two million years ago, during the time of the dinosaurs that roamed the New Mexico landscape, massive red rock hills were formed near Gallup,

New Mexico. This park has excellent hiking trails of varying degrees of difficulty, on which dogs are allowed.

Church Rock and Pyramid trails offer great views of Fort Wingate, Gallup, and mining sites in the region. Trails are well-marked providing the hiker with good directions. The red striated geological formations of the park mixed with the azure skies are a perfect opportunity for stunning photos and is listed as one of the best places in New Mexico for photography.

In the park is a 5,000-seat arena used for rodeos, concerts, and the Inter-Tribal Indian Ceremonial. On the first weekend of December, Red Rock Park becomes even more colorful, if possible, as it hosts the Red Rock Balloon Festival. Staking its claim as one of the world's largest balloon rallies in the world, you will be able to see over 100 hot air balloons glide over the stunning red sandstone landscape below. Address: 5757 Red Rock Park Drive, Church Rock, New Mexico 87311.

Shiprock

Rising 1,800 feet from the flat desert surface with a peak measuring 7,178 feet tall, the black volcanic formation known as Shiprock was once the inner magma core of an ancient volcano that erupted over 30 million years ago, otherwise known as a monadnock. This magnificent formation is visible for 100 miles in all directions and is considered sacred to the Navajo Nation and has been called Ship Rock and Shiprock Peak.

Shiprock is named Tsè Bit' a'ì by the Navajo, which means "the rock with wings." According to tribal legend, the mountain was once a bird that flew the people a day and a night from a place in the far north where they were under attack to the desert southwest where they now call home. After landing, the bird was fatally wounded by a monster and was turned to stone by a shaman to remind the people of its sacrifice.

Another legend tells how the Dinè (the People) lived on the rock and would only leave to plant and water their crops, until the trail was destroyed by a fierce lightning storm and the People starved. The Navajo believe the ghosts, or *chindi*, of the People still haunt the mountain. Climbing, it is felt by the tribe, would disturb the chindi, but it is also said young Navajo men would climb Shiprock as part of a vision quest.

Although the magnitude of the rock is tempting to avid rock climbers, climbing has been strictly forbidden and illegal on Shiprock and all Navajo lands since 1970 following a tragic death of a climber. The Navajo have a fear death as well as the aftermath and consider anywhere a death occurs as taboo and contaminated by evil spirits.

According to the U.S. Geological Survey, Shiprock is one of the finest examples of a diatreme existing in the country. Radiating out from the formation are rock dykes (six known), which resemble a backbone or dragon's tail. Shiprock from the air gives an impression of being a skeleton of a pterodactyl, but, are dykes formed by magma that escaped through a crack in the Earth's surface and cooled in this interesting pattern. The lengthy dragon's tail portion along with Shiprock itself are the only formations in the red sands and can be accessed only by off-road vehicles.

In 1975, Shiprock was designated a National Natural Landmark by the National Park Service and has appeared in numerous movies such as *Transformers*, *The Lone Ranger*, *The Host*, and *John Carter*, as well as being one of the most photographed rock formations in New Mexico.

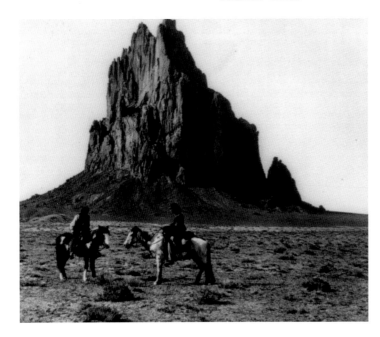

"Rock with Wings," Shiprock, is steeped in Native American folklore and is highly sacred to the Navajo Nation. (*Library of Congress*)

Directions: Shiprock can be easily seen from Hwy. 64, but you can get a closer look by driving 7 miles south on U.S. 491 and then 6 miles along BIA-13 or Navajo Route 5010, or the Red Rock Highway. A high ground clearance vehicle is recommended, but if you have a good telephoto lens on your camera, you can get some spectacular images from Hwy. 64. Please be very respectful of the Navajo Lands and restrictions.

Soda Dam

Soda Dam, a large hot spring deposit thought be over a million years old comprised of mostly calcium carbonate, provides for a spectacular roadside attraction a mere mile from the town of Jemez Springs. (Roadside parking is precarious, so use caution with children and pets.)

The hot water, which rushes through the dam opening, originates in the Valles Caldera, and is warmed by the hot rocks and magma in the volcanic bowl. Water levels vary depending on the amount of rainfall received, but there is generally a good flow gushing out of the opening. It is said Soda Dam rock has been used in studies of how Martian life may be detected, making this attraction both beautiful and scientific.

Blasting for road construction in 1960 created a new outlet at Soda Dam formed by more calcium carbonate deposits. The water used to empty out into the dam over the Jemez River, but the road construction rerouted the hot water to the present-day location. The waters and mineral deposits of Soda Dam are extensively studied for microbial life. The slight sulfur smell at the site is caused by the production of Sulphur-oxidizing bacterium, but the water has a near-perfect pH neutral balance.

Directions: Immediately outside Jemez Springs as you travel towards Valles Caldera, on the right-hand side of the road. New Mexico Highway 4, Jemez Springs, New Mexico.

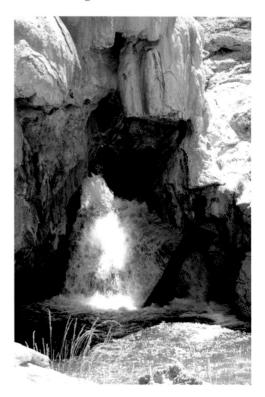

Volcanic-warmed water gushes forth from the Soda Dam providing a relaxing stop for humans and their pets. (*DB*)

Valles Caldera National Preserve

The Valles Caldera ("*valles*" is Spanish for "valley without trees"), which was formed 1.25 million years ago after an enormous volcanic eruption created the 13-mile-wide circular bowl we see today, is our nation's newest National Preserve. The walls of the bowl rise from a couple of hundred to over 2,000 feet above the caldera floor. To look at the lush, rolling green landscape it is difficult to think of this serene setting as a super volcano containing fumaroles, volcanic domes, natural gas seeps, pumice stone, and obsidian as well as hot springs and being capable of producing a volcanic eruption thousands of times stronger than other regular volcanos. Redondo Peak jets up out of the valley floor 11,253 feet as a resurgent lava dome and the highest peak in the Preserve.

Jemez Volcanic Field contains two calderas, with Valles Caldera being the youngest and Toledo Caldera being the oldest. Valles Caldera is home to the first experiment conducted by Los Alamos National Laboratories on the development of Enhanced Geothermal Systems (EGS). An Enhanced Geothermal System is the generation of geothermal electricity without the need for the natural movement of liquid hydrothermal resources. According to research done at Los Alamos, the liquid dominated geothermal reservoir of the caldera reaches between 295 and 300 degrees Celsius.

Do not worry, the last time Valles Caldera erupted was over 1.14 million years ago and was said to have spread ash and debris as far as modern-day Iowa with a 150-mile-long lava flow. The Preserve was at one time part of a Spanish land grant and owned by the

King of Spain. Valles Caldera National Preserve was once home to Native tribes and ranchers, evidence of both cultures is apparent within the caldera. Some 5,000 acres of the Preserve were retained by the Santa Clara Pueblo, which borders the Preserve on the northeastern rim, because they contained sacred and culturally significant land.

The caldera contains the historic cabin used by the Baca Ranch—which is still preserved today. Baca Ranch encompassed over 100,000 acres of prime grasslands. Heavy logging, grazing, and hunting of the area in the late 1800s saw a decline in the watersheds, which are not fully recovered today. The Preserve (95,000 acres and the geothermal mineral rights) was sold to the U.S. government in the year 2000 for $101 million. Since this sale, the Preserve's integrity has started to return.

As a haven for elk, it is not unusual for the over 120,000 visitors each year to see a herd that numbers upwards of fifty heads in Valle Grande—the largest of the surrounding grass valleys. When observing wildlife, use the bump-outs, and as with all wilderness areas, do not approach the animals since they are wild animals and are dangerous. There are also bears in the Preserve, so be bear aware as well. Pets are only allowed in the following areas: the Valle Grande Entrance Station and hiking on the La Jara Trail, Valle Grande Trail, and the Coyote Call Trail. Pets must be kept on a leash no longer than 6 feet in length. You are also required to pick up after yourself as well as your pets. The Preserve is home to seventeen species of endangered animal and plant species, so it is important to maintain this land's integrity for future generations.

Weather can play a big factor in your enjoyment of the Preserve, as with all of New Mexico, weather tends to change frequently, sometimes dramatically, as thunderstorms (with violent lightning) are quite frequent in the park. It is recommended to bring a walking stick, sunscreen, hat, water and food supplies, and a light jacket (depending on the season, in winter, snow is always possible and can come on quickly so a heavy jacket, gloves, and face protection is recommended); also note the nearest restaurant and gas station is 20 miles away.

Fly fishing and hunting are two of the most desired activities in the Preserve after hiking. You must enter the lottery for the elk hunts in Valles Caldera National Preserve, and if drawn, you have an opportunity to hunt the estimated 2,500 elk who call the Preserve home. Turkey hunting is also permitted since there are over 400 Merriam Turkeys residing in the caldera as well. Please note during these hunting seasons, generally September, October, and November, prescribed burns may also be conducted, and you may possibly encounter smoke and fire crews during your hunt.

The fall is a spectacular season for New Mexico in general when she puts on her colorful cloak, but the Jemez Mountains are a fantastic place to sightsee and use your photography skills as the aspens and cottonwood's tree leaves turn golden and shimmer in the autumn sun. This is most likely why film makers have used Valles Caldera Baca Ranch house as a backdrop for five movies and five television shows, most notably *The Buffalo Girls* and the *Longmire* series; remnants of these "Old West" towns are still visible.

Please be extremely careful when handling fire in Valles Caldera National Preserve. The Preserve has been plagued with frequent natural and human-caused fires, the largest of which to date is the 2011 Las Conchas Fire, which was caused by sparking of electrical lines in the Preserve. This devastating fire destroyed 158,000 acres in the caldera and the neighboring Bandelier National Monument.

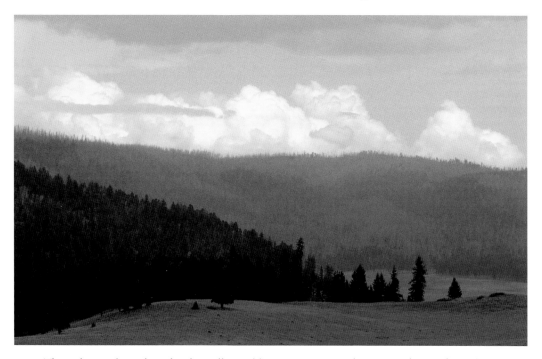

The only words to describe the Valles Caldera is majestic and serene, a far cry from the turmoil with churns below the surface of this super volcano. (*DB*)

The Preserve is open daily except for Thanksgiving and Christmas Day. Weather will also impact hours. Vehicle entrance fee: $20 per vehicle, $10 if entering by foot. Summer season: open from 8 a.m. to 8 p.m. Winter season: open from 9 a.m. to 5 p.m.

Directions: when traveling from Jemez Springs, follow Highway 4 north. Valles Caldera National Preserve is about 22 miles from Jemez Springs. Look for the Main Gate at Mile Marker 39.2. From Los Alamos, NM, take Trinity Drive to Diamond. Take a left on Diamond, then a right on West Jemez Road to the intersection with State Highway 4. Take a right (away from Bandelier National Monument), following the highway up and into the Jemez Mountains. The Preserve is 18 miles up Highway 4 from Los Alamos. Look for the Main Gate at Mile Marker 39.2. Look closely, you may be able to spot a large herd of elk strolling along the valley floor.

Please call (505) 661-3333, option #3 for Visitor Center and weather information.

Cultural Heritage

Acoma Pueblo

Known as the longest continuously inhabited place in the U.S. built in A.D. 1150, Acoma Pueblo, or Sky City, sits high atop a long mesa in the middle of the 5 million-acre Acoma (AH-koh-mah) Indian Reservation. The mesa was only accessible by means of hidden, hand-hewn rock stairs etched into the sandstone formation, which provided a great

deal of protection from other Indigenous tribes and the new settlers who were moving into the region. Shuttle buses provide a five-minute transportation to the pueblo today.

Some 60 miles west of the metropolis of Albuquerque, Acoma has endured centuries of great prosperity as well as equally great despair. The Acoma Pueblo was a target of the Spanish Conquistadors, led by Don Juan de Oñate in his search for the Seven Cities of Cibola. As punishment for not informing the Spaniards where the gold was hidden and providing the soldiers with all the pueblo's food storage and supplies, Oñate instructed part the right feet of the young men of the pueblo be cut off.

Perched atop a 367-foot sandstone mesa, Acoma Pueblo has spectacular views of the surrounding sacred monoliths and valley below. The Acoma culture is widely known for their skills with pottery and have passed on the traditions to future generations. Pueblo pottery is recognized by their fluted rims and intricate geometric decorations and animals painted in black, white, and red on the surface. This pottery provided function as water carriers, cookware, and storage vessels for the ancient people; today, this is collected for their true artist quality.

You can learn more about the pottery history and process at the Haak'u Museum and Sky City Cultural Center at the pueblo. Gaits'i Gift Shop carries a wide variety of the handmade artwork provide by the people of Acoma for purchase, as well as Native American turquoise jewelry and artwork from around New Mexico and nearby Arizona, and, of course, their signature pottery pieces.

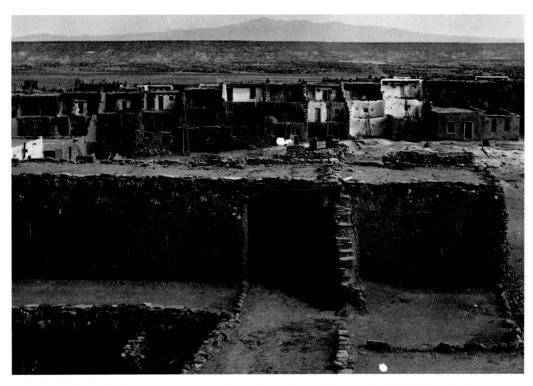

Acoma Pueblo, or the Sky City, meaning "a place always prepared," is perched high above the desert landscape of northwestern New Mexico and is still inhabited. (*Library of Congress*)

Acoma Pueblo is open seven days a week from 9 a.m. to 5 p.m. Guided tours of the Pueblo are held every hour on the half hour from 9:30 a.m. to the last tour at 3:30 p.m. Tour vans will take you to the pueblo. Please visit the Acoma's website at www.acomaskycity.org for a list of feast days and other closures.

Rules to follow when visiting Acoma Pueblo: when arriving at the Haak'u Museum and Sky City Cultural Center, register with the admissions clerk to pay your fee, get a camera permit if you want to do some photography, and receive your tour packet. Strict rules apply to the tours of the pueblo since these are sacred lands and still inhabited by tribal members. No pets or smoking are allowed during the tours. Photography of the pueblo and inhabitants are permitted only if permission is granted and the results are not going to be used for personal gain. No photography is allowed inside the mission church, inside the walls of the cemetery, or during feast days. Cameras, film, and recording equipment will be confiscated if the rules are not adhered to completely. A word of caution: do not bring your cell phone to the pueblos since they can be confiscated if the tribal members feel they are being used for photography purposes. Videotaping or recording on pueblo property is strictly prohibited. This is a village and the home to the residents who live there.

Also, please respect the elders and religious leaders who reside on the mesa by not wearing revealing clothing, which is deemed inappropriate—such as short shorts, short skirts, halter tops, tank tops, spaghetti straps, and tube tops. If your clothing is deemed inappropriate, you may be asked to cover up using the clothing the pueblo provides.

Entrance fees are $25 dollars per adult, $15 dollars for camera permits; group, senior, military, and college student discounted rates are also available.

Aztec Ruins National Monument

In the middle of the quaint town of Aztec lie ancient ruins that were once mistaken for Aztec architecture; although there are some who still believe the Aztec's settled the area, it is thought to have been the Anasazi. Named an UNESCO World Heritage Site in 1987, the ruins are a popular destination for students, archeologists, and tourists alike. In fact, the persona of Indiana Jones was modeled after Aztec resident archeologist Earl Morris. The artifacts that have been discovered in the ruins date back to the eleventh and thirteenth centuries.

The site consists of over 400 masonry rooms and a reconstructed Great Kiva originally constructed by the Ancient Puebloan People. You can take a self-guided tour, which winds through the National Monument. The Great Kiva is the largest semi-subterranean reconstructed kiva in the United States measuring in at 40 feet in diameter. When found in the 1920s, the Great Kiva has sustained a lot of damage and had collapsed in on itself. The decision had to be made then whether to backfill the hole and move on, or to reconstruct. Luckily for us, they decided to reconstruct this sacred structure.

With over 400 rooms on 300 acres at Aztec Ruins National Monument, it is easy to imagine the sheer size of the ancient community. Some of these amazing structures stood up to three-stories tall and housed close to 300 people. Many of these people have left their fingerprints in the mortar, the challenge to find some of these ancient prints makes your visit even more interesting.

Inside the Great Kiva are two different sized vaults, which archaeologists believe were once covered with wood and used as foot drums for ritual ceremonies. Lining the

circular wall of the Kiva are inserted lines of wooden rungs leading up into individual rooms. This configuration has not been used elsewhere. There are four pillars in the Great Kiva, curiously constructed of a staggered pattern of stone and wood. Also found during excavation during the 1920s by Earl Morris were four large limestone discs, thought to have been placed under the pillars—limestone is not a local stone. The Great Kiva is the largest kiva at the site and was used for religious ceremonies and community meetings.

Although construction took upwards of a century and started on the bluffs behind the current ruins, great care was given to the engineering of the living spaces and ceremonial areas of the Ruins. In the "Green Stone Room," a three-stone-thick border line of green stones were used to define the room. The green stone is was mined from a special quarry about 3 miles away. It is estimated the timber logs came from a forest in Colorado, many miles away. Such great care was taken in the construction of the Aztec Ruins; for example, each end of the exposed logs was smoothed off.

The grand scheme of the community of Ancient Puebloan People continued for centuries until the 1200s when they were forced to leave the area in search of better crop lands. It is not certain where exactly these peoples settled and many hypotheses have been raised by archaeologist and historians, but for the most part, they seem to have melded into other cultures or vanished completely.

As with all National Parks and Monuments, the kids are encouraged to sign up for the Junior Ranger Program and become official Junior Rangers. This program provides activity brochures for the kids to take through the park as they answer the questions. They can also earn Junior Ranger patches online. In the summer months, astronomy plays a large role as the monument hosts evening tours for gazing at the stars.

There is no charge to enjoy these fascinating ruins and they are well-worth the diversion. Address: 725 Ruins Road, Aztec, New Mexico 87410. The Visitors' center can be reached via (505) 334-6174. Directions: from Albuquerque follow Highway 550 north to the City of Aztec, turn left at the "T," which will be Highway 516. Travel

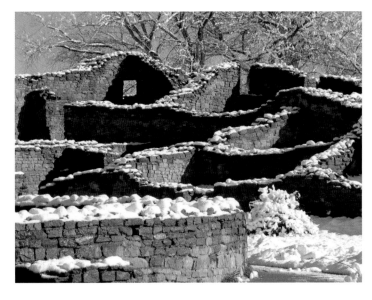

Aztec Ruins National Monument is located nearly in the center of the tiny town, which also bears the name. (*Author's collection*)

three-quarters of a mile then turn right immediately after crossing the Animas River on to Ruins Road, continue for another half of a mile to the Visitors' center.

Bandelier National Monument

If you are in the Jemez Springs area, a trip to Bandelier National Monument is a must. Over 33,000 acres of land were once inhabited over 10,000 years ago by Ancestral Puebloan People. Amazingly, these people were able to dig out dwellings from the volcanic tuff for living and protection from not only the elements, but the threats of other tribes in the area. The Ancestral Puebloan People established dry farms on the mesa tops to support essential crops of beans, squash, and corn (known as the three sisters). Added protein was provided by deer, squirrel, turkeys, and rabbits, which also inhabited the canyon. Water had to be hauled up by hand in large earthenware pots to the mesa top farms. The volcanic pumice soil would act like a sponge, soaking up any liquid presented.

Volcanic tuff, a soft material deposited in the area by the eruption of Valles Caldera 1.14 million years ago, was mixed with mud, much like adobe, to form the building blocks for the structures built on Frijoles Canyon floor. Holes in the surrounding canyon walls, be it natural or man-made, were utilized as living quarters in an apartment building style. Interior walls of the cavettes were plastered and the ceilings scorched to make the material less likely to crumble. Evidence of petroglyphs (carved) and pictographs (painted) are present throughout the National Monument.

A sacred kiva, 140 feet in the air, is part of the Alcove House, which is located halfway through the Main Loop Trail and is reached by climbing a series of four wooden ladders to reach the living area. Restoration of the kiva was begun in 2018 since part of the structure collapsed over time.

Designated a national monument on February 11, 1916, by President Woodrow Wilson, Bandelier was named for Swiss anthropologist Adolph Bandelier, who researched and worked diligently to preserve the structure and culture of the park. Civilian Conservation Corps were brought in to develop the infrastructure in the 1930s. It was the Corps who built the trails, visitor center, and the road leading up from White Rock. Bandelier is a National Historic Landmark due to how well the structures have been preserved.

There are ten short trails and three long trails in the monument for a total of 70 miles, with various degrees of difficulty on all trails within the park, so plan according to fitness level, time, and, as always, the weather.

By 1550, the inhabitants of Bandelier moved on to the Cochiti and San Ildefonso pueblos along the Rio Grande. The ability to sustain themselves had grown nearly impossible in the mountains due to the extreme drought conditions which covered the entire state. There were reports of native tribes making the terrible decision of offering to sell their children to other tribes so they would be fed and could survive. Fires are also a threat and have been known to sweep through the canyon at a rapid pace.

To access Bandelier National Monument, it is required for visitors to board a shuttle bus in nearby White Rock, New Mexico. Shuttles are available between the hours of 9 a.m. and 3 p.m. It is free to ride the shuttle, but an entrance fee still applies to enter the Monument. Please visit their website to get exact fees since there are several different

categories. As an enticement to visitors, the National Parks Service also offers free admission on five days a year.

The park service also wants to remind you of the high heat, which may be present during the summer months, and to dress accordingly, use sunscreen, bring a hat, walking stick, and a lot of water. During monsoon season, generally during the months of July and August, flash floods can occur because of heavy downpours in the late afternoon and the park sits along Frijole Creek, a tributary of the Rio Grande.

There may be wildlife such as deer, rabbits, black bear (the state mammal), and even an occasional rattlesnake along the trails, so be vigilant for these as well. In the winter months, ice and snow may be present and create a whole new set of obstacles. Ladders to the alcoves can ice over, so caution is urged. Adverse weather conditions will result in closure of the park. Camping is allowed in the park with permit. A special note: dogs are only allowed in the parking area and campground.

Chaco Canyon National Historical Park

Sacred home of the Ancestral Puebloan People, Chaco Canyon National Historical Park provides visitors with an insight into pueblo culture with extensive ruins to explore. In the center of the Chaco Canyon was Bee Burrow, a community that flourished for over 1,000 years and was strongly associated with the ancient Anasazi. Archaeologists have found evidence that Chaco was the center of the cultural region where large pilgrimages would occur for religious or purely social reasons.

By A.D. 1100, the Anasazi migrated northward to the Aztec region, mainly due to the extensive droughts that have plagued the state since its inception. Aztec provided the use of three rivers, the San Juan, Animas, and La Plata, to cultivate crops and sustain life among the people. It is said Chaco Canyon was used as a huge gathering spot for all the local tribes to share their rituals and knowledge, but much is still unknown about the true function of the large village.

Although the Anasazi people are long gone, they left behind structures that are a marvel even today. Using the masonry style of core and veneer, the mainly mud and straw constructed buildings have withstood the test of time and give researchers a huge field to study. As with other places in the state, petroglyphs have been found in the housing ruins as well as along the ancient road, which led to Chaco Canyon National Historical Park.

Archaeologists have found the existence of chocolate in the interiors of the earthenware pots excavated from the site, lending credence to the possibility Chaco Canyon may have been inhabited by ancient people of Mayan or Aztec heritage since chocolate played a large role in both societies.

Directions: when traveling from the north, turn off U.S. 550 at County Road 7900, which will be 3 miles southeast of the town of Nageezi and nearly 50 miles west of Cuba, New Mexico. It will be 21 miles from U.S. 550 to the park boundary. Only 8 miles of this route will be paved (County Roads 7900 and 7950). Be warned that the last 13 miles of County Road 7950 will be a rough dirt road, with the last 4½ miles considered very rough before entering the park. Passenger cars are not recommended. If you are traveling up from the south, the two routes that can access Chaco Canyon from Highway 9, which runs from the towns of Crownpoint, Pueblo Pintado, and Cuba, are considered very rough to nearly impassable—this route is not recommended for use by

Bandolier National Monument's human history spans back over 10,000 years ago. (*Library of Congress*)

RVs or low passenger cars. It is highly recommended you call ahead for road conditions before visiting Chaco Canyon.

Coronado Historic Site

On the banks of the Rio Grande, north of Albuquerque in the town of Bernalillo, is a fascinating historic site tucked back away from the hustle and bustle of Hwy. 550, which intersects the town. Ruins of the Kuaua Pueblo still stand as testimony of the Tiwa people who populated the Rio Grande Valley. First settled around A.D. 1325, Kuaua Pueblo housed approximately 1,200 people and was the first pueblo encountered by Spanish explorer Francisco Vásquez de Coronado in 1540. Searching for the legendary Seven Cities of Gold, Coronado arrived with 500 soldiers and over 2,000 Indian allies from New Spain.

The explorers were not prepared for the harsh conditions they found in the new land, and if it were not for the kindness (either forced or otherwise) of the Tiwa people, the group would have starved to death. Coronado dubbed these people "*Los Indios de los Pueblos*" and went on to visit the twelve other pueblos nearby, which included Isleta, Taos, Picuris, and Sandia, where many of the Kuaua Pueblo descendants live still today.

When the Coronado Expedition arrived, the sight presented to them was of a tightly knit community of families that built their village out from a central plaza and

constructed some of the first apartment buildings and skyscrapers—with many of these structures being said to have been seven to eight stories tall.

Views of the Sandia Mountains from the Coronado Historic Site are stunning, especially in the fall when the cottonwoods along the bank of the Rio Grande turn bright gold. In the shadows of the view is an archaeological site, which explains the culture that inhabited the small historical site at the time. The town of Bernalillo has grown up around the adobe ruins, which are now surrounded by car parts stores, casino, and restaurants that line New Mexico Highway 550. Despite being in the city central, it is a quiet retreat from the busy surrounding town. Picnic tables beckon you to sit down, relax, and reflect on the history that encircles you. Listen to the birds and watch for rabbits and rattlesnakes in the warmer months.

Women played an important role in the development of the pueblo, for they were the actual builders of the walls. The men would bring the wood for the walls, but the women mixed the adobe slurry and constructed the homes. It also fell on the women to maintain the exteriors of the buildings and do the cooking while the men would spin and weave. This tradition was prevalent in most to the Puebloan cultures. It is still a tradition today; each year, the exteriors of the homes and churches are resurfaced by mostly women.

First excavated by the Museum of New Mexico in the 1930s, Coronado Historic Site had not been established. Discoveries of a ceremonial underground kiva complete with stunning murals painted on the walls within created great excitement in the world of southwestern archaeology. These murals represented some of the finest examples of Pre-Columbian art in the northern hemisphere. Great efforts were made to protect and recreate the fourteen murals in the visitors' center designed by famed architect John Gaw Meem.

Exciting recent discoveries of bits of chain mail, nails, musket balls, and parts of armor have given a boost to the idea that not only did Coronado camp in the area, but there was a battle fought on the site as well. Local historians are certain the Kuauan Pueblo people resisted the invasion of the Spaniards on their ancestral lands. The Spaniards had a reputation of domination when entering an area throughout the southwest and it proceeded them on their journey, and it appears it also occurred here too. Studies, digs, and research are ongoing at the historical site to find more of the story of the Kuauan Pueblo's fascinating past.

The Coronado Historic Site prides themselves in their museum, which contains prehistoric, historic Puebloan and Spanish artifacts for the public to discover and interact with. The site provides guided and self-guided tours for the small entrance fee of $5. Tours for the Painted Kiva are only guided so to protect the priceless artwork.

Added support for the historic site is provided by donations to the Friends of the Coronado Historic Site organization, which operates a small gift shop in the visitors' center and serve as knowledgeable trail guides. Countless hours of volunteerism have led to raising tens of thousands of dollars for the preservation of this important site. Their efforts need to be applauded.

Directions: to access the Coronado Historic Site, take Highway 550 a mile west of Bernalillo and 16 miles north of Albuquerque (off Interstate 25, Exit 242). It is tucked away off the road in the heart of Bernalillo. Address: 485 Kuaua Road, Bernalillo, New Mexico 87004. The Visitor Center can be contacted at (505) 867-5351.

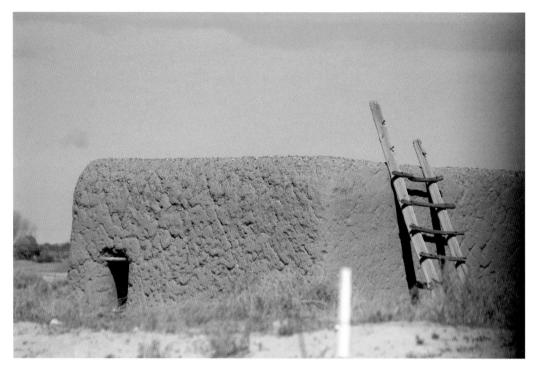

Situated along the bosque of the Rio Grande, Coronado Historic Site contains the ruins of the Kuaua Pueblo and relics from the Spanish explorer Coronado expedition to find the Seven Cities of Gold. (*DB*)

Jemez Historic Site

Step through a portal to history as you leave the Visitor Center at Jemez Historic Site and walk along the same paths traveled by the Jemez people 500 years ago. Travel along 1,400 feet of paved paths to visit a beautiful underground scared kiva for the Guisewa Pueblo and ruins of the San Juan de los Jemez mission church, which dates to 1621–2. As you stand in the nave of the impressive rock walled church, you can almost imagine hearing the Mass being said by the priests and the responses echoing through the church.

A nominal fee of $5 per person (children aged sixteen and under are free) will get you through the door to experience history. If you happen to be from New Mexico, you get in free on the first Sunday of the month and New Mexico seniors get free admission on Wednesday with a state I.D. The easy trails are also wheelchair accessible. Since Jemez Springs is within an hour's drive from Albuquerque, they offer a combination ticket for both Jemez and Coronado Historic Sites for $7, which is a great deal. It is easily possible to visit both sites in one day while based out of Albuquerque. The site is closed on Monday and Tuesday during the week as well as Thanksgiving, Christmas Day, and New Year's Day.

As one of the largest pueblos in the area, Guisewa Pueblo was occupied until the late 1500s by the Ancient Puebloan People who settled the area to take advantage of

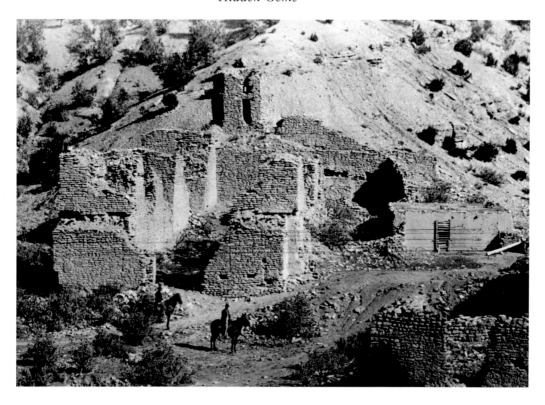

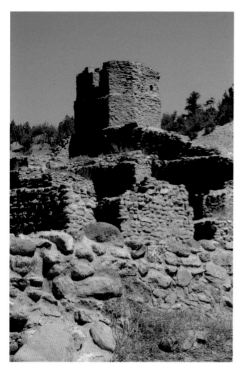

Above: As the cultural center of Jemez Pueblo, San Diego de los Jemez Church has stood the test of time since 1621. (*Library of Congress*)

Left: Modern-day preserved San Diego de los Jemez Church is the site of the much-anticipated event in December called the Light Among the Ruins. The ancient walls are lined over 1,400 farolitos in a celebration of the holiday season. (*DB*)

the great water resources and healing waters of the springs. The Spanish arrived and conquered the people in 1598, placing the native people under strict Spanish rule until the Pueblo Revolt of 1680 when the people regained their lands and drove the Spanish out of northern New Mexico mainly by killing all they could find. All reminders of the Spanish culture were attempted to be wiped from the land so they could return to their own rituals and traditions.

It was not until 1694 that the Spanish returned to the area in Cañon de San Diego and reconquered the native people once again, this time there was little resistance at first. The Spanish religion of Catholicism replaced most of the Native rituals as churches were built in the surrounding countryside.

One of the most cherished events at Jemez Historic Site is the Light Among the Ruins, generally held in the middle of December each year. The red sandstone ruins of San Juan de los Jemez church and the Guisewa Pueblo are illuminated with lines of farolitos (traditional paper bags of sand with lit candles inside). This is truly a breathtaking sight to behold. The Visitor Center can be reached via (575) 829-3530.

Unique Lodging

El Rancho Hotel & Motel
Hollywood was attracted to the sandstone red rock scenery of northwestern New Mexico for decades. The Mother Road–Route 66, which stretched from Chicago, Illinois, to Los Angeles, California, brought a bevy of travelers across the country as they traveled and "got their kicks on Route 66." One of the best destinations was the El Rancho Hotel & Motel in Gallup, New Mexico, which was built in 1937. The hotels motto states: "Charm of Yesterday, Conveniences of Tomorrow." The El Rancho in its heyday was said to be one of the premier hotels in the Southwest—one step in the front door and you will see why.

Polished brick paver floors lead into a massive beamed ceiling lobby, which is flanked on both sides by rock stairways rising to the second floor. A recessed brick fireplace takes center stage giving the El Rancho's guests a cozy place to warm themselves or to read a good book. Authentic Navajo rugs adorn the stair railings and floor surrounded by chunky pieces of mission-style furniture. Artwork, vintage photographs of actors who stayed there, taxidermy elk and deer heads, topped off by a three-tiered wagon wheel chandelier add to the lodge feel.

Authentic Native American turquoise jewelry, rugs, baskets, pottery, and blankets are offered for purchase in the gift shop from the talented skills of the Navajo, Zuni, and Hopi tribes. If you are going to purchase Native made items, Gallup, New Mexico is one of the best places in New Mexico to be sure you are getting truly authentic art works.

The surrounding countryside was perfect for making movies and therefore many of the stars stayed in the El Rancho during filming. The hotel claims to have had many famous people stay under their roof, so you may be sleeping under the same roof as Katherine Hepburn, Mae West, Humphry Bogart, and President Ronald Reagan just to name a few of the over 150 stars who stayed at the El Rancho while filming movies in the '30s and '40s.

Well-appointed rooms of the El Rancho are modestly priced, making your stay even that more enjoyable. Be sure to check out the 49 Lounge, which Errol Flynn once rode his horse into when he was thirsty. You can almost imagine "The Duke," John Wayne, sashaying up to the bar after a long, hot day in the desert sands filming.

Address: 1000 E. Highway 66, Gallup, New Mexico 87301. The site can be contacted via (505) 863-9311 or elranchohotelgallup.com.

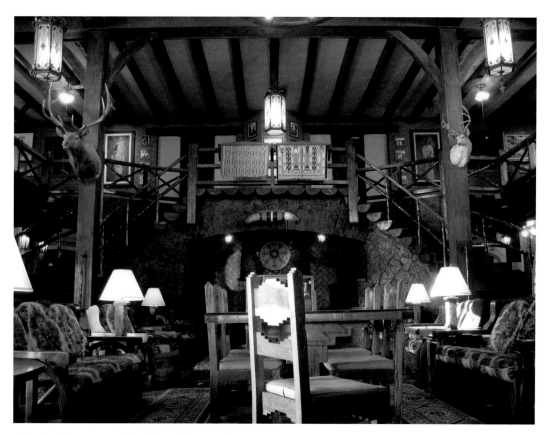

The lavish interior of the El Rancho Hotel in Gallup harkens back to the 1930s and '40s when the hotel was first built. (*DB*)

2

ALBUQUERQUE

Historical Background

As the largest populated city in the state of New Mexico, Albuquerque has a wealth of attractions to offer. Ranging from unusual museums, internationally recognized festivals, unique shops, and cultural diversity, Albuquerque has it all. Sometimes described as a "large small town," Albuquerque has all the amenities you need within your neighborhood. Dubbed the "Duke City" because it was named after the 8th Duke of Alburquerque, the Viceroy of New Spain. The extra "r" eventually disappeared over time.

Beginning life in the dusty landscape at the foot of the Sandia Mountains, Albuquerque was but a small farming village mostly populated by the Hispanic community whose ancestors had settled the region after following the Rio Grande north from Mexico with the Conquistadors. Albuquerque's development into the metropolis we know today began with the arrival of the railroad; it was then the world was suddenly accessible to New Mexico.

Probably best known for some of its more famous residents, Albuquerque was home to Bill Gates, Neil Patrick Harris, Al Unser, Demi Lovato, Vivian Vance, Holly Holm, Ronnie Lott, Johnny Tapia, and Chip Gaines, to name but a few. Maybe one of the most famous residents is completely fictional—Walter White of *Breaking Bad* fame. Filmed in Albuquerque, the five-year-long series *Breaking Bad* garnered attention to the city and New Mexico as a whole. Although the television series ended in 2013, dedicated fans still flock to Albuquerque to retrace Walter's steps on tours.

Should you be a fan of the shows *Breaking Bad* and *Better Call Saul*, fear not, there are RV tours for you which originate in Old Town and at the Hotel Albuquerque. The *Breaking Bad* RV Tours, based in Old Town, allow enthusiasts to visit seventeen locations of the famous show, including "The Dog House." Check their website for tour fees and schedule, www.breakingbadrvtours.com. Also, The ABQ Trolley Co., based out of the Hotel Albuquerque also provides their BaD Tour of *Breaking Bad* locations via historic trolley. Their fees and schedule can also be accessed at www.ABQTROLLEY.com.

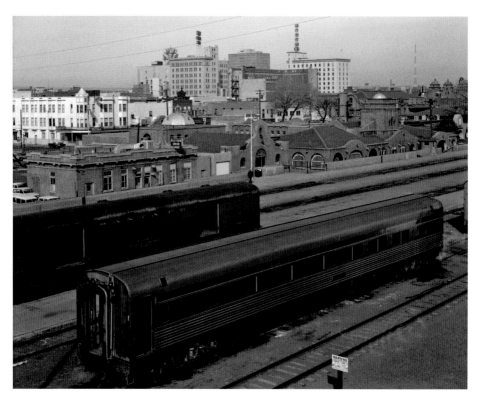

When the railroad came to Albuquerque, it set in motion the development of New Mexico's largest city. (*Library of Congress*)

The Dog House Restaurant on Central Avenue was made famous by the series *Breaking Bad*; it is now part of a local RV tour. (*DB*)

Old Town Albuquerque

The old and new blend flawlessly in the high desert region, allowing the visitor to experience the town as it was in its early existence in Old Town. An active town plaza ringed with 150 adobe shops is where you will find ten blocks of historical buildings. Flanked on the north end by the San Felipe de Neri Church, which was built in 1793 and considered the oldest building in the city, the plaza exhibits a charming view of a life gone by. Old Town is the crossroads of the southwest and is still inhabited by members of the founding families.

You will find treasures at every turn, art galleries, unique gift stores, a bookstore that features only New Mexico subjects and authors, cafes, coffee shops, and t-shirt and memorabilia shops, all centered around a plaza that features a gazebo. The gazebo is used extensively for weddings, music concerts, and rallies. Take advantage of the long-covered portals (porches), which provide shade, benches, and a cool breeze to shoppers. Outdoor cafes give an opportunity to sit down, have a refreshing beverage and enjoy the beauty that surrounds you at every glance.

Over 150 original adobe buildings, most with wooden floors polished by centuries of foot traffic, are connected by portals (porches) supported by vigas (large wooden beams that jet out from the roof) and latillas (small branches sometimes cut from the ocotillo plant), garnished artistically with flower baskets and chile ristras. Benches and courtyards along the walkways are a welcomed respite for shoppers who need a small break from the sun, which shines approximately 300 days a year, and the sensory

Above left: San Felipe Church, on the north end of the Plaza in Old Town Albuquerque, has many treasures and mysteries within its thick adobe walls. (*DB*)

Above right: Old Town Albuquerque provides visitors with a unique experience. You can stroll along the same streets and brick pavers where many of New Mexico's most famous once walked. (*DB*)

overload of colors, textures, and delicious smells emanating from the many small cafes in the area. Today, this historic district it still has its Old World charm and is a mecca for tourists wanting to experience the Pueblo-Spanish-style architecture.

For a more in-depth experience in Old Town, tours are available—including the fascinating Ghost Tour of Old Town given nightly. During this one-hour walking tour, you will learn about some of the more macabre experiences and the residents of the three centuries old Old Town while discovering well-hidden historical adobe buildings not noticed by the public. Guaranteed to give you chills, but reservations are required. Visit www.toursofoldtown.com for further information.

If you are into history and want to follow along some of history's most interesting roads, then the ABQ Trolley Tour is for you. They provide a "front-row seat to the sights and sounds of Albuquerque." Owners Jesse Herron and Mike Silva saw a niche that needed to be filled, and now they provide a much enjoyed and unique sightseeing option for the public. Jesse is also the owner of the Painted Lady Bed and Brew, which has a trolley car on the property used as a tap room.

Please be sure to visit the Treasure House Book Store on the Plaza, which is a huge supporter of New Mexico authors—it is truly a hidden gem.

Outdoor Adventures

ABQ Bio Park, Aquarium, Zoo, and Botanic Gardens

Near Old Town is the ABQ BioPark, Aquarium, and Botanic Gardens, which is a unique environmental museum in the heart of the city. The Botanic Gardens alone have over 32 acres of exhibits, ranging from native southwestern plants to those found around the world.

This is a magical part of the city, giving the visitor in the middle of a desert a glimpse at life under the ocean, mostly the Gulf of Mexico, highlighted by a 285,000 gallon, six species, salt-water shark tank—38 feet wide by 9 feet tall—with the viewer being protected by 8-inch-thick glass panels. It has many aquatic exhibits, including a beautiful jellyfish display entitled "Jellies: Aliens of the Sea."

The Botanic Gardens are so beautiful that they are used quite often as a perfect backdrop venue for weddings, family reunions, photo shoots, and just a great place to spend a leisurely afternoon as you stroll the 1.5 miles of trails. Tucked into the back corner of the gardens is a Heritage Farm, which features a farmhouse, corrals, barn, and fields filled with such crops as chile, sunflowers, and an apple orchard used as a teaching tool to show how food is grown.

You will be able to get up close to polar bears, elephants, hippos, lions, orangutans, zebras, and many more exotic species. Just added and already extremely popular is the Penguin Chill exhibit, which feature the King, Gentoo, and Macaroni penguins.

A narrow-gauge train runs through the park constantly, so if it is too much of a walk for you, hop on the train. The ABQ Bio Park is a great place to visit all year long, but the most magical time is during Christmas when the park comes to life with over 600 electrical light displays, with new ones added each year. Voted the eighth Best Botanical Holiday Lights by *USA Today* in 2018, the River of Lights display runs from November 30 to December 30 each year. Park and Ride services are available on designated nights, please call ahead to plan your visit (505-768-2000). Their website is www.cabq.gov/culturalservices/biopark.

Albuquerque Bio Park features a zoo, heritage farm, botanical gardens, and an aquarium with species of marine life native to the Rio Grande and the Gulf of Mexico. (*Author's collection*)

Rio Grande Nature Center State Park

Located on 270 acres of prime bosque (cottonwood forest) along the banks of the mighty Rio Grande, the Rio Grande Nature Center State Park provides a refuge for over 250 species of native and migrating birds (many waterfowl), reptiles, and wildlife literally in the middle of the city of Albuquerque. The Nature Center is designed so you can observe nature while not being seen yourself with a wall of cut-out windows. Many of the wildlife have been living in the preserve so long, the presence of humans does not seem to faze them. Address: 2901 Candeleria Rd, NE, Albuquerque, NM 87045.

Sandia Peak Tramway

The Sandia (which translates as "watermelon" in Spanish) Mountains project skywards to the east of the city and glow a soft pink hue during the spectacular New Mexico sunsets—hence the name. The Sandia's provide a perfect backdrop for one of the most thrilling experiences in Albuquerque—the Sandia Peak Tramway.

Board the tram car at the base of the Sandia Mountains and travel up towards the crest, enjoying the magnificent views along the trip. Be prepared to stand during your journey since there are only a few spots on which to sit, but all the tramcars are wheelchair accessible. The windows are highly prized and can fill up quickly, so there is a bit of a rush getting into the cars from the platform as everyone is jockeying for a good view. You will complete your journey in fifteen minutes, whereas it took 5,000 trips by helicopter to get men and materials to build the tram to the top of the summit during construction.

The 2.7-mile-long cable somehow does not seem like it can support the weight of the tramcar and her passengers, but be assured it can; all the supports for the tram are anchored up to 40 feet deep in granite, and each tramcar is capable of holding 10,000 pounds. Daily maintenance is performed on the cables to check for any abnormalities.

Be prepared to be awed by the magnificent views you will see during your 2.7-mile ascent to the top of Sandia Peak. (*Author's collection*)

There are several times when the tramcar glides over the tower supports, which give a thrilling sensation. As you travel up the mountain, it will be difficult to decide on where to point your camera. Rock formations, deep canyons, huge boulders, tall trees, and breathtaking expanses will be sure to have you snapping away.

At the top, you will be able to depart the car and walk around the observation center at the top, which houses a small museum of tram history. Be sure to bring a jacket or coat even in the summer months as the summit is much colder than the base by upwards of 30 degrees. It is highly suggested you check with the weather report before making your trip to Sandia Peak Tramway, which will close in adverse weather conditions, such as wind, lightning, and heavy rain.

Address: 30 Tramway Road, Albuquerque, NM 87122. Tram Info: (505) 856-7325 or (505) 856-1532.

Not Your Ordinary Museums

American International Rattlesnake Museum

On narrow San Felipe Street in the heart of Old Town Albuquerque is a unique museum made of adobe not for the squeamish or those afraid of snakes. The American International Rattlesnake Museum gives the visitor a fascinating insight into one of the most dangerous snakes in the world. Dedicated to the education of the public on snakes in general, but especially the rattlesnake, the museum is an animal conservation museum and explains the many ways snakes influence our lives on Earth. It is a goal of the museum to lessen the stigma of snakes as bad creatures through education and exposure.

Ever want to see a live rattlesnake up close? If you answered yes, the Rattlesnake Museum in Old Town Albuquerque is the place for you. (*DB*)

The largest collection of rattlesnakes in the world is on site, which is a proud claim for the museum. Rattlesnakes from North, Central, and South American grace the exhibits giving the visitor an unprecedented look at the many varieties of species of rattlesnakes (thirty-four to be exact) that exist in the world, many in New Mexico. Opened on May 5, 1990, a day the museum describes as "Snako-de-Mayo," the exhibits receive over 50,000 visitors each year.

Displays feature the rattlesnake and other snake-related items in fossil form, paintings, sculptures, movie advertisements, music, flags, medical items, jewelry, and religious items to name just a few. The world has had a long-standing love/hate relationship with the snake dating back to Biblical times, with some seeing the snake as a symbol of evil, while others see a beneficial part of the circle of life.

Only one-fourth of all snakes in the world are venomous, with the rattlesnake, although not as highly dangerous as the vipers and cobras, being on some of the top rungs of the snake danger ladder. They can deliver a large amount of venom to their victims, which will incapacitate and eventually kill if not treated. The rattlesnake is generally large, which gives them a long strike zone, but do not be cavalier about the baby snakes since they can be the deadliest due to the fact that they have not learned to control the amount of venom delivered to the intended victim.

It is reported there are nearly 8,000 snake bites per year in the U.S. alone, but most of them have been due to aggravation of the snake. Most rattlesnakes will avoid conflict with humans and will use the bite as a defensive mechanism only to obtain their release. Always give any snake a wide berth when encountered.

Be sure to visit the gift shop while at the museum, where you will find a large variety of rattlesnake related items, including the much-desired t-shirt featuring the logo of the

American International Rattlesnake Museum, which comes in a variety of colors, as well as a plethora of other rattlesnake related items you can purchase to give as gifts to your friends and family who were not lucky enough to tour the museum.

Without snakes, the world would be over-run by rodents, which spread disease and pestilence. The motto of the American International Rattlesnake Museum is "the only good snake is a live snake." Address: 202 San Felipe NW, Suite A, Albuquerque, NM 87104-1426. Contact the museum via (505) 242-6569. Admission fee: $6 adults, $4 children, seniors, military, teachers, students $5. Open daily, check website for hours (www.rattlesnakes.com).

Anderson-Abruzzo Albuquerque International Balloon Museum

Ballooning has long been synonymous with Albuquerque as it is a common sight to see brightly colored balloon drifting over the city nearly every day. The Anderson-Abruzzo Albuquerque International Balloon Museum celebrates everything connected to the lighter than air sport.

Named in honor of balloonists Maxie Anderson and Ben Abruzzo, the museum has welcomed over a million visitors since 2005. The famed International Balloon Fiesta is one of the most attended and photographed events in New Mexico, held the first weekend and week of October each year. Part of the mission of the museum is to "inspire a spirit of exploration, discovery, and achievement through experiences that engage our visitors in the history of the science, sport and art of ballooning..."

The Museum grounds play host to the spectacular International Balloon Fiesta. The 47-acre Balloon Fiesta Park is north of the museum and provides a perfect location to launch the over 500 balloons that grace the Albuquerque skies each year, as well as deliver a venue for a multitude of other uses like weddings, golf, sporting events, concerts, and graduations. The use of the park is free for private use, but is often closed for special events.

Open Tuesday through Saturday, the museum displays colorful examples of balloon history, which date to 1783. The museum building and grounds are a sight to behold with multiple sculptures and mosaics to capture your attention.

Mimicking the shape of a hot air balloon, the Anderson-Abruzzo Albuquerque International Balloon Museum is the showpiece of Balloon Fiesta Park. (*DB*)

Address: 9201 Balloon Museum Dr, NE, Albuquerque, NM 87113. For more information, the Visitor Center can be contacted at (505) 880-0500. Admission: $6 adults ($1-discount with a valid New Mexico I.D.), $4 seniors (sixty-five years-plus), $3 for children (six to seventeen years of age), free admission for children five years old and younger. Free admission on Sundays 9 a.m. to 1 p.m. and the first Friday of the month. The Museum is open from 9 a.m. to 5 p.m. Tuesday through Saturday and is open every day during the International Balloon Fiesta.

Holocaust & Intolerance Museum of New Mexico

The mission of the Holocaust & Intolerance Museum of New Mexico is to teach about the cause and effect of genocide and to eliminate hate and intolerance in our state "one mind at a time." Through books, photographs, and artifacts, the tragic story of the Jewish people during World War II is presented to educate the next generations of the horrible consequences of not only war but hate and prejudice. Opened in 2001, the Holocaust & Intolerance Museum of New Mexico has enlightened visitors on the unthinkable efforts the Nazi German's enacted against the Jewish and Non-Jewish people of Germany, Poland, and Russia, which takes up 60 percent of their museum space.

Located near the historic Kimo Theater in the Freed Company Building at 415 Central Avenue, the museum has continued to open new exhibits that deal with the experiences of the African-American people who were brought to American soil; it will soon create an exhibit concerning the Native-American experiences as well. Opened by

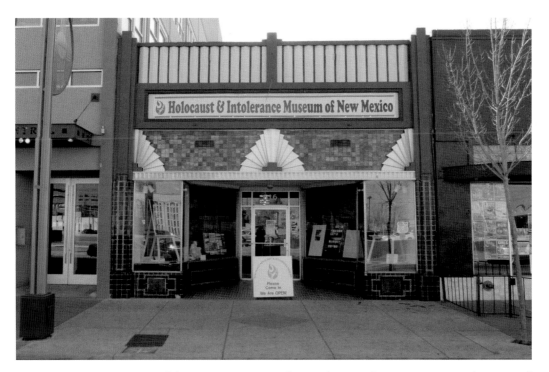

Commemorating one of the worst atrocities in human history, the New Mexico Holocaust and Tolerance Museum continues to educate against hate. (*DB*)

a holocaust survivor, Warner Gellert, the museum has been instrumental in educating visitors on the sensitive subjects of bullying, intolerance, and genocide.

Address: 616 Central Avenue, SW, Albuquerque, New Mexico 87102. The Museum can be reached via nmholocaustmuseum.org.

National Museum of Nuclear History and Science

By circumstance or just location, New Mexico has been involved in many key projects involving the nuclear industry. The Manhattan Project, Trinity Site, Project Gnome, and the Waste Isolation Pilot Plant, as well as the city of Los Alamos, have all played a strategic role in the development of the global nuclear industry. New Mexico has been home to many brainy types, such as nuclear engineers, designers, and rocket scientists for decades.

The National Museum of Nuclear History and Science has many exhibits that track the progression of the nuclear industry from inception to today. Nuclear medicine, Nano-technology, nuclear waste storage, an interactive lab for the little ones, the role of the atom in the Cold War, and pop culture are but a few of the fascinating treasures you will find. Planes, rockets, and missiles are but a few museum pieces you will find on the grounds.

Education is the main mission of the museum. Nuclear energy is a highly misunderstood field, and it is the museum's goal to change this perception. As the only Smithsonian Affiliated Museum in Albuquerque, the National Museum of Nuclear History and Science "strives to tell the story of the Atomic Age, from early research of nuclear development, through today's peaceful uses of the technology". With a yearly attendance rate of over 60,000—with 10,000 of this number children—it is safe to say the museum is accomplishing its goal.

Directions: located east of Kirkland Air Force base in the Sandia Science Technology Park, six blocks south of Central Avenue and off I-40 at Exit 165. Address: 601 Eubank Blvd, SE, Albuquerque, NM 87123. You can contact the Museum via (505) 245-2137 or www.nuclearmuseum.org.

Southwest Soaring Museum

Take a short detour off Interstate 40 at Moriarty, a small prequel to Albuquerque, you will find a museum solely dedicated to gliders. This small museum is one of only two such museums in the United States which is completely about gliders, soaring, sailplanes, and the like.

Across the street is the Lewis Antique Auto and Toy Museum, which gives visitors a wonderful walk down memory lane as they tour the museum building. Situated along old Route 66 in Moriarty, this museum has won high reviews from past visitors—well worth the diversion.

The Soaring Museum address is 918 Historic U.S. 66, Moriarty, New Mexico 87035. They are contactable via 505-832-9222 and www.swsoaringmuseum.org. The Lewis Antique Auto and Toy Museum address is 905 Historic U.S. 66, Moriarty, New Mexico 87035. They are contactable via 505-832-6131.

Telephone Pioneer Museum of New Mexico

In the days before the cell phones, telephone connections were far more complicated. Switchboard operators, insulators, telegraph wires, party lines, wall phones, rotary dial, Princess-style phones, extra-long cords, which constantly got tangled, and phone booths were all part of everyday life. We now live in the day and age where a phone booth is

a rarity, but then they used to adorn nearly every other street corner in a city and you would carry at least a quarter in change, just in case you needed to make a call.

The Telephone Pioneer Museum has a wonderful collection of telephone-related items sure to keep your curiosity going strong. For the extremely nominal entrance fee of $2, you can get a tour given by a volunteer, by reservation, who most likely used to work for the phone company. In fact, the museum itself is in the original 1908 telephone building of Albuquerque.

Phone directories, dating back to 1916 from nearly every town in New Mexico, are housed at the museum and make for fascinating reading as well as a great research resource. Address: 110 4th Street, NW, Albuquerque, NM 87102. Their phone number is (505) 842-2937.

Tinkertown Museum

Twenty-two rooms of collectibles await the visitor to the Tinkertown Museum. Launched in the 1960 by Ross Ward, the museum represents over thirty years of collecting. The collections mainly consist of art, dolls, animatronic bands, and toys put together in circus/sideshow vignettes. Many of Ward's early dioramas toured with carnivals until he decided to build a permanent home for them in the 1970s. The maze-like structure in Cedar Crest, New Mexico, also included 51,000 bottles in the construction, which used 20 tons of rock and cement. Ross Ward was truly one of the first trash to treasure recyclers.

Since her father's death from Alzheimer's in 2002, Carla Ward has become the caretaker of the fascinating property, which she describes as "a feast for the eyes." Tinkertown Museum attracts 30,000 visitors a year, and although they are open from April 1 to October 31, they do not have a public restroom. Tucked off Sandia Crest Road, Tinkertown is well-worth a slight diversion off the road to experience the visions Ross Ward.

Address: 121 Sandia Crest Road, Sandia Park, NM 87047. Their phone number is (505) 281-5233, and their website is www.tinkertown.com. Directions: Located on the Turquoise Trail National Scenic Byway in Sandia Park on NM Hwy. 536 on the way to Sandia Crest twenty minutes from Albuquerque. Take exit 175 North off 1-40, which will take you to Highway 14. Travel 6 miles up Highway 14 through Cedar Crest, turn left on Highway 536 towards Sandia Crest. Tinkertown is 1½ miles on the left.

Turquoise Museum

Nestled in the heart of Albuquerque is a unique museum in an equally unique setting. The Turquoise Museum features all things turquoise: geology, history, lapidary, displays of the magical stone, and silversmithing—all which being housed in a castle. The 8,500-square-foot Turquoise Castle was originally built in 2008 by Gertrude "Zachary" Schmidt to house her antique collections of European origin and was designed to look much like a French castle. The Zachary family were turquoise miners and jewelry makers for generations—much of what is displayed was crafted and collected by them.

The stunning blue stone known as turquoise is also New Mexico's official state gemstone. Cherished by the native tribes to use in their detailed silversmithing, turquoise is thought to be the stone of life since the stone can change colors throughout its lifespan to suit the environment where it is found. The stone is also thought to hold the ability to bring success, increase communication with the spirit world, and bring healing when needed.

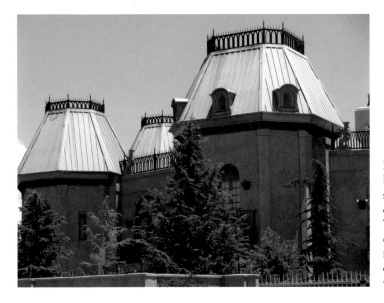

Dedicated to the beautiful official sky-hued gemstone of New Mexico, the Turquoise Museum displays fifteen of the most collectible pieces of turquoise in the world. (*DB*)

In the Turquoise Castle, you will learn the answer to many burning questions about the gemstone, like how it is formed, why some of the stones are blue while others are green, and how the stone got to be called turquoise. The gemstone goes in and out of popularity as styles change, but many of the cultures in New Mexico are not fazed by fashion and always wear the beautiful blue stones proudly out of tradition, art, and sophistication.

Turquoise jewelry has been worn by the various native tribes, especially the Navajo Nation, for centuries. These world-renowned silversmiths have offered their stunning creations for sale to the tourists who have flocked to the western U.S. since the 1890s. The size of the turquoise stone and jewelry piece not only showed off the workmanship of the artist, but also made a statement as to the wealth of the person owning the piece.

Address: 400 2nd St., NW, Albuquerque, NM 87102. You can contact them via (505) 433-3684 and www.turquoisemuseum.com. Admission fee is required.

Unique Annual Events

Day of the Dead Festivities

Celebrated throughout New Mexico, the Day of the Dead, or Día de Muertos, is a Mexican tradition brought to New Mexico by early settlers. Although macabre to some, it is a sweet way to honor those who have gone before us. White painted faces to resemble sugar skulls, brightly colored costumes, paper flowers, sunflowers, and Spanish veils are part of the typical attire worn on All Souls Day, November 1. This is the day when it is believed the souls of the departed walk freely among the living.

Statewide, the holiday is celebrated on the first Saturday after Halloween. Parades, special Masses, traditional foods such as sugar skulls, flowers, and decorated altars are all part of the merriment. Remembrance and honor of those who have gone before us is the reason for the festivities which are held in all corners of New Mexico.

International Balloon Fiesta

Hundreds of brightly colored and special shaped balloons take to the skies over Albuquerque on the first week of October each year to give truth to the city's claim as being the "Ballooning Capital of the World." Designated in 2005, the hot air balloon is the official state aircraft. The International Balloon Fiesta is presented by Canon© and is the most photographed event and largest hot air balloon event in the world, and no wonder, the wide palette of bright colors on display mixed with the azure skies is truly a photographer's playground.

Started in 1972 to celebrate the fiftieth anniversary of local radio station, the fiesta began with only thirteen balloons in the Coronado Mall parking lot in Albuquerque in an attempt to draw attention to the business and break the record for the most hot air balloons gathered together, which was nineteen in England. Although they did not break the record that time, they had 20,000 onlookers and launched the most spectacular balloon event in the world, which today averages over 500 balloon entries and 500,000 plus onlookers during the fiesta. It is highly suggested you make your hotel reservations for this nine-day event well in advance since every hotel within a 100-mile radius will be full and charging triple the normal rates.

Why Albuquerque? It is all due to the "Albuquerque Box," which is caused by the Sandia Mountains to the east, the Rio Grande, and the Rio Grande Valley to the west creating gentle prevailing winds, which blow in a box pattern. This can also create adverse weather conditions and some years have had quite a few cancellations due to wind and fog in the past, but for the most part, the International Balloon Fiesta is a huge success each year with perfect weather.

Hordes of people brave the chilly October weather beginning at 4:30 a.m. to fill the grounds of the Anderson-Abruzzo Balloon Museum to witness the truly breathtaking event. Food and souvenir vendor tents ring the perimeter of the grounds providing visitors with mementos and sustenance. As the dawn approaches balloons begin their preparations for launch. A few balloons, known as the Dawn Patrol, launch into the darkness to report conditions back to the ground. If given the green flag, each balloon launches to the cheers of the crowd below. The National Anthem is sung at dawn followed by a fly over from planes from nearby Kirtland Air Force Base on opening day, which receive a chilling fiery salute from the gondolas in the park. Be prepared for a good case of goosebumps and maybe even some tears.

It is highly recommended you take advantage of the "Park and Ride" option to get to Balloon Park. Traffic during the International Balloon Fiesta is immense and by riding the school busses from various locations, you cut out all the wait time and aggravation of dealing with the extremely long lines of personal vehicles vying for a parking spot. It is not unheard of to spend hours in line waiting to enter the park—therefore missing the launches altogether. Be sure to make your hotel reservations several (three to six) months in advance to avoid the rising prices and unavailability that occurs each year.

Mass Ascension is a feast for the eye as every color, shape, and design imaginable is represented. You will see flying pigs, chickens, sheep, black widow spiders, stagecoaches, Darth Vader® with Yoda®, penguins, pink elephants, and many others, as well as a new addition of a balloon in the likeness of Jesus Christ. Sensory overload will have you not knowing in which direction to point your camera. Be sure to have your batteries fully charged and tons of storage for the hundreds of photos you will take in the first couple of hours.

The fuel used to launch the balloons is quite expensive, but as a great perk to balloonists, the fuel is provided free to the fiesta participants, which they use readily to give the spectators a wonderful thrill. On mass ascension days, the American flag balloon will rise first as "The Star-Spangled Banner" is played—it is truly a breathtaking sight.

One of the favorite events of the fiesta besides the Mass Ascension is the Splash and Dash. The nearby Rio Grande provides a unique experience for balloonist and spectators alike as the beautiful balloons dip down just slightly in the river water only to ascend quickly to continue their daily journey. Many spectacular images have been captured by kayaker's who are waiting on the orbs to touch down. These actions are part of the tasks and competitions given to the balloonists each year. Long-distance competitions are also part of the International Balloon Fiesta each year, which are great challenges to the balloon pilots who are up to the task at hand.

For those of you who have "ride in a balloon" on your bucket list, you are in luck! There are several privately-owned ballooning companies who will provide you with the thrill of a lifetime—for a fee, of course. People have been known to propose in a balloon, get married in a balloon, or just enjoy the amazement of the ride.

There are still more events after dark as the Twilight Twinkle Glow, Balloon Glow, and the Night Magic Glow take center stage. Rows and rows of brightly colored balloons simultaneously fire their burners for the Balloon Glow, which started in 1987. These glows have been locally dubbed and trademarked as "Glowdeo's" harkening

There is nothing more spectacular than the sight of a hot air balloon glowing against the pre-dawn sky. (*DB*)

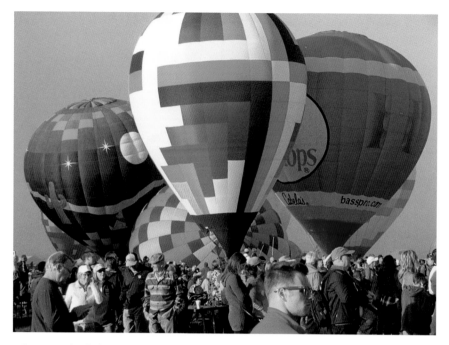

Above: With all the brilliantly colored hot air balloons surrounding you at every turn, it is easy to see why the International Balloon Fiesta is the most photographed event in the world. (*DB*)

Below: The International Balloon Fiesta attracts balloon pilots from all over the world to participate in the high desert of New Mexico. (*DB*)

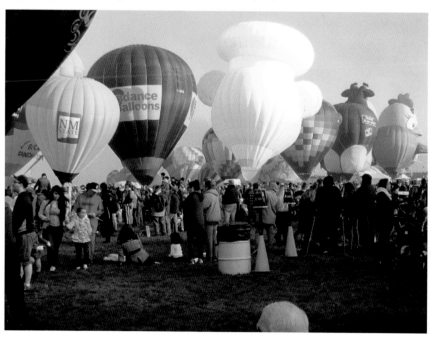

back to New Mexico's western heritage. This event is followed by a magnificent firework display, which can be seen in nearly all of Albuquerque and Rio Rancho.

Until you attend the event, marvel at the sheer size of these airy giants, listen to the roar of the burners, see the wonderment in a child's eyes, you will not understand the draw. The International Balloon Fiesta will certainly be an experience you will never forget. Visit www.balloonfiesta.com/Park-Ride for more details.

New Mexico State Fair

With opening day occurring the first weekend in September, and running for at least ten days, the New Mexico State Fair is a huge draw for Albuquerque who hosts the event at the New Mexico Expo in the middle of the town. The annual event has carnival rides, parades, art and botanical shows, livestock competitions, rodeos, live music, car shows, and some of the best fair food you could ever eat. This highly anticipated annual event draws thousands through the gates to enjoy the wonders within and as with any large event, please be aware of your surroundings. Every year, the food vendors try to outdo each other by putting together some extremely interesting food concoctions such as fried Oreo ice cream taco, deep fried bacon-wrapped jalapeno popper dog, red chile brownie pie, chocolate chip green chile cheeseburger, and compete for the Unique Food competition. It may be suggested to have some antacids on hand after tasting these dishes.

If you plan to attend the New Mexico State Fair, like the International Balloon Fiesta, be sure to make your hotel reservations well in advance for room prices will drastically rise as the hotels fill up. Address: 300 San Pedro NE, Albuquerque, NM 87108. Contact via statefair.exponm.com.

Unique Lodging

Painted Lady Bed & Brew

Breakfast is Overrated: The theme of the Painted Lady Bed and Brew where you will find your evening beverage needs catered to instead of your usual breakfast culinary fare.

Historic, restored, and haunted are three words that describe the Painted Lady Bed & Brew to a tee. If you are up for an adventure, or just want to taste some of the best craft beers in New Mexico, 1100 Bellamah Avenue NW is your perfect destination. Formerly a grocery store, saloon, and brothel, the Painted Lady has seen it all, and according to the owner Jesse Herron, some of the residents have loved it so much, they refuse to leave. You will too!

Built in 1881 in the historic Wells Park neighborhood near Old Town, the structure is typical early Albuquerque architecture, with thick adobe walls, high clapboard ceilings, and vintage light fixtures, door handles, and windows. The brick-floored covered portico, which stretches along the front of the restored rooms, lends a cool place to soak up the evening or early morning breezes.

Newly featuring a beer garden, complete with ABQ Trolley tap room, Jesse serves craft beers from the region to his guests in a courtyard, which is highlighted by a stunning mural, painted by Mauricio Ramirez for the MuroABQ project. Jesse's ABQ Trolley Co. provides trolley tours of the over fifty murals painted in Albuquerque's downtown area for this outstanding art project. Albuquerque has always been a colorful place, but with the addition of the gorgeous murals, the city shines even brighter.

The Painted Lady Bed & Brew has been many things in its lifetime, but thanks to owner Jesse Herron, this hidden gem is continuing with its service to the community and is a great place to relax. (*DB*)

The Painted Lady's haunted reputation has drawn many to her door. Maybe you will be lucky enough to hear "Uncle Charlie" as he rattles each door during his nightly lock check or hear the merriment of glasses clinking and ladies laughing coming from what was at the one time, now nonexistent saloon. Billy the Kid and Pat Garrett have also been rumored to have stayed at the Painted Lady during their time when they were in Albuquerque for the Kid's trial in early 1881.

Address: 1100 Bellamah Avenue, NW, Albuquerque, NM 87104. Contact via (505) 200-3999 or www.breakfastisoverrated.com.

Red Horse Vineyard Bed & Breakfast

Settled in the historic South Valley of Albuquerque sits a charming bed and breakfast with winery. The Red Horse Vineyard Bed & Breakfast is now owned by Carl Londene and his daughter, Darlene, who run the family business, which over the years was a campsite for the Confederate soldiers during the Battle of Albuquerque, home to the Braceros, and a proud part of the Atrisco Spanish Land Grant.

Today, tranquility is all you will feel as you enter the gate past the vineyard into another world. All the troubles on your shoulders will melt away as you enter this country inn. Tucked into the south valley, the bed and breakfast itself is a bit difficult to find but is well worth the efforts. Do not trust your navigation system to be accurate, I

was personally taken to a brewery near Old Town the first time—which coincidentally, belongs to Darlene's sister.

The original house, built in 1870 stood on the property until it collapsed in 1971, salvaged wood from this structure was used to rebuild the house. Heavy beams adorn the main house and ceiling of the wine cellar, these are wood used in old wagons picked from around the South Valley area. When Carl and his late wife, Donna, bought the property, it was the only house in the valley. There are now twenty-six different varieties of trees surrounding the Red Horse, all planted by the Londene's.

Along with providing their guests with a wonderful experience when they stay at the Red Horse, the owners are also winemakers. Growing in their front yard are some grapevines of an unknown varietal that have been on the property over 100 years. Carl Londene has some of his first bottles of wine, vintage 1969, stored in the wine cellar. Guests of the bed and breakfast not only get a tour of the cellar, but also are treated to a wine tasting.

One can almost imagine the Pony Express riders, who made this house one of their stops, hitching their horses to the wooden corrals behind the house. Migrant workers known as Braceros, who picked the crops in the region used what is now the pottery shed for a house. In this cramped five-room building, there were housed five or six people per room and furnished with only a bed and a stove. When a fire swept through the valley destroying the crops, the Braceros were no longer needed there so they moved on.

Art is everywhere at the Red Horse. Carl and Darlene create ceramic Dalecarlian horses, which harken back to their Swedish heritage. The pair also create bells, gnomes, jewelry, Christmas ornaments, and coffee mugs. Painting and ceramic classes are also offered for guests who want to be creative as well. Carl gathers found items around the property to put into vignettes, which are hung in and outside the home, as well as his beautiful paintings. Murals by local artist, Sharon Higgins, also adorn the walls of the property. It is truly a feast for the eyes.

A peaceful respite in Albuquerque's south valley was once a campground for the Confederate troops loyal to General Sibley in the American Civil War. (*DB*)

To make the Red Horse Vineyard Bed and Breakfast more of an experience rather than just a stay, the proprietors provide a pool, hot tub, and gazebo, which is the perfect setting for a wedding or reunion.

Address: 2155 Londene Lane, SW, Albuquerque, NM 87105. Contact details: (505) 967-7610 and www.redhorsebb.com.

Spy House

The Downtown Historic Bed & Breakfast has a titillating history. The Arts-and-Craftsman-style home surrounded by Victorian houses nestled in the heart of old Albuquerque, presents itself as quite normal to the rest of the world, but it has secret. The beautiful home, now bed and breakfast, was once visited by Julius and Ethel Rosenberg, the famed spies who were convicted of conspiring with the then Soviet Union in obtaining atomic secrets from the U.S. government—secrets regarding radar, jet propulsion, and nuclear weapon design. A crime for which the couple was tried, convicted, and executed by electrocution in 1953.

Friends of the spy couple owned the Spy House, and it is known that the Rosenberg's stayed in the bed and breakfast when it was a private home and David Greenglass (Ethel's brother and co-conspirator) was a tenant. Greenglass, an atomic scientist, was working at Los Alamos at the time on the highly secretive Manhattan Project; it was through his connections the Rosenberg's were able to obtain most of their material.

Greenglass met with Harry Gold, another co-conspirator, the pair used Jell-O™ brand gelatin box-tops to pass on what type of information was needed. Greenglass would then loosely draw the components of the atom bomb on pieces of paper and pass them off to Gold the next day.

The current owners have taken full advantage of their home's heritage by hosting interactive Murder Mystery Dinners where their guests are the main characters of the murder mystery script, as well as some opportunities for *ad-lib* and hilarity.

Address: 209 High Street, NE, Albuquerque, NM 87102. Contact details: (505) 842-0223 and www.albuquerquebedandbreakfasts.com.

Quirky Roadside Art

Los Muros de Burque

Derived from the Spanish word meaning "walls," Los Muros de Albuquerque was developed to bring the Duke City together using over fifty murals and outdoor artworks featuring local artists. The murals boost the pride of the neighborhoods that are graced with the pieces.

The mission of the project is best expressed in their own words:

In Albuquerque, our walls bring people together. Throughout our vibrant city, you will see our diverse culture expressed not just through the color of our skin, but through the color on our walls. Take a journey into the heart of who we are and discover the murals of Albuquerque.

A fascinating mural project has covered Albuquerque with colorful pieces of artwork, like this stunning mural by Mauricio Ramirez created with spray paint, which can be found at the Painted Lady Bed & Brew. (*DB*)

You can either take a walking tour or a trolley tour (recommended because these are narrated) to see these outstanding pieces of breathtaking art. Burque has become a favorite nickname for Albuquerque with the locals. Visit murosabq.com for more details.

Musical Highway

Travel along a short part of legendary Route 66 in Tijeras Canyon outside of Albuquerque, you will find a musical highway. That is right, it plays music as you drive along on the rumble strips. You must go exactly 45 miles per hour to hear the highway's rendition of "America the Beautiful," but it is worth the extra effort.

Funded by the National Geographic Channel for a program called *Crowd Control*, the idea behind the study was to improve human behavior—much like Pavlov's dogs who were rewarded for certain behaviors, you are rewarded for following the speed limit and rules with a song. The rumble strips are carefully placed and coincide with metal bars under the road.

The tone of the song is influenced by each vehicle that travels over the strips—the weight of the vehicle changes the tone. It was constructed by a New Mexico company, San Bar Construction, who completed this unique project in one day.

Directions: take Exit 170, drive eastbound on Route 333 (part of the old Route 66 system) about 3.5 miles between mile markers 4 and 5. Route 66, Interstate 40, Exit 170, Tijeras, New Mexico 87059.

Roadside Rattlesnake

A huge rock sculpture of a rattlesnake hangs out on the median on University Boulevard. Placed there as an attention-getter for the southern part of Albuquerque, the snake is now isolated. The Rattlesnake is 400 feet long and winds along the gravel. It is in an awkward spot with no parking and can be a bit tricky to get to at first. Please be cautious when taking a photograph of the snake since you will still be parked partially in the roadway.

Directions: when traveling from the North/Headed down I-25 South, stay on I-25 South. Take the Rio Bravo Boulevard SE exit 220. Upon exiting, take the first left turn (east) under the bridge approximately 0.2 miles off Interstate 25. You will stay on this road for a short time, and then it will dead end into the southernmost part of University Boulevard. Turn right on University Boulevard.

Cultural Heritage

Gutièrrez-Hubbell House History & Cultural Center

Along the El Camino Real, which is known to be the oldest roadway in North America, the 5,700-square-foot Gutièrrez-Hubbell House History and Cultural Center is a shining example of blended cultures in the region. Influences from the Spanish, Mexico, Native, and Anglo societies combined in 1860 to become a home to newlyweds Julianita Gutièrrez and James Lawrence "Santiago" Hubbell. This union produced at least twelve children who were all born and raised within the walls of this enormous home. In 1868, the *Santa Fe New Mexican* wrote: "Captain Santiago Hubbell has finished there one of the largest most convenient and comfortable homes for a residence that we know of in New Mexico." The house is now a National Historic Site.

Julianita Gutièrrez descended from one of the wealthiest families in the Parajito land grant and the New Mexico Territory and was the granddaughter of Don Francisco Xavier Chavez the first Republic of Mexico governor of New Mexico. Docents tell stories of the relationship between the wealthy property owners and the workers to be a symbiotic one. James Hubbell, who hailed from Connecticut, came to the Territory on the Santa Fe Trail to open a trading post in the Arizona Territory. Hubbell met Julianita since her family had also long been traders as well.

The stunning private home also served as a trading post, post office, mercantile, farm, and stage stop during its lifetime.

Address: 6029 Isleta Blvd, NW, Albuquerque, NM 87105. Contact details: (505) 897-0337 and www.hubbellhousealliance.com.

Indian Pueblo Cultural Center

Founded in 1976, the Indian Pueblo Cultural Center was formed by the nineteen pueblos in New Mexico as a place for all to discover pueblo history. The Center provides visitors a fascinating look into the pueblo life and culture by providing interactive hands-on museum exhibits, galleries, and permanent exhibits that depict the legacy of the ancient traditions of Puebloan People. American Indian art markets, native dances and festivals are held throughout the year on site and the public is invited to participate.

On site you will find a full-service restaurant and bakery, Pueblo Harvest. Be sure to enjoy the tacos and horno-baked pizza and bread available for your enjoyment. A horno

Hornos (Spanish for oven) are constructed from adobe, for baking bread and firing pottery. (*DB*)

is a round outdoor adobe oven used by the Native Americans to cook breads and even fire their pottery. The horno oven is sometimes called the "beehive oven" as well due to the round shape and can be found in many backyards of northern New Mexico homes.

Cedar and juniper woods are traditionally used for the most even cooking in a horno. Temperature is checked by tossing oats into the oven—if they blacken quickly, some of the oven coals are swept out, if it turns a nice brown, it is the correct temperature to cook bread. Bread generally takes forty minutes to an hour to bake, but the entire process from mixing to baking will take four hours of the baker's day. The results are delicious and well worth the wait! If you want bread at the Pueblo Harvest restaurant, due to the time-consuming process, please call ahead to reserve your loaf.

Address: 2401 12th Street, NW, Albuquerque, NM 87104. Contact details: (505) 843-7270 and www.IndianPueblo.org.

Isleta Pueblo

As one of the pueblos affected by the Pueblo Revolt of 1680, Isleta Pueblo, only 15 miles south of the city of Albuquerque, was established in the 1300s. Isleta means "little island" in Spanish and covers over 329 square miles of land between the Manzano Mountains and the desert lands of the Rio Puerco, solidifying its place as one of the largest of the nineteen pueblos in New Mexico. Today, the pueblo offers a variety of entertainment opportunities such as a world-class resort/casino, bowling alley, golf course, lake, and RV park. The concert venue attracts well-known musicians from all genres to New Mexico each year to play in the Isleta Showroom.

Isleta Pueblo was built on a knife-shaped reef of lava that runs along the Rio Grande. The community is mainly Southern Tiwa, of which most of the residents speak. This pueblo, like many of the others in the eastern pueblo groups, relied heavily on farming corn, squash,

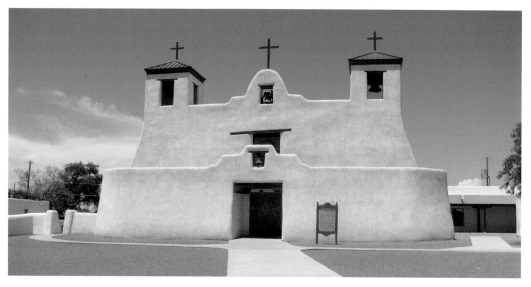

Some 15 miles south of Albuquerque off Interstate 25 sits the Isleta Pueblo, which played a large role in the 1680 Pueblo Revolt. (*DB*)

and beans, while utilizing irrigation to maintain these crops. During the Revolt, many Isleta residents escaped to the Hopi Nation in Arizona where they would remain until after the uprising. Those who returned were said to have brought Hopi spouses along with them.

St. Augustin de la Isleta Mission was built in 1613 by the Tiwa people when the Spaniards arrived in the late 1500s and is still a beautiful example of craftsmanship and faith. Originally built under the direction of a Spanish missionary, the church Gothic Revival-style elements added in the 1920s. Today, St. Augustin has reverted to a Spanish mission-style adobe church and is the cornerstone of the community that surrounds it.

Directions: Seven minutes south of Downtown Albuquerque at Interstate 25 and Highway 47, Exit 215. Address: 11000 Broadway, SE, Albuquerque, NM 87105. Contact details: (877) 747-5382 and www.isletapueblo.com.

San Felipe de Neri Church

The most prominent feature of the Old Town Plaza is the San Felipe de Neri Church. The original church was built in 1706 under the direction of Franciscan priest Manual Moreno. When first built, San Felipe was named San Francisco Xavier by Don Francisco Cuervo y Valdez, who founded the city of Alburquerque. (Notice the initial spelling of Albuquerque included two "r's" in honor of the Duke of Alburquerque of Spain).

One of the most interesting features of the 300-year-old San Felipe de Neri Church is the fact encased in the west side (left) spire of the church are human bones dating back to the 1700s. The first church was built across the way from the present-day church on Romero Street where the Aceves Old Town Basket & Rug Shop now does business. Due to massive flooding of the Rio Grande in 1793, this structure and the cemetery (close to where the present-day gazebo is today) was destroyed and many bones were washed away. When the new church was constructed, workers exhumed the remaining bones

from the cemetery and encased them in the west bell tower. It is said this was a European tradition at the time and thought to be a great honor to be "buried" in a sacred building.

Sister Blandina Segale (1850–1941) began the first public school on San Felipe's grounds and was instrumental in the construction of many other schools as well as hospitals, like St. Vincent's in Santa Fe. Her work took her not only in Albuquerque, but around New Mexico. For her tireless work to fight the injustices experienced by the Native Americans and immigrants to get their lands returned to them, Sister Blandina has been nominated for sainthood. The process for sainthood is long and Sister Blandina must have a new miracle charged to her to complete the cycle.

Many legends surround the humble nun, but one seems to have substance. After hearing that a bandit was wounded and near death in a nearby shack, Sister Blandina went to his aid when no one else would. Sister Blandina nursed the outlaw back to health only to find that he was part of the infamous gang headed by the New Mexico outlaw Billy the Kid. It was also reported the nun stopped the outlaw leader from carrying out his plans to kill four doctors in the area who refused his band mate care.

The original design of the church was in the traditional pueblo style with flat-roof and thick adobe walls, Bishop Jean-Baptiste Lamy favored the gothic style of his French heritage and ordered the roof to be pitched adorned with gothic elements. In keeping with the European style, Lamy wished to have the newly built New Mexico churches to have a marble altar, but it was far too expensive, so it was constructed out of wood and given a *trompe l'oeil faux* marble finish. The exterior was not only adobe, river rocks were incorporated into the structure as well as sun-dried cut sod—or terrones. The roots of the terrones were incorporated to give more strength and stability to the church building.

The tabernacle, home to the Holy Eucharist, was stolen during Easter Week in 2016 from the painted altar. Devastated by the loss of the holy article, Father Andrew Pavlak spread the word that the church would like to have its property back. Contacted by an intermediary for the thief, the sacred tabernacle was returned to its rightful spot on the altar—to which it is now bolted for safe keeping.

Housed within the church walls are boxes of over 3,000 books, journals, and manuscripts dating back to 1625. It is the hope of the current diocese to have these tomes organized and displayed soon to give access to researchers, authors, theologians, and parish members. The thought is to open a small museum, complete with a replica nun's quarters, much like Sister Blandina's, and library to reveal even further the rich history of San Felipe de Neri Church. This is an expensive dream, however, and could run into the hundreds of thousands of dollars before it is completed, money that the diocese does not presently have to spend.

Directions: at the north side of the Old Town Plaza. Address: Old Town Road, NW, Albuquerque, New Mexico 87104. Contact number: (505) 243-4628.

Petroglyph National Monument

Along the volcanic escarpment of the westernmost reaches of the city of Albuquerque are 17 miles of boulders, which house of the some of the most historic objects in the state—the Petroglyph National Monument. Massive amounts of volcanic activity formed the landscape we are all familiar with in New Mexico and one of these volcanic features is called the Rio Grande Rift, 7,236 acres of which are comprised in the Petroglyph National Monument, which is jointly managed by the National Park Service and the City of Albuquerque.

Nomadic tribes, Spaniards, and cowboys have all left their marks on the basalt boulders. Many have been asked what these images mean and the best response to my knowledge is "You'd have to ask the artist," given by National Parks Ranger Murt Sullivan at Quarai Mission, Salinas National Monument. Each petroglyph is a record of the people who traveled the region, a cultural heritage storyboard if you will.

The volcanic boulders that litter the hillside bordering the Duke City are enhanced by over 24,000 fascinating examples of ancient artwork. Each petroglyph is basically an etching in the basalt boulder which has been left to cure in the elements to form what is called "desert patina or varnish" by officials. This varnish a form of oxidation or rusting of the manganese and iron rich stones when it is exposed to oxygen.

The glossy finish gives the petroglyphs a highly polished artistic look but can be instantly damaged with cracking by the addition of water on a hot summer's day. Nature or human damage is always possible by accident, but when the damage is intentional and vandalism, it wipes out not only the art piece, but the opportunities for others to enjoy it in the future. Unfortunately, vandalism is occurring with people stealing small embellished stones or chipping away entire reliefs. These are national treasures and need to be protected fully.

Petroglyph National Monument has four major sites that can be accessed by visitors: Boca Negra Canyon, Riconanda Canyon, Piedras Marcadas Canyon, and the Volcano Day Use Trails. Boca Negra Canyon has petroglyphs that have been dated back to over 3,000 years ago. The visitors' center has a fascinating twenty-minute video that explains the possible thoughts behind the drawings and gives a wonderful cultural background for the visitor to absorb.

Address: 6001 Unser Blvd, NW, Albuquerque, New Mexico 87120. Contact details: (505) 899-0205 and www.nps.gov/petr.

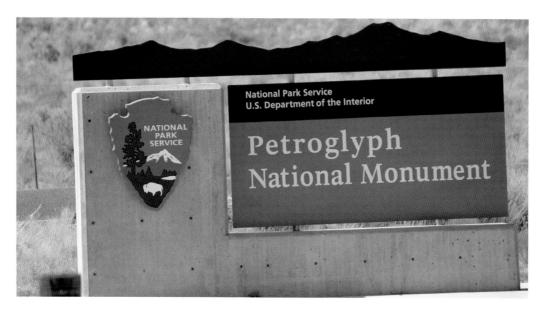

Nestled along the West Mesa flanking Albuquerque are thousands of petroglyphs carved by ancient man. (*DB*)

3

NORTHEASTERN NEW MEXICO REGION

Truly one of the most beautiful regions of New Mexico, the northeast provides enjoyment for not only the body and mind, but the soul. Prepare to embark on a spiritual journey.

Historical Background

Abiquiú, New Mexico

Red and white sandstone formations and cliffs in the Carson National Forest form a feast for the eyes. As you travel Hwy. 84 towards the Colorado border, you will begin to see why artist Georgia O'Keeffe was so fascinated by the scenery around her beloved Ghost Ranch. This surrounding landscape of the Rio Chama Valley had prominent roles in O'Keeffe's most famous paintings. The legendary Ghost Ranch received its name when the original owners of the ranch, who were reported cattle rustlers, spread the rumor that the land was haunted by evil spirits to keep people away so they could hide their cattle. The locals began calling the beautiful acreage Rancho de los Brujos, or Ranch of the Witches. Curse or not, the cattle-rustling brothers ended up in an argument over gold, which led to them killing each other.

Being 53 miles north of Santa Fe, Abiquiú was settled in 1742 by the Tewa Pueblo people who were led by Catholic priests. The Comanche tribe caused so much trouble for the settlers, Abiquiú was abandoned for several years to prevent the raids.

As with other places in New Mexico, Abiquiú has been the setting for many movies over the years including *Red Dawn*, *The Wild, Wild West*, *Lone Ranger*, *Cowboys and Aliens*, and *City Slickers* to name a few.

Abiquiú is Tewa for "wild choke cherry place" and is home to many resorts and spas who take full advantage of the gorgeous countryside. On the way to the famed 21,000-acre Ghost Ranch Education and Retreat Center, you will pass a natural amphitheater that was formed by the natural erosion of the sandstone by rain and other elements. The Echo Amphitheater is a perfect stop to take in the natural beauty which surrounds you. Shout out your name and it will repeat back to you. There is a nominal parking fee should you want to get out and explore.

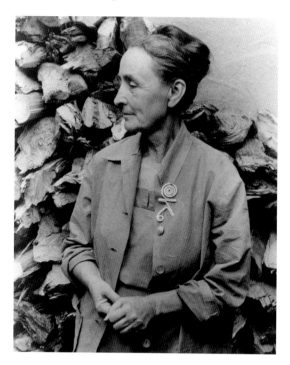

New York artist Georgia O'Keeffe came to New Mexico and fell in love with the landscape; she soon became one of the most iconic artists of her adopted state. (*Library of Congress*)

The Purple Adobe Lavender Farm, which was established in 2004, will lull you to become relaxed just by walking by the beautiful purple hued fields. The summer months of July and August are a perfect time to visit since the blooms will be at their peak. Be sure to visit the gift shop and walk the labyrinth as you enjoy the scenery and partake in a lavender scone at the 100 percent gluten-free tearoom.

Chimayó, New Mexico

The picturesque northern New Mexico village of Chimayó is home to one of the most sacred places in the state, El Santuario de Chimayó. The tiny, mostly Hispanic farming village is famous also for its red chile and weaving. Trujillo's and Ortega's Weaving Shops have many fine examples of the hand-weaving skills of the residents.

The road from Santa Fe to Chimayó is a narrow two-lane road, which winds through a tree-lined route. Adobe houses, coyote fences, and cottonwoods make for a relaxing drive along the High Road to Taos.

While in Chimayó, visit the Vigil Store (El Potrero Trading Post), opened in 1921 by Alfonsa Vigil as a market. Today, the historic store carries religious items, which coincide with their famous neighbor, red and green chile, fine examples of New Mexico folk art, and even ice cream to cool you down on those hot high desert days.

Just up the road is probably one of the best restaurants to get true northern New Mexican cuisine, Rancho de Chimayó Restaurante. Started over fifty years ago by Florence and Arturo Jaramillo, the restaurant has been proudly serving northern New Mexico foods made from the famous Chimayó chile. More about this delicious stop will be featured in Chapter 9.

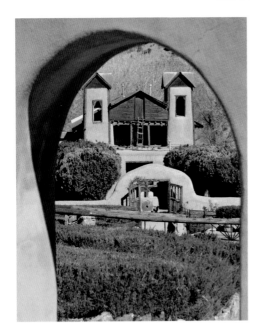

As the destination for hundreds of pilgrims at Easter, Santuario de Chimayo is surrounded with love from those hoping to receive a special blessing at this sacred church. (*DB*)

Cimarron, New Mexico

Home to one of the largest landowners in the U.S., Lucien Maxwell, Cimarron, in its time, was one of the wildest towns in the Old West. Named by the Spanish settlers, Cimarron means "wild or unruly"—it certainly lived up to its name.

Gunfighters such as Clay Allison, Doc Holliday, Bat Masterson, "Black-Jack" Ketchum, and rumored Jesse James were a common sight strolling the streets in the sleepy town. Notables like Wyatt Earp, Buffalo Bill Cody, Annie Oakley, Pat Garrett, Frederick Remington, Governor Lew Wallace, and Zane Grey were all said to have been guests at the St. James Hotel. The Cimarron of today is much the same as it was in the late 1800s, just less dangerous. Now you will encounter deer or elk on the streets instead of outlaws, but it still has the same charm.

A few miles up the road is the Palisades Sill, which are in Cimarron Canyon State Park. High cliffs formed from porphyritic dacite sill, or igneous rock, which were created the same time frame as the Southern Rocky Mountains. The jagged cliffs are a beautiful natural wall in front of which the Cimarron River runs swiftly. A perfect spot for a leisurely picnic or fly-fishing trip.

Clayton, New Mexico

Walk in the footsteps of the dinosaurs and outlaws as you visit the town of Clayton, New Mexico. Established in 1887, Clayton was heavily frequented by travelers along the Cimarron Cutoff of the Santa Fe Trail. Rabbit Ear Mountain was used as a landmark by those utilizing the Santa Fe Trail on their way to the gold fields of California. Home to Clayton Lake State Park and Capulin Volcano National Monument, Clayton is adjacent to the nearly 1-million-acre carbon dioxide field known as Bravo Dome and Black Mesa State Park in the panhandle of Oklahoma.

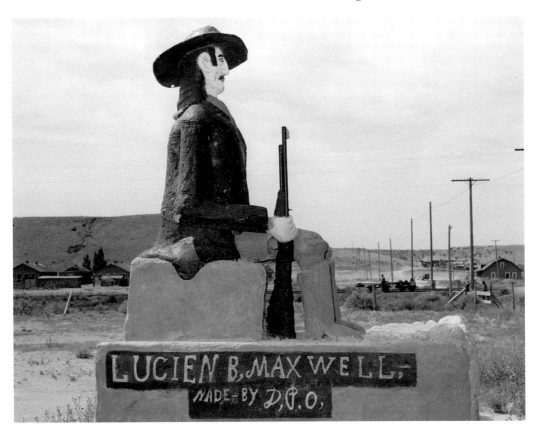

Above: Cimarron and its surrounding countryside were home to the owner of 1.7 million acres in the state, Lucien Maxwell, and for whom the Maxwell Land Grant was named. (*Library of Congress*)

Right: To say train robber Tom "Black-Jack" Ketchum lost his head over his execution would be accurate. Due to several miscalculations, the outlaw was decapitated during his hanging in 1901. (*Library of Congress*)

Chama, New Mexico

Breathtaking beauty surrounds you in Chama, New Mexico. Some 8 miles from the Colorado border, Chama is home to the Cumbres and Toltec Railroad. Especially beautiful in the fall as the leaves of the aspens and cottonwoods turn golden and shimmer in the mountain breeze, Chama will leave you in awe as you drive along the narrow, winding highway into the historic village.

Stark contrasts in scenery will be the most remarkable as you pass through the red gradient sandstone formations of Georgia O'Keeffe country in Abiquiu on the road to the mountains of Chama. This is truly a paradise for artists, photographers, and hunters. Beauty awakes at every bend in the road.

Dawson, New Mexico

The history of Dawson, New Mexico, a tiny coal mining town, is a tragic tale. Mineral rich lands of New Mexico lured many to the territory in search of vast riches, some succeeded, while others were denied the opportunity. As the demand for coal rose, so did the population of Dawson, which in its heyday was 9,000.

The Phelps Dodge Corporation bought the property and mines in 1906 and quickly developed a mining town, which included a swimming pool, movie theater, golf course, department store, and hospital, as well as company provided housing. These amenities were a good enticement for people to work at one of the ten, often dangerous, mines in the region. The Dawson mines had already seen two mining accidents in 1903 and 1905 prior to Phelps Dodge acquiring the properties.

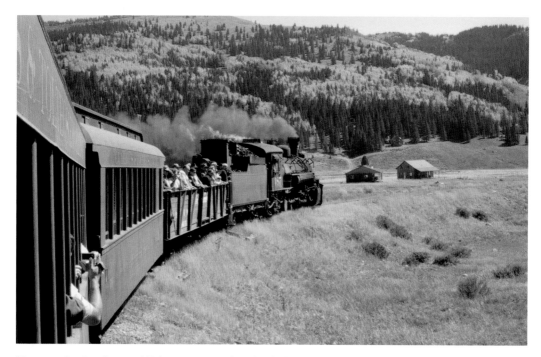

Home to the Cumbres and Toltec Scenic Railroad, which will take you on an unforgettable 64-mile journey from Chama, New Mexico, to Antonito, Colorado. (*Author's collection*)

Dawson was tragically the site of two of New Mexico's worst mining disasters in 1913 and 1923. October 22, 1913 would be a day of great human loss for the tiny town. Phelps Dodge Corporation mine Stag Canyon Mine No. 2 would suffer an explosion, which would be felt 2 miles away in the town of Dawson. Only twenty-three of 286 men came out of the mine that went in to work that morning. The casualties would also include two emergency workers who tried to rescue the men. The cause of the explosion was said to have been the ignition of coal dust set off by the miners using dynamite.

The second explosion occurred in Stag Canyon Mine No. 1 on February 8, 1923 when a mine car derailed underground, knocking down timbers and an electric trolley car, which also ignited coal dust setting of a huge explosion. This explosion killed 123 miners—sadly, many of whom where descendants of the explosion victims of 1913.

The cemetery, which holds the graves of the accident victims, is about all that is left of the now ghost town, which was founded in 1869 by John Barkley Dawson, a former Texas Ranger and one of the largest cattle ranchers in the Maxwell Land Grant. Dawson and railroad promoter Charles B. Eddy (founder of Eddy/Carlsbad) started the Dawson Fuel Company and built a 137-mile-long railroad from Dawson to Tucumcari, New Mexico.

Sitting approximately 12 miles northeast of Cimarron, New Mexico, the Dawson cemetery, with its hundreds of white painted iron crosses that cover the hillside, became a landmark and is on the National Register of Historic Places and is a stark reminder of how dangerous coal mining can be.

In 1950, Phelps Dodge Corporation sold the mines and company town to National Iron and Metals Company who would dismantle it. The residents were given only thirty days to pack up and move before the new company razed the town. Today, it is said to be one of the most haunted places in New Mexico.

Directions: take Route 64 twelve miles east of Cimarron, then head north on A38 at the striped sign—proceed for 5 miles. After A38 crosses the railroad tracks twice, turn on to the dirt road on the right to reach the cemetery. The ruins of Dawson can be seen by continuing north on A38 to Barus Road, which splits into Lauretta Road and Rail Canyon Road.

Folsom, New Mexico

Folsom's population today at fifty souls is far fewer than the prehistoric populations of the Ice Age hunters in the region 10,000 years ago. Discovery of the famed Folsom Point proved that humans were living in the northeastern sections of New Mexico and used the points to hunt mastodon during the Pleistocene Era. More recently, the town of Folsom was founded 30 miles east of Raton, New Mexico in the late 1800s as a mining town.

Las Vegas, New Mexico

Called the "wildest of the wild" the New Mexico Las Vegas gave her wicked Nevada sister a run for her money. John Henry "Doc" Holliday and his lady fair, Mary Catherine Horony-Cummings, otherwise known as "Big Nose Kate," set up shop in the town along the Santa Fe Trail. Doc opened what was to be his last dental practice in 1879 above the still-in-business drugstore, and a saloon in the seedier part of town

suited the duo during their short stay in Las Vegas. The gunman's reputation proved true when Doc got into an argument with local gunslinger Mike Gordon, who was invited to take the dispute outside where Gordon soon lay dead from three gunshots to the abdomen. Rumors of a lynch mob sent Doc and Big Nose Kate to find sanctuary in a small town in Arizona called Tombstone.

As a support town for nearby Fort Union, Las Vegas knew how to show the troops a good time, with many troops becoming absent without leave (AWOL) so much, the fort officer forbade the soldiers from returning to town. Not being deterred, the soldiers soon found a new avenue for their entertainment: Loma Parda—a small farming settlement that had recently opened a dance hall, saloon, and brothel only 7 miles from the fort. Loma Parda is now a ghost town on private land, but it can be accessed with permission.

Las Vegas was the largest and richest town in the New Mexico Territory in the 1870s by playing host to the above-mentioned outlaws, gunslingers, gold miners, and trappers.

Taos, New Mexico
Known for their world-class skiing, Taos, New Mexico, has an ancient feel—the whispers of the past are loud in this small town. If you tend to be a sensitive, you will be embraced by those who have passed this way before. Narrow streets, which once served as burro paths, wind through the mountain community, lined with historical adobe buildings and homes.

The Taos Society of Artists, known widely as the Taos Twelve, was founded around 1893 by a group of artists, who included H. Joseph Sharp, Ernest L. Blumenschein, Bert Geer Phillips, E. Irving Couse, Kenneth Adams, Julius Rolshoven, Oscar Berninghaus, Martin Hennings, Walter Ufer, Catherine Critcher, Victor Higgins, and Herbert "Buck" Dunton, who studied art around the world and had each become mesmerized by the beauty of Taos when they visited it and converged on the tiny village to paint what inspired them in the culture and scenery. With over eighty galleries to choose from, each celebrating the talents of hundreds of artists who express their love for New Mexico on canvas, in sculptures, woodcarvings, pottery, metals, textiles and photography, Taos is an art lover's dream.

Ghost Towns and Frontier Forts

Fort Union National Monument
A ghostly reminder of a time when brother fought brother, when the west was truly wild and the settlement of America was in full force, Fort Union National Monument stands as a testament of a bygone era. On the Santa Fe Trail, Fort Union has had three lives as a fort. The first of the three structured forts were built in 1851 to protect the hundreds of wagon trains moving west to the California gold fields along the Santa Fe Trail from attacks by the indigenous people who roamed the plains of the New Mexico Territory.

The location of one of the biggest arsenals in the New Mexico Territory, Fort Union was a prize to be taken and it was the plan of the Confederate Army to invade and capture the fort for their own. The rebels were determined to take the supplies and weapons of the fort on their way to the gold and silver rich fields of Colorado—should this have happened, the Civil War would have taken a decidedly different turn.

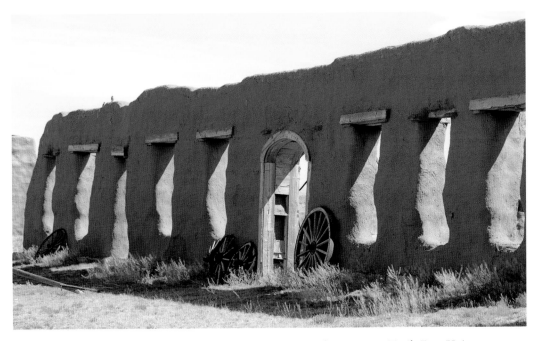

Vital to the protection and supplies for travelers on the Santa Fe Trail, Fort Union saw two reconstructions before settling on the version known today. (*DB*)

Three versions of the fort were built on the site open to the public today and should you travel to the beautiful location off Interstate 25, approximately 156 miles from Albuquerque, you will see massive ruts created by the thousands of wagons that traveled the Santa Fe Trail to the center of Fort Union. Time has taken its toll on this proud relic and is literally melting away the adobe walls with each rainstorm that passes over.

Directions: travel 8 miles from Interstate 25 on Highway 161 to reach Fort Union National Monument. This is a walking tour, no food or gasoline is sold at the site, so you will have to obtain these items in either Wagon Mound, 31 miles north, or Las Vegas, 28 miles south. Fort Union has a great gift shop, museum, and clean restrooms available. Since the fort is located on a sweep plain, weather conditions may vary, so please call ahead. Address: P.O. Box 127, Watrous, New Mexico 87753. Contact number: (505) 425-8025.

Outdoor Adventure

Blue Hole, Santa Rosa, New Mexico

Along I-40 and the original Route 66 is a natural attraction loved by scuba divers and swimmers alike, the Blue Hole. The bell-shaped sink is one of seven sister lakes fed by a natural spring and was once called Blue Lake. As water is precious in the desert, Blue Hole was often used as a watering hole for cattlemen moving herds to and from Texas.

Deriving its name from the sapphire blue water of the lake, Blue Hole is a beautiful sight and stays a constant 62 degrees as the water renews itself every six hours with a

flow of 3,000 gallons per minute. Fed by an artesian well, Blue Hole was once used as a fish hatchery; today, it supplies Santa Rosa with the distinction of being the "scuba diving capital of the southwest" with a depth of 80 feet and one of the top eleven "best swimming holes in the United States." Over 8,000 dive permits are sold each year for those wanting to explore the caves in the depths or gain certification.

Address: 1085 Blue Hole Road, Santa Rosa, NM 88435. Contact details: (575) 472-3763 and www.santarosabluehole.com.

Capulin Volcano National Monument

Said to be the youngest cinder cone volcano in New Mexico, only 55,000 to 62,000 years old, Capulin Volcano allows visitors to drive to the volcanic site and park on the rim, except for years when there is extreme rain run-off. From the rim, you are within eyeshot of five states: Colorado, Texas, Oklahoma, Kansas, and, of course, New Mexico.

Declared a National Monument by President Woodrow Wilson on August 9, 1916, Capulin is part of the Raton-Clayton Volcanic Field. From 1916 to 1987, Capulin Volcano was called Capulin Mountain. This unique experience includes a paved 2-mile hiking trail to the rim from the road and a 5-mile hiking trail into and around the volcano. At an elevation of 8,182 feet above sea level, the Capulin rim rises 1,300 feet above the lava flow plains. The interior of the volcano is covered with pine and juniper forests and the chokeberry bush, which in Spanish is Capulin. Mule deer and other wildlife call the volcano home. There is also archaeological evidence that early man, namely the Folsom culture, inhabited the region as well.

Please be aware, dogs are not allowed on the hiking trails. Please allow at least two hours to complete the full hike around the rim and interior, and also note that the weather can be windy at the top.

One of the most anticipated events at Capulin is the arrival of the ladybugs each summer around mid-June until August. Hundreds of the tiny beetles take up residence at the highest point of Capulin each year, which is called hill-topping. After feeding all summer, some of the ladybugs hibernate through the winter on the volcano, while others migrate away. The best area to see the thousands of ladybugs is usually at the Crater Rim Trail.

Address: 46 Volcano Road, Des Moines, NM 88414. Contact number: (575) 278-2201.

Clayton Lake

For you dinosaur enthusiasts out there, Clayton Lake is touted as being one of the best places with preserved dinosaur tracks in the world. The Clayton Dinosaur Trackway presents over 500 fossilized footprints of the ancient inhabitants who called New Mexico home 100 million years ago. Coincidently, these tracks can be found close to one of the most famous passageways used by the pioneers who ventured west in search of gold—the Santa Fe Trail.

Three-toed prints of eight bipedal animals such as the Orinthopods, Iguanodons (plant eaters) are more commonly found preserved in the mud base of the lake, but a few Theropods (meat eaters) have been located there as well. This ancient evidence gives Clayton Lake the title of "Dinosaur Track Capital of the World" and became known as the "Dinosaur Freeway" as it is known that large herds of these ancient animals migrated north and south for hundreds of miles through the lake area.

Address: Clayton Lake, RR, Box 20, Seneca, NM 88437. Contact number: (505) 374-8808.

Rio Grande Gorge State Park

Approximately 50 miles long, the Rio Grande Gorge State Park is 10 miles outside of Taos, New Mexico in a Rift Valley. The North American and Pacific plates scraped together over 29 million years ago to form a long gash in the Earth's surface, which stretches from northwest to southeast of Taos through basalt flows of the Taos Plateau Volcanic Field.

A steel suspension bridge spans the 650-foot-deep gorge and is not for the squeamish, as you will be able to feel movement of the bridge as you drive your vehicle across the bridge. Park along the side of the highway, browse the vendors and venture out on the bridge itself for an experience you will not soon forget. The bridge spans the Rio Grande in a flatland area, so be prepared, there will always be wind. As the second tallest bridge in the U.S. Highway System and the fifth highest bridge in the nation, the Rio Grande Gorge bridge is called the "High Bridge" or the "Gorge Bridge" by locals. It is also known as the "Bridge to Nowhere" since funding was not available at the time of construction to complete the road on the other side.

In 1966, the steel bridge has been given an award from the American Institute of Steel Construction as the "Most Beautiful Steel Bridge" and has been the location for several popular movies such as *Wild Hogs*, *Natural Born Killers*, and *Terminator Salvation*.

Directions: Travel U.S. Highway 64/New Mexico State Road 522 north for approximately 3.5 miles to the last four-way intersection in Taos. Turn left on to U.S. Highway 64 West for about 8 miles. Cross the bridge and park in the parking lot to the

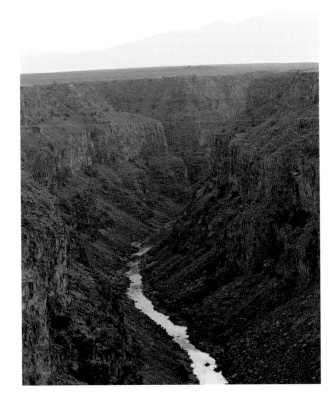

Carved into the high desert by the Rio Grande 650 feet below is the Rio Grande Gorge, which is spanned by the fifth highest bridge in the U.S. (*DB*)

left. There will be vendors at the bridge, and you are encouraged to walk the expanse to experience the sensation on your own. You will notice many signs, as well as telephones located on the bridge urging people to seek help since the bridge also attracts those who wish to commit suicide. It is a stunning view from the steel bridge, and it is relaxing to watch the eagles and hawks fly below you as they look for their next meals.

Kasha-Katuwe Tent Rocks National Monument

Some 40 miles southwest of Santa Fe, near Cochiti Pueblo, lies a National Monument that will make you think you have landed in an alien land. The trails which lead you through the fascinating landscape sculpted by nature are for foot traffic only. As volcanic eruptions occurred 6 or 7 million years ago, it produced conical formations comprised of volcanic ash, pumice, and tuff.

The Cave Loop Trail is 1.2 miles of gravel/sand trails, which are accessible by wheelchair and provide the visitor with many birdwatching, hiking, and geologic experiences. Canyon Trail is more difficult, steep, and narrow, but provides excellent views of the Jemez, Sandia, and Sangre de Cristo Mountains after the 1.5-mile-long trek. The Veteran's Memorial Trail is an easy mile-long, wheelchair accessible trail.

Be mindful as weather can play a factor with your enjoyment of the monument; lightning strikes and flash floods can occur without warning.

Opening hours: the monument is open from 8 a.m. to 4 p.m. in the summer months and experience a high flow of visitors so expect delays and small crowds. Dogs, except for service dogs, are not allowed in the park. No collection of rocks, plants, or artifacts is allowed, no motorized vehicles or mountain bikes are allowed, no fires or glass containers, you must remain on the designated trails and are not allowed to climb the tent rock formations. Address: Rio Puerco Field Office, Cochiti Pueblo, New Mexico 87072. Contact number: (505) 331-6259.

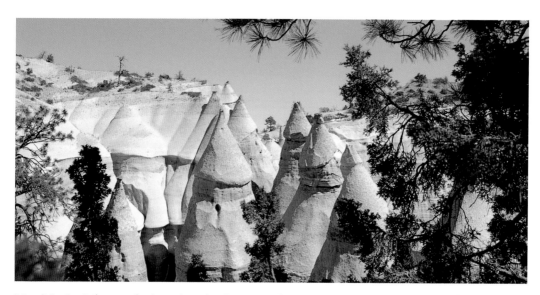

New Mexico is known for its unique landscapes and sites; Kasha-Katuwe Tent Rocks National Monument is the definition of this category with its incredible rock formations. (*Author's collection*)

Not Your Ordinary Museum

Chimayó Museum

Although the village of Chimayó is tiny, it has one of the best museums in the state. Situated in a former residence in the historical Plaza del Cerro neighborhood, the Chimayó Museum houses a large collection of vintage photographs, weavings, and local artwork in a classic New Mexican-style hacienda established in 1740. The museum is also a traditional backdrop as it serves as a venue for special events and art exhibits. Probably one of the biggest treasures of the museum is the staff who are a wealth of knowledge.

Address: 13 Plaza Del Cerro, Chimayó, New Mexico 87522. Contact number: (505) 351-0945.

Classical Gas Museum

When you drive along narrow NM-68 between Santa Fe and Taos, you will not only marvel at the winding Embudo River and beautiful countryside surrounding you, but also the great attractions along the way. One of these attractions is the Classical Gas Museum, which was started by a former Los Alamos laser scientist Johnnie Meier in the tiny village of Embudo. You will immediately be amazed by the rows of colorful vintage gas pumps that line the entrance to the museum. Once inside, there are huge collections of gas cans, oil cans, signage, maps, clocks, and thermometers.

The museum comes up quickly and it is on a tight curve, so you must be prepared to turn out of traffic. During the summer and fall months, NM-68 sees a good amount of traffic, which makes turning off the road a bit tricky. Meier lives on site, so the museum is open all the time. Although there is no admission fee, donations are greatly appreciated.

Address: NM-68, Embudo, NM 87531. Contact number: (505) 852-2995.

Rough Riders Museum

Open Tuesday through Saturday from 10 a.m. to 4 p.m., the Rough Riders Museum is dedicated to the over 7,000 pieces of memorabilia of Theodore Roosevelt's Rough Riders (the First Volunteer Calvary Regiment of the Spanish-American War, many of whom were from Las Vegas, New Mexico) and is housed in a 1940 rock Works Progress Administration funded building. Admission is free and well worth the slight deviation from Interstate 25. Donations are accepted and highly recommended so the museum can continue to host programs, authors, and tours for the public and school children.

Directions: From Interstate 25, take Exit 345 and go one block north on Grand. The museum is between University and National Avenues. On-street parking is available. Address: 727 Grand Avenue, Las Vegas, New Mexico 87701.

Vietnam Veterans Memorial

Located in the stunning vistas surrounding Angel Fire, New Mexico, is a somber memorial dedicated to those who served in the U.S. military forces during Vietnam. Known as the Vietnam Peace and Brotherhood Chapel, the memorial building has an appearance of angel wings at one angle and a stairway to Heaven at another. Built in the memory of U.S. Marine Corps First Lieutenant Victor David Westphall III by his parents, Jeanne and Dr. Victor Westphall, after his death in the ambush near Con Thien, Vietnam, on May 22, 1968 along with fifteen of his fellow soldiers at the

urging of his mother. Although not popular at the time it was constructed in 1971, the Westphall's strongly felt a memorial of this type had to be built: "We who must will do what we can to encourage humankind to preserve rather than destroy." The memorial was transferred to the State Parks Department of New Mexico after the deaths of the Westphall's, who are buried on the grounds. A moving sculpture of a soldier at the grave of a buddy reads, "Never Again will one Generation of Veterans Abandon Another." Rising behind this statue is a UH-1D Huey Helicopter, which was flown in Vietnam.

Directions: take U.S. Highway 64, from Taos, 26 miles to County Road B4. Turn left and veer to the right for one-half mile to the Memorial parking area. There is a museum and gift shop at the site. Chapel open twenty-four hours a day. Address: 34 Country Club Road, Angel Fire, NM 87710. Contact number: (575) 377-6900.

Quirky Roadside Art

D. H. Lawrence Forbidden Art

Tucked safely away behind a curtain in a conference room at the La Fonda de Taos is a collection of art by artist/writer D. H. Lawrence of *Lady Chatterley's Lover* fame, which is obscured from public view. Nine sexually suggestive paintings, which were banned in England, now hang on a wall in a New Mexico hotel away from peering eyes.

Lawrence had been a controversial figure of his time, believing in sexual freedom, which went against the ideals of the early twentieth-century Victorian era in which he lived. Although some may view these artworks mild by today's standards, the paintings ran a risk of being destroyed in the artist's day. Friends with socialites and artists Mabel Dodge Luhan, Georgia O'Keeffe, Millicent Rogers, and Lady Dorothy Brett, as well as his wife, Frieda, Lawrence soon garnered the reputation about town as the "Don Juan of Taos."

Address: 108 South Plaza, Taos, New Mexico 87571. Contact details: (575) 758-2211 and www.lafondataos.com.

Cowboy Ruckus

Approximately 22.5 miles east of the tiny village of Vaughn, appears a pair of 18-foot photo-realistic billboard works of art featuring two modern-day ranchers. *Cowboy Ruckus* rises out of the stark landscape dotted with cholla cactus and sparse sagebrush to provide the traveler who has just endured 70 miles of the same view with a giggle. California artist John Cerney has graced highways across the U.S. with his talents—including an alien scene outside of Roswell, New Mexico.

Produced from the likenesses of the brothers who own the land on either side of Highway 285, the billboards, setting between mile markers 183 and 184, feature a cowboy on the right-hand side of the highway (depending on which direction you are traveling, of course), pointing an accusatory finger at the other on the left. The accused is presenting a "whatever" shrug in response.

Anyone who has lived or at the very least driven in New Mexico is aware of the amount of high winds the state can produce—these artworks are certainly made of sturdy materials to survive the strong winds by Vaughn.

Artist John Cerney created the likenesses of two double-sided wooden cowboys that appear to be arguing across Highway 285 between Roswell and Vaughn, New Mexico, relief on the long desolate highway. (*DB*)

Canyon Road, Santa Fe, New Mexico

A trip to Santa Fe would not be complete without walking the narrow street of Canyon Road. Home to art galleries, antique shops, cafes, bistros, and some of the most magnificent statuary work in the city. Everywhere you look, it is a feast for the eye. Pink hollyhocks, purple sage, yellow black-eyed Susan's planted in clay pots in front of the terra cotta, and pink and tan adobe shops will have you snapping hundreds of photographs before you travel a half a block.

I would recommend parking in one of the public lots and strolling the often-called "magical half mile" along Canyon Road to truly get the best experience. Or even better, take the free Santa Fe Pick-Up Shuttle, which runs every thirty minutes seven days a week from 10 a.m. to 5:30 p.m.; there are four stops on Canyon Road alone. Santa Fe traffic can be a bit daunting due to the narrow streets and heavy traffic, so letting someone else do the driving can be a welcomed relief.

During your walk, you will find over one hundred art galleries, boutiques, and restaurants, which offer some of the best examples of Santa Fe art and jewelry. Please know that the sidewalks are narrow and uneven so do not get too distracted by the gorgeous art and be prepared to watch where you step.

Be sure to visit KaKawa (derived from the Olmec word for chocolate or cacao, the name is pronounced ka-KA-wa) Chocolate House at the mouth of Canyon Road to experience some exotic flavor combinations that will be sure to amaze and delight—many include red chile, which is a wonderful spicy hot sweet sensation. The tradition of drinking a hot chocolate drink harkens back to the Mayan, Mesoamerican, Aztec, and pre-Columbian eras. KaKawa supports organic farms, as well as the history and anthropology of chocolate through their delightful concoctions.

Miracle Churches

El Santuario de Chimayó

One of the most sacred spots in New Mexico, Chimayó is the destination for hundreds of pilgrims who walk many miles to the tiny church from Santa Fe or even Albuquerque (90 miles away) on Good Friday to demonstrate their great faith and devotion to God. It is not unheard of to witness people carrying heavy crosses on their shoulders much like Jesus did on that day. Some walk barefoot, others even walk on their knees; it is a humbling and spiritual sight to behold. The end of their pilgrimage is the stunning and historical El Santuario de Chimayó.

There are several oral legends of how the picturesque chapel came into existence. One such account says in 1810 the landowner named Bernardo Abeyta saw a strange glow in the distance and went into the hills to investigate. When he approached, he was amazed to find the source of the glow was a hole filled with dirt, and inside the hole was a crucifix. The crucifix was taken to the village priest who took the crucifix to the Santa Cruz Church in the valley, but it would disappear three times, only to be found in the exact spot where it was originally discovered. The priest and landowner took this to be a sign and had the chapel built over the hole. This crucifix is said to also have healing powers and is still hanging at the El Santuario de Chimayo's altar.

Another version has the landowner Bernardo Abeyta tending his sheep in the hills during Holy Week when he prayed for blessings because he was sick. The shepherd said a vision of Saint Esquipula appeared beckoning him to come to him. When Abeyta knelt in the dirt at the place the saint appeared, he was cured immediately.

Being a devote believer, and one of the first members of the *Los Hermanos de la Fraternidad Piadosa de Nuestro Padre Jesus Nazareno* (The Brothers of the Pious Fraternity of Our Father Jesus the Nazarene)—otherwise known as the Penitentes—which was a strict religion group who practice self-flogging and mock crucifix as penance in honor of the flagellation and crucifixion of Jesus Christ. The group has roots in Spain and Italy and is a "secret society" in the U.S. They are also known to build small chapels called moradas for worship. The practices of the society are not condoned by the Catholic Church and unsuccessful efforts were made by Bishop Jean-Baptiste Lamy to suppress the group.

Yet another legend involves a much earlier figure, a priest from Esquipulas who traveled with the first Spaniards who settled in Chimayó. The priest was killed by Indians and buried at Chimayó, but a flood of the Santa Cruz River, which runs behind the current day Santuario, in the spring of 1810 uncovered the priest's body as well as the crucifix. The shrine was originally dedicated to the Christ of Esquipulas by Bernardo Abeyta.

The local Tewa People have been using the dirt found in the church's location for years as a curative and knew of its healing powers as well and used the mud to relieve ailments such as arthritis and even cancer. Although skeptics deny the powers of the

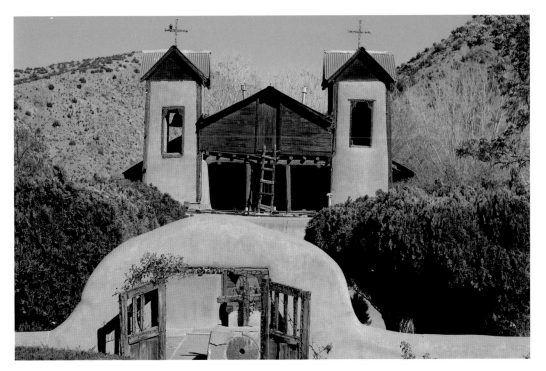

Known as the "Lourdes of the West," the sacred dirt at Chimayo has proven its healing powers time after time. (*DB*)

As with other Colonial Spanish Mission churches in New Mexico, El Santuario de Chimayo has some of its early parishioners and priests buried in the courtyard and under the floor. (*DB*)

dirt, El Santuario de Chimayó receives over 300,000 visitors each year. Lining the walls of the prayer room leading to the room where the holy dirt is held are crutches, braces, photographs, affidavits, and shoes left by those who were cured at the site. Originally, the dirt was ingested, but now believers rub on the loose dirt or make a mud to rub over the affected area—it is all a matter of preference. Rosaries and crosses are attached to nearly every possible spot along the chain-link fence leading up to the church—left as offerings from pilgrims.

Personally, the El Santuario de Chimayó gives me great peace and serenity. You can feel the holiness and reverence, with the church being far more than just a building to hold Holy Mass. A sacred presence truly exists within the adobe walls and will bring you to tears if you just stop to reflect and soak in the serene atmosphere.

Holy Week may not be the best time to visit if you do not like crowds. If you desire a more peaceful time, go during the weekdays to get a true one-on-one with this holy place. Photography is not allowed inside the Santuario or at the adjoining church, Santa Niño Chapel; however, there are plenty of photo opportunities outside to satisfy any photographer.

Directions: Off Highway 76. Address: 15 Santuario Drive, Chimayo, New Mexico 87522. Contact details: (505) 351-4360 and www.holychimayo.us.

San Francisco de Asis Church, Rancho de Taos, New Mexico
Tucked deep in the heart of Rancho de Taos, 4 miles south-west on the outskirts of the town of Taos, is one of the most photographed and painted churches in New

Mexico—San Francisco de Asis. It was a favorite subject of artist Georgia O'Keeffe and Ansel Adams, who were instrumental in introducing the world to the desert southwest. O'Keeffe described San Francisco de Asis as "one of the most beautiful buildings left in the United States by the early Spaniards." The architectural lines, buttresses, and cruciform shape provide great angles for light, and whether it is black and white or a colorized image, the church is immediately recognizable.

Built between 1772 and 1816, the pueblo-style adobe church has seen many tragedies and triumphs of New Mexico history. Spanish Franciscan friars constructed the church in honor of Saint Francis de Assisi and was used in the early period as protection for the surrounding community against attacks by the local native tribes who would raid the area. Today, it sits center stage surrounded by relics of the past as it is the only original intact church left in the Taos region and is a National Historic Landmark.

San Francisco de Asis is still an important part of the community, and each year in June, the "*enjarre*," or "mudding," of the church is taken on by the parishioners. To preserve the integrity of the historic church, a slurry of a mixture of straw, clay, sand, and water is used to resurface the exterior walls of the church. It is a community effort and many from outside Taos also participate. In the early days, the women of the village were the ones who did the mudding, but it has evolved to where everyone takes a turn. The church is said to sparkle like a jewel once the mudding is finished.

The reason the church is part of the Miracle Church category lies with a mystery painting held within the adobe walls. Painted by Henri Ault in the eighteenth century, *The Shadow of the Cross*, or as it is sometimes referred to as *The Mystery Painting*, has baffled many for years. The 8-foot-tall painting of Jesus Christ used to hang in the church itself but has now been moved to a more controlled environment. For an entrance fee of $3, you too can marvel at the sight.

In the light of day, *The Shadow of the Cross* appears to be a beautiful rendition of the image of Jesus Christ standing by Himself on the shore of the Sea of Galilee, but when the lights are turned off, several astounding events occur.

The first is a glowing image of a cross appears over His left shoulder and a halo over His head. Then the bow of a small boat also appears at the shore. One of the most startling aspects of this painting is that it appears to go from two dimensional to three dimensional, even His robes begin to flow in a breeze. I remember seeing this occur as a twelve-year-old and the experience was humbling even then. The painting is known to provoke great emotion in people viewing it, whether it be awe at the glowing images, being startled by witnessing an image change dimensions, or anger when someone cannot see what everyone else does.

Church members say there are also four other "miracles" about this painting that defy explanation. First being Christ's eyes follow all viewers; secondly, an image of the Sacred Mother appears in His robes above the right knee; thirdly, although paint is chipped all around the image of Jesus, His image is pristine; and fourth and last, His right foot always points toward viewer.

Tests have been conducted on the painting over the years to detect fluorescent paint and radiation by Los Alamos National Laboratory to see if there were any compounds that could cause the effect, to no avail. The Catholic Church is extremely careful not to call the painting a "miracle," but it does say a phenomenon not fully understood. The Church states that the while the painting is certainly a mystery, it has not healed anyone

and is not considered to be miraculous. The artist denies using special hues or effects, and none of this other works glow in this manner. *The Shadow of the Cross* was the hit of the 1904 World's Fair in St. Louis, even though the artist only saw a minimal amount of success in his art.

Mrs. Herbert Sidney Griffin, a wealthy Texas, bought the painting in 1948 for an undisclosed amount and donated it to San Francisco de Asis since she considered Taos to be her second chosen hometown. The beautiful church receives between 250,000 and 400,000 visitors each year—mainly because of the striking architecture rather than the painting, of which only 45,000 view.

Donations are greatly appreciated and needed at the gift shop, which barely supports the maintenance of the church. Repairs, especially to the over 250-year-old roof, are reaching a critical point.

Directions: travel on NM-68 South towards Albuquerque. On the left-hand side of the road past the intersection with State Road 518. There are signs, but it can be easy to miss in the traffic on the narrow two-lane road. Turn left on San Francisco Street, there will be a post office on that corner. Address: 60 St. Francis Plaza, Rancho de Taos, New Mexico 87557. Contact number: (575) 758-2754.

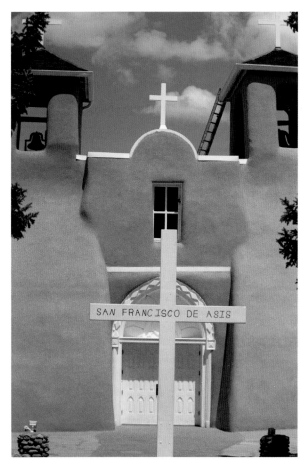

As one of the most illustrated churches in New Mexico, Rancho de Taos was a favorite subject of artist Georgia O'Keeffe. (*DB*)

Taos Pueblo

Known as the longest-inhabited pueblo in New Mexico, standing for over 1,000 years, Taos Pueblo is a shining example of the architectural mastery of the Ancient Puebloan People. Before the Spaniards arrived, the pueblo had no windows and could only be access through a hole in the roof by means of a wooden ladder. This was a means of protection from other Native tribes, which stirred up trouble in the region.

The pueblo is constructed entirely of adobe, which is mud/clay mixed with straw and water to form a brick. These bricks provide a strong building tool and allow the structure to be cool in the summer and warm in the winter. Most walls are generally up to 5 feet thick, which provides great insulation from the elements. There are approximately 150 people who still live in Taos Pueblo proper, with over 1,800 people living in the surround area. Tribal rules dictate that no electricity or running water is allowed in the Pueblo, so this is the reason many live outside the site and only use the pueblo for ceremonies.

Mica, a mineral found in the local clay, gives the pueblo a golden glisten. Due to this effect, the Spanish explorers were convinced they had found their "Cities of Gold," but unfortunately for the Spaniards, this did not pan out to be true.

As this is still an active community, it is demanded you be respectful of the inhabitants and treat the site as you would your own neighborhood. On September 30, the Annual San Geronimo Feast Day is observed, and the public is invited to join in on the festivities and feast. Due the fact this is a sacred day for the pueblo, no recording devices of any kind will be allowed; if found, they will be confiscated. An open market will be available so you can purchase some authentic Native American pottery and jewelry on site.

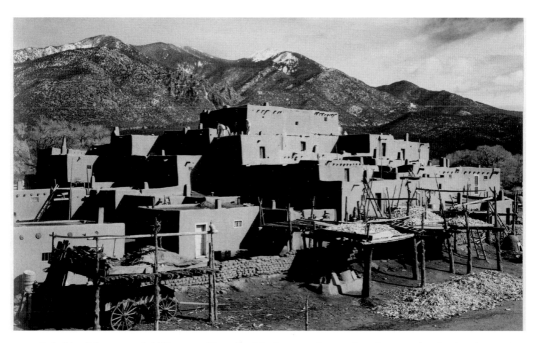

Inhabited for over 1,000 years, Taos Pueblo is a much sought-after tourist destination today. (*Library of Congress*)

The World Heritage Society recognized Taos Pueblo in 1992 as "one of the most significant historical cultural landmarks in the world." This honor was also given to the Taj Mahal, the Great Pyramids, and the Grand Canyon, so Taos Pueblo is in great company. Taos Pueblo invites you to "come, enjoy and experience the history, triumph and tradition of the Red Willow People." The Taos Pueblo is the only Native American community to be designated both a World Heritage Site and a National Historic Landmark.

Professional and commercial photography, painting, and sketching is allowed Taos Pueblo with a permit, though fees vary. Do not photograph any tribal member without permission and absolutely no photography inside the San Geronimo Chapel.

Entry rates: adult $16 per person; seniors $14 per person; students $14 per person (ages eleven and up with I.D.); groups $14 per person (groups of eight and more); children ten years old and under are free. Address: 120 Veterans Highway, Taos, New Mexico 87571. Contact details: (575) 758-1028 and www.taospueblo.com.

Unique Lodging

Express St. James Hotel

Sporting over 400 bullet holes in the ceiling of the saloon, the Express St. James Hotel, currently owned by the Express UU Bar Ranch, has been the witness to over twenty-six deaths since opening in 1872. Gunslinger Clay Allison was said to have been the source for most of the ceiling punctures. Alcohol and a temper do not mix, and it was reported Allison was usually full of liquor and angry about something most of the time. Local legend conveys the outlaw was known to dance naked on the bar when he was fully into his drink. The talk of the town on Monday mornings was who got shot over the weekend at the St. James.

Since being built by Henri and Mary Lambert in 1872, the Express St. James Hotel has played host to numerous celebrity guests. William F. "Buffalo Bill" Cody, Annie Oakley, Frederick Remington, Bat Masterson, Jesse James, Wyatt Earp, Doc Holliday, Lew Wallace, Zane Grey and Waite Phillips all have rooms named after them. A treasured landmark on the Santa Fe Trail, the Express St. James has been in business in one capacity or the other for 140 years.

Before moving west, Henri Lambert was employed as President Lincoln's personal chef. After Lincoln's assassination, Lambert moved to the New Mexico Territory and opened a saloon and restaurant in Elizabethtown. The main draw to Elizabethtown was gold, but Henri (later changed to Henry) only found gold in his business.

The Lambert's moved to Cimarron in 1872 and opened Lambert's Inn, which is now the Express St. James. Cimarron did a booming business as a stop on the Santa Fe Trail, but when the railroad became the desired means of transportation, the town and Inn fell into disrepair. The Express St. James would be passed down from family member to family member with a varying degree of success. In 1985, the Express St. James was restored to its former glory and looks much the same today.

The Express St. James not only play host to hundreds of living guests over the years of its operation, but also now home to several none paying guests. Thought to be one of the most haunted hotels in New Mexico, the Express St. James caters to the needs of all its guests. The most famous ghost in residence is that of Thomas James Wright, known as "T. J." by the hotel staff.

T. J. was a gambler and a frequent player at the tables in the St. James saloon. After many years of playing high-stakes poker without too much success, T. J.'s luck changed, and he won the rights to the hotel. As he returned to Room 18 that night, he was shot from behind and bled to death in the room. Wright is said to be an angry spirit who does not like to be disturbed. His room is not rented out due to strange things happening and guests reporting being shoved or hurt in some manner.

I was honored to be allowed in Room 18 to take photographs for my book *Haunted Hotels and Ghostly Getaways of New Mexico*. The kind staff member was extremely respectful asking permission of T. J. to enter the small room, which contained a single bed, rocking chair, dresser, and a few mementos, such as cigars, cigarettes, whiskey bottles, and playing cards, left from previous visitors. During the tour, I felt I had invaded T. J.'s private space, so I left him a shot of whiskey on the transom window to his room as a thank you. I was awoken at 3 a.m. to the smell of cigar smoke (smoking is not allowed in the hotel) and the sounds of pacing in the hall. The next morning, the shot glass was empty. This, of course, proves nothing, but it sure makes for a great story.

If you must have a television or radio in your room, the historic hotel of the Express St. James is not for you, the Annex will be more to your liking. The hotel prides itself in giving their guests a break from the everyday stresses and provides a relaxing atmosphere. Live music is commonplace on the outdoor patio, complete with fountain and colorful murals. There, you can enjoy a favorite beverage and dine on the famous

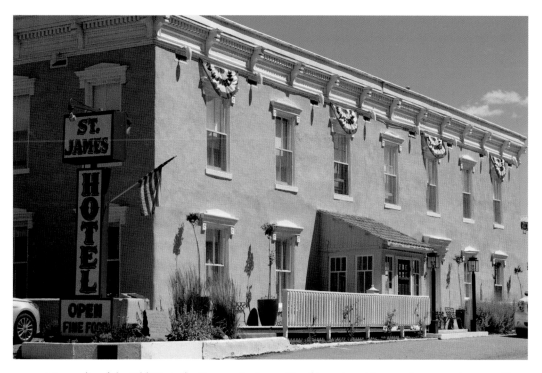

A true relic of the Old West, the Express St. James Hotel has played host to famous artists, gamblers, authors, and outlaws. (*DB*)

food served at the Express St. James restaurant. Do not be surprised if you see large groups of Boy Scouts during the summer months—Philmont Ranch is only a few miles up the road and the St. James is the only game in town.

Address: 617 S. Collison Avenue, Cimarron, New Mexico 87714. Contact details: (575) 376-2664 and www.exstjames.com.

The Eklund Historic Hotel and Restaurant

This quaint, three-story historical hotel made from quarried stone is a step back into the past. The original structure, built in 1892, now serves as the Eklund Hotel Saloon and once had a storied past as a saloon and dancehall. For over 100 years, the Eklund has been Clayton, New Mexico's premier boutique hotel and is determined to provide the traveler with the Wild West experience.

Within 2 miles of the grave of train robber Tom "Black-Jack" Ketchum, the Eklund was in the thick of things during the Old West days. Owned by Carl Eklund in the 1890s, the saloon of the historic hotel still features an ornately carved back bar, which the owner was reported to have won in a poker game for $10 he had borrowed, is still in use today. Originally a two-story building, the Eklund was used as a store with rooms for rent above. The third floor, or opera porch, was added in 1905.

As with most of the historic hotels in New Mexico, the Eklund is rumored to be haunted—but no worries, they are reported to be friendly. The onsite restaurant features many delectable New Mexican dishes that will certainly delight any palette. The historic Eklund Hotel is pet friendly, wheelchair accessible, and is close to many of the attractions that the town of Clayton, New Mexico, has to offer.

Address: 15 Main Street, Clayton, New Mexico 88415. Contact details: (575) 374-2551 and www.hoteleklund.com.

Historic Taos Inn

Located in the heart of the village of Taos, New Mexico, the Historic Taos Inn was once a private residence. Today, this gorgeous adobe structure is the gathering spot for locals, tourists, and celebrities alike. Once the home and office of the only doctor in northern New Mexico, Doc Martin, to say the Inn is historic is almost redundant. Considered to contain "Taos' most charming guest rooms" the Historic Taos Inn is the center or heart of the Taos community. The Adobe Bar is known to attract celebrities and is the best place to be seen and enjoy an award-winning Adobe Bar Margarita while listening to live music.

Originally comprised of several adobe homes dating back to the early 1800s, the Historic Taos Inn is built around a plaza and central well, which now serves as a fountain. The Taos Society of Artists was started on premise, thus beginning a rich traditional of art in Taos. The Historic Taos Inn has the honor of being placed on both the National and State Registers of Historical Places since 1982. If you want to experience true New Mexico living, this Inn will give you that and more. Kiva fireplaces are available in some rooms, as well as authentic viga and latilla ceilings and southwest décor providing the guest with Old World charm.

Address: 125 Paseo del Pueblo Norte, Taos, New Mexico 87571. Contact details: (575) 758-2233 and www.taosinn.com.

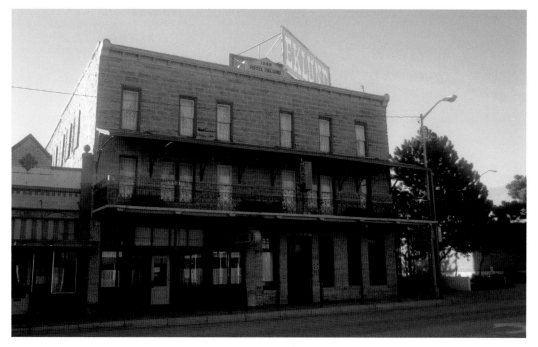

One of the most historical buildings in Clayton houses the Eklund Hotel. (*Author's collection*)

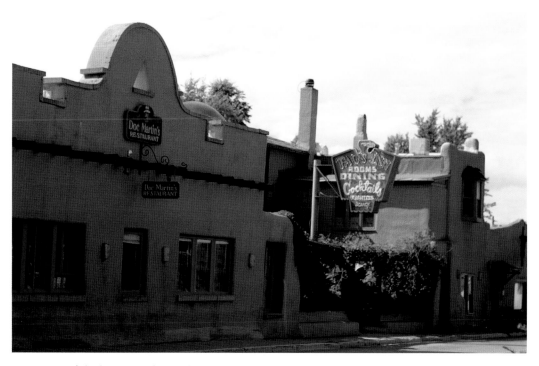

One of the best "people watching spots" in Taos is at the Historic Taos Inn. (*DB*)

Historic Plaza Hotel

Proudly standing as the anchor of the Las Vegas Plaza, the Plaza Hotel is a true historical throw-back to a time gone by. Known as the "Belle of the Southwest," the Plaza Hotel was built in 1882 by Byron T. Mills and is strategically located on the Old Town Plaza, which is also on the Santa Fe Trail. Las Vegas was the hub of trade until the late 1800s and the Plaza Hotel played a large role in providing travelers with accommodations.

This majestic Victorian Italianate building boosts 14-foot ceilings and looks much the same today as it did in the 1880s and was the finest hotel in the New Mexico Territory. A host of well-known characters have stayed within its walls. The infamous Doc Holliday with his lady love, Mary Katherine Horony-Cummings, or better known as Big Nose Kate, stayed at the Plaza Hotel while they were establishing a dental office and saloon. In recent times, the Plaza Hotel has been a movie star in movies such as *No Country for Old Men*, *Easy Rider*, the old silent movies of Tom Mix, and television series *Longmire* were all filmed at the hotel. The stars of these shows stayed at the stately hotel during the filming.

Today, the Plaza Hotel is a sight to behold, but it was not always the case. Owner Byron T. Mills came up on hard times, eventually having to sell his beloved building, but not before it was beginning to show its age. It is said that Mr. Mills had so much regret over how he had treated the hotel, when he died, he still haunts the third floor today. Hotel clerks, staff, and visitors have relayed many a spine-tingling tale of their encounters with the ghostly former owner.

Address: 230 Plaza Street, Las Vegas, NM 87701. Contact details: (505) 425-3591 and www.plazahotellvnm.com.

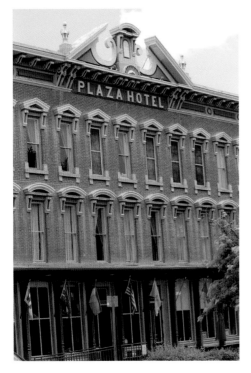

On the historic plaza in Las Vegas, New Mexico, the Plaza Hotel is a great hang-out for tourists, writers, actors, and ghosts. (*DB*)

4

SANTA FE

Historical Background

The oldest capital city in the U.S., established in 1610, is often called the "City Different" by those who reside in the high desert town. Many cultures meld in the shadow of the Sangre de Cristo (Blood of Christ) Mountains to form a completely unique city. First settled by the Tewa Indians who resided in pueblos, Santa Fe was but a few dwellings and farms, but when the Spaniards arrived in the region the population exploded—and so did the troubles.

Atomic Age & Scientific Spots: 109 E. Palace Avenue

This famous address in Santa Fe played an important role in the nuclear industry of New Mexico in the 1940s—as the cover office for Los Alamos Laboratory workers to report to for briefings. These same workers were assigned the extremely sensitive "Manhattan Project," which produced the first atomic bomb. Originally built as a hacienda in the 1600s the address is directly off the Plaza in a prime location.

Recruits would be brought from the train station in Lamy, New Mexico, to Santa Fe without being told their location, to be shuttled up "the Hill" to Los Alamos on the Pajarito Plateau some 35 miles away.

A plaque on the outside of the adobe structure reads:

All the men and women who made the first atomic bomb passed through this portal to their secret mission at Los Alamos. Their creation in 27 months of the weapons that ended World War II was one of the greatest scientific achievements of all time.

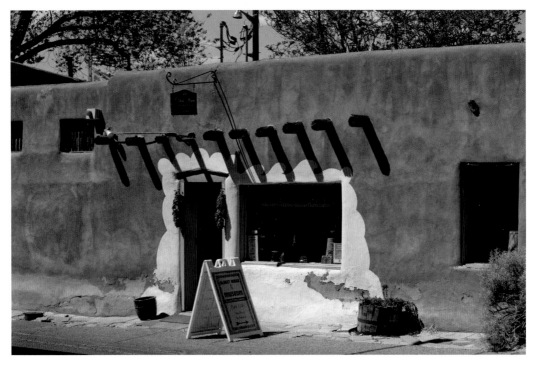

The DeVargas Street house in Santa Fe is the oldest house in America. (*DB*)

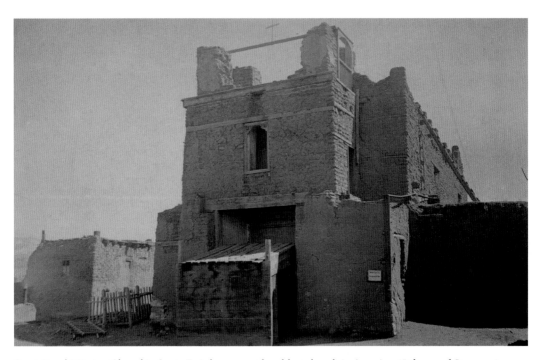

San Miguel Mission Chapel in Santa Fe is known as the oldest church in America. (*Library of Congress*)

In a Category All Its Own: Meow Wolf's House of Eternal Return

It is incredibly hard to describe the Meow Wolf to someone who has not experienced the unique, fascinating, confusing, and bewildering attraction for themselves. After starting humbly in 2008 as a less than well-received art collective, the Meow Wolf has transformed itself into the most shared spot in New Mexico on social media. You will immediately be drawn to the former bowling alley, which was purchased by *Game of Thrones'* author and Santa Fe resident George R. R. Martin in 2016, by the 30-foot flower-smelling Robot, created by artist, Christian Ristow for the Burning Man Festival. The Robot and his trusty sidekick, Spider are on permanent display in front of the Meow Wolf's unassuming building and give a hint as to the journey you will have inside.

Enticed by the story and concept of the art collective's dream, author George R. R. Martin invested $3.5 million to make this dream a reality. Up to this point, the original ten artists who lived on premises, were not paid for their work, and were coming to the end of the rope, thus the birth of the Meow Wolf's House of Eternal Return.

A full-sized Victorian mansion was built inside the empty bowling alley, accessible by portals in everyday items such as refrigerators and washing machines. Once in the bowels of the magical world, you are transported into a crazy, interactive, weird dimensional art experience, which challenges your mind, as well as tricks your eyes. Be prepared to be amazed.

Over-the-top eclectic, the Meow Wolf has cemented itself as one of New Mexico's most unique destinations. (*DB*)

Now, with 300 people in their employee, the once broke artists, who now number 100, had over 400,000 visitors the first year of their adventure. In addition to the art experience, a mystery is also afoot in the mansion which can be solved via clues the newly developed, Anomaly Tracker app. With 20,000 square feet of space, the facility is a marvel for all who visit.

Directions: located one block off Cerrillos Road in Santa Fe, behind the Tortilla Flats Restaurant. Address: 1352 Rufina Circle, Santa Fe, New Mexico 87507. Contact number: (505) 395-6369.

Miracle Churches

Loretto Chapel

Home to a magnificent wooden spiral staircase that many believe was constructed by none other than St. Joseph, the grey French Gothic chapel of Loretto, which mirrors some of the same architectural features as the famed Norte Dame, rises up in the heart of Santa Fe and draws thousands of visitors each year to view a miracle. A stark contrast to the pueblo-style architectures that surrounds it, Loretto Chapel pays tribute to the early clergy, which developed the Catholic religion in New Mexico; the most famous of those is Bishop Jean-Baptiste Lamy who had St. Francis Cathedral built in the Gothic style as well.

Bishop Lamy saw a need for the education of girls in the New Mexico Territory and sent pleas out to the diocese of the church to which the Sisters of Loretto replied favorably. After a long and treacherous trip from France to the New Mexico Territory, during which their Mother Superior died, the nuns established the Loretto Academy.

When the chapel was built, a choir loft was incorporated into the design, but there was no means of getting to the loft since Antoine Mouly, the renowned French architect died before completing the staircase. The Sisters of Loretto prayed a nine-day novena to Saint Joseph, the patron saint of carpenters, to have their problem solved since the church budget was very tight and there was no money to pay a craftsman to create the needed staircase. In 1878, their prayers were answered when a mystery man showed up at the Chapel door with his woodworking tools strapped to a donkey.

In the course of four years, a gorgeous staircase, complete with two 360-degree turns, no visible means of support was created using wooden pegs instead of the traditional nails, the nuns were finally then able to access the choir loft. The staircase was built with a natural spring-like action when it was accessed and the entire weight of the masterpiece rests on the bottom stair. Modern supports added much later were intended to protect the staircase from the vibrations of the passing traffic, but they did the opposite and did damage to the integrity. Due to the steep 22-foot ascent of the staircase, a railing was later added to ensure the safety of the nuns.

As soon as the job was completed, the mystery man disappeared into the night without asking for pay. The similarities between Saint Joseph and this skilled carpenter were too many to ignore, thus the legend began. To add to the mystery, it was found the wood used for the staircase was not native to the American Southwest and the Sisters could not find an account at a local lumber store for the mystery man or the wood he used. Studies conducted on the staircase have not been successful in determining exactly how it was constructed.

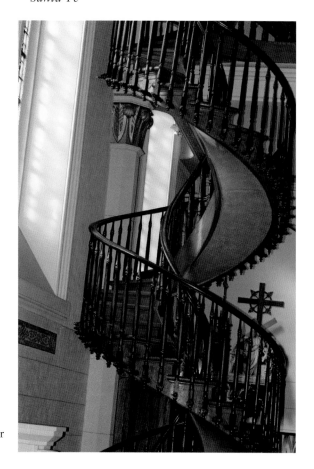

Saint Joseph is thought to have built this miraculous staircase after the nuns completed a series of novenas for Devine intervention. (*DB*)

Today, Loretto Chapel is a highly trafficked tourist attraction in the center of Santa Fe and a favorite venue for weddings since it is not only beautiful, but non-denominational.

Address: 207 Old Santa Fe Trail, Santa Fe, New Mexico 87501. Contact number: (505) 982-0092.

Saint Francis Cathedral

Also known as Cathedral Basilica of Saint Francis of Assisi, Saint Francis Cathedral is the cornerstone of Santa Fe. The looming Romanesque Revival-style church, which bears a striking resemblance to Norte Dame in France, was built by Archbishop Jean-Baptiste Lamy between 1869 and 1886 on the site of a church destroyed during the Pueblo Revolt of 1680.

Stained-glass windows, including a large rose window, adorn the walls of the basilica. The cathedral is home to many stunning works of art and architecture, including a set of bronze doors at the entrance, which contain sixteen carved panels created by artist Donna Quasthoff. A small wooden retablo featuring the image of Mother Mary, entitled "Our Lady of Peace" is tucked into a niche within the church wall and is said to be "the oldest representation of the Madonna in the United States."

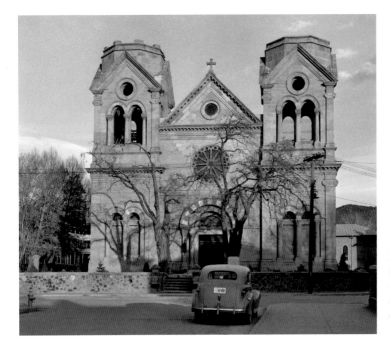

In the heart of
Santa Fe, St Francis
Cathedral is one
of Santa Fe's most
cherished landmarks.
(*Library of Congress*)

A statue in honor of Archbishop Lamy is proudly displayed outside as well as a representation of Saint Kateri, the first North American Indian to be beatified in 2012. Saint Francis Cathedral remains as the premiere landmark in Santa Fe.

Address: 131 Cathedral Place, Santa Fe, New Mexico 87501. Contact number: (505) 982-5619.

Cultural Heritage: El Rancho de las Golondrinas

History is alive and well at El Rancho de las Golondrinas (The Ranch of the Swallows) just outside of Santa Fe. A recreation of a Spanish colonial village, El Rancho de las Golondrinas is much like the Williamsburg of New Mexico. A historic ranch located on the El Camino Real (The Royal Road), which brought settlers and trade from Mexico City to Santa Fe, New Mexico. Developed by owners, Leonora and Y. A. Paloheimo, who dedicated their lives into making the ranch into a learning center by restoring existing structures and adding structures in the Spanish colonial style. When the living museum opened its doors in 1972, it quickly became the largest promoter of the Hispanic heritage in Northern New Mexico.

An army of over 300 volunteers help to bring El Rancho de las Golondrinas to life. Dressing in period clothing, giving tours and demonstrations, and providing hands-on experiences in weaving, embroidery, as well as traditional bread-making in the hornos on site.

Many festivals dot the calendar for the ranch, including a Renaissance Faire and Wine Festivals being a couple of the crowd favorites. Events are year-round in the peaceful, historic setting. The site is also available as a picturesque venue for weddings,

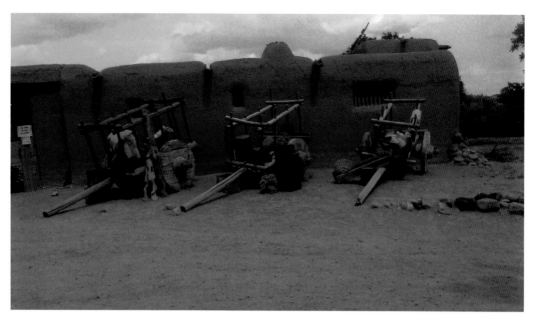

Rancho de las Golondrinas, Ranch of the Swallows, is a living history museum near Santa Fe. (*DB*)

photography classes, and has also been seen on the big screen in the movie *Godless*. Open June 1 through October 6, the ranch can be seen in a couple of different ways. One being a self-guided tour, which will cost adults $6 or, with advance notice, a docent guided tour. Hours and days of operation are varied, so call ahead or check the website before making the trip.

Please note weapons, alcohol, and tobacco are not allowed on the premises, so please be respectful of their wishes. Food and drinks are available in the food service area on the weekends only. Website: www.golondrinas.org.

Natural Formations: Camel Rock Monument

Rising off the desert floor between Albuquerque and Santa Fe in the town of Tesuque, directly off Interstate 25, sits a sandstone rock formation that bears a striking resemblance to a resting camel, thus the name. Recently, however, due to the ravages of time and the elements, a section of the camel's nose fell off in 2017, but it still holds the resemblance to a resting camel. Standing 40 feet tall and 100 feet long, the pinkish-tan sandstone Camel Rock has picnic tables and a small parking lot. In nearby Tesuque, you can try your hand at the gaming tables at the Camel Rock Casino. Both Camel Rock Monument and Casino can be seen from Highway 84.

Address: 17500 W. Frontage Road, Santa Fe, New Mexico 87507. Directions: exit 175 off Highway 84 and Camel Rock Road.

Outdoor Adventures

Santa Fe Ski Basin

On the road to the Santa Fe Ski Basin, you will encounter Hyde Memorial State Park; you do not have to pay the entrance fee to go to the ski resort at the top of the mountain. Only minutes from the City Different, Ski Santa Fe gives visitors the full experience. You will be at 10,350 feet above sea level when you reach the top, where you will find full ski rentals available, as well as top-notch restaurants, coffee bar, food court, and retail shop at your disposal. Ski Santa Fe offers instruction for every level of skier.

Directions: at the end of State Road 475 (Hyde Park Road). Address: Santa Fe, New Mexico 87504. Reservation can be made at (505) 982-4429 or www.skinewmexico.com.

Hyde Memorial State Park

The narrow winding two-lane road, which snakes up the Sangre de Cristo (Blood of Christ) mountainside to New Mexico's first state park, will provide you with awe-inspiring views of the town capital city below as well as thousands of aspens that turn bright yellow in the fall and tall pine trees. The Little Tesuque Creek flows along the same path as the road and peeks out occasionally for photo opportunities. Please be cautious along this route as you will encounter bicyclists making the trek up or down the mountain. There are several bump-out areas along the road to pull off to take pictures or let traffic pass.

A large historic lodge in Hyde Park is the perfect venue for weddings, reunions, and other gatherings as it holds over 300 people and is available from May 1 through October 15. Another unique feature offered in the state park is the availability of rental yurts. These are considerably basic and be prepared to provide all your provisions—drinking water (since there is no running water inside the structure) and bed coverings. Animals are not allowed inside the yurts and must be leashed or tethered outside. Camping is also permitted in the park, which provides fifty developed campsites for your enjoyment.

Multiple hiking routes provide over 4 miles of high elevation trails around the historic lodge area. If you park in this area, you must pay the day use fee and display your ticket on the dashboard of your vehicle. Passes can be purchased at a self-pay station.

Address: 740 Hyde Park Road, Santa Fe, New Mexico 87501. The Visitor Center, perched at nearly 9,000 feet elevation, provides Wi-Fi signals, and can be reached at (505) 983-7175.

Unique Lodging

Nearly every historical hotel in Santa Fe could be classified as a unique lodging experience, but a couple make the cut as standouts.

La Fonda on the Plaza

As the only hotel located on the historic Santa Fe Plaza, La Fonda on the Plaza has a distinct honor of sitting on the site of the first inn built in Santa Fe in 1607 making it the oldest hotel corner in America. Originally a stop at the end of the Santa Fe Trail, the La Fonda was also part of the Harvey House enterprise and is now a proud member of the Historic Hotels of America.

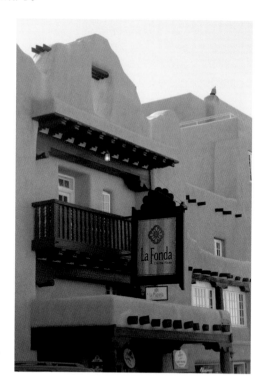

The La Fonda on the Plaza Hotel is one of the oldest hotels in the country. (*DB*)

Today, the La Fonda is a multitude of different delights under one flat adobe roof. You will find first class accommodations and five-star restaurants as well as bakeries, coffee shops, swimming pool, spa, art galleries, clothing, and jewelry shops, and two bars at your disposal. One of the secrets of the locals is watching a magnificent New Mexico sunset from the Bell Tower Rooftop lounge while enjoying your favorite beverage and appetizers.

The La Fonda's architecture is stunning as it features 25-foot ceilings, hand-carved beams, stained-glass skylights, terra cotta tile, and hammered tin chandeliers—it truly personifies Santa Fe style. When visiting the City Different, the La Fonda on the Plaza is a must-see experience.

Address: 101 E. San Francisco Street, Santa Fe, New Mexico 87501. Contact number: (505) 982-5511.

Unique Annual Events: Burning of Old Man Gloom

Old Man Gloom, otherwise called Zozobra, is a menacing sight as he stands glaring down at the crowd from fifty feet above. A huge frown covers Zozobra's face, and dressed in a long white gown, this evil lord of mayhem is one of the most hated figures in Santa Fe. Zozobra is a mythical character who is said to relish in bringing gloom to the City Different, is part of the Fiestas de Santa Fe, and Old Man Gloom must pay for his many offenses. This event is brought to Santa Fe each year by the Kiwanis Club, who in the beginning would dress up in black robes and dance around the feet of the puppet.

Zozobra was first introduced to the Fiesta de Santa Fe in 1924 when artist Will Shuster made his first Old Man Gloom, who was only 20 feet tall at that time. The artist fashioned the puppet after a Holy Week celebration held by the Yaqui Indians in Mexico. Originally, Shuster made the puppet only for the group of artists and writers who celebrated the Fiesta at the artist's private home, but a proposal to city officials to include the burning of Zozobra in the annual events was accepted.

A "gloom box" filled with written papers of people's troubles, anxieties, ill-wishes, police reports, bad luck, and even legal papers is placed at the feet of the giant marionette so that all the gloom experienced by the residents will be taken away as Zozobra burns after being stuffed with these papers.

Hundreds of people gather in Fort Marcy Park to watch what can only be described as a bizarre event. Standing facing the crowd all day, Zozobra awaits his doom in silence. As darkness falls on the field, all the lights are completely turned off and the Zozobra Orchestra begins an eerie funeral song. Zozobra, one of the largest marionettes in the world, begins to look around, shaking his head at the crowd. An amazing fact is the effigy takes three weeks with over 3,500 volunteer hours to construct and a day to move and set up.

The Gloomies, who are followers of Zozobra, take the stage to free Old Man Gloom, but they fail. Zozobra becomes incensed, waving his arms around wildly and groaning, sensing his fate. The Fire Dancer, dressed in red and gold, is the mortal enemy of Zozobra and begins to taunt him mercilessly. During this taunting, the Fire Dancer sets Zozobra's gown aflame.

Constructed from milled lumber, 70 yards of muslin, and dozens of rolls of chicken wire, Zozobra is filled with explosives. Fireworks explode behind and from the arms of the marionette as he is consumed by the fire. Crowd chants of "burn him" arise and cumulate with a loud cheer when Zozobra is finally gone.

The citizens of Santa Fe gather to release gloom and bad wishes of the year by burning the marionette Zozobra. (*Author's collection*)

5

SOUTHWESTERN NEW MEXICO REGION

Rugged and mountainous, maintaining the feel of the Old West, the southwestern region of New Mexico harkens back to a wilder time in the state's history. The stomping grounds of Billy the Kid during his youth, the site of numerous Indian attacks, frontier forts, amazing women, and huge mining projects, the southwestern part of New Mexico has seen it all.

Historical Background

Hillsboro, New Mexico
Home to Madam Sadie Jane Creech Orchard, "Lady Godiva of the West" in her later years, Hillsboro was also base camp for the many silver, gold, and copper miners who were working in the mountainous region founded in 1877. Ruins of adobe houses and the courthouse are scattered throughout the town mixed in with art galleries, cafes, antique shops, a winery, and the Black Range Museum, which was once the Orchard Grove Hotel owned by Sadie Orchard.

A sensational murder trial occurred in Hillsboro in 1896 in the case of the deaths of Judge Albert Jennings Fountain and his eight-year-old son, Henry. Judge Fountain had just entered an indictment against cattleman Oliver Lee in Lincoln County and was on his way home when the two were killed. Oliver Lee was arrested and charged with the crime, although there were no bodies as proof. It is said that the two-year trail delayed New Mexico from statehood since the trial was being followed in the east and New Mexico was deemed to be still too uncivilized to join the Union.

When the county seat was taken from Hillsboro and given to Hot Springs (now Truth or Consequences), the beautiful two-story brick courthouse, which was perched high on the hillside overlooking the town, was torn down brick by brick until there was nearly nothing left. It is said most of the homes in Hillsboro and Kingston have at least one brick from this structure and salvaged bricks were also used to build the new courthouse in Hot Springs.

The people of Hillsboro come from all walks of life, but all enjoy the relaxed atmosphere and true sense of community that surrounds them. Located on Highway 152

Ruins of the once beautiful courthouse loom over the village of Hillsboro. (*DB*)

approximately 30 miles from Truth or Consequences. As you travel the narrow highway, be on the lookout for free range cows and wildlife on or beside the road.

Kingston, New Mexico

Founded in 1882 with the establishment of the Solitaire Mine, the village of Kingston was said to have been the largest city in New Mexico during the silver mining boom of 1890. Veins of silver radiated through the surrounding mountains, drawing miners, prospectors, outlaws, gamblers, and shady ladies to the town to profit from the find. At the height of the boom, Kingston's population ballooned to nearly 7,000 people, a far cry from the population of thirty-two artistic souls today who reside in this living ghost town.

The lure of a fortune in silver brought in celebrities of the era to town such as Butch Cassidy and the Sundance Kid, Tom "Black-Jack" Ketchum, and Madam Sadie Orchard, all of whom gave a great deal of flavor to the growing town. With twenty-two saloons squeezed into the approximately one-mile length of street, Kingston was a wild and wooly place. Supporting the patrons of the saloons were fourteen grocery stores, three large hotels, and several boarding houses.

Sadie Orchard was a character who personified the Old West madam. She was rough, could cuss like a sailor, outshoot any man in town at one moment, and come across as a refined English rose the next. Gutsy as they come, Sadie opened her brothel on Virtue Street in Kingston—probably as a play on words more than anything else. When Sadie first arrived in Kingston, she played the part of a lady from England, complete with Cockney accent, who was traveling with her "sisters." The ladies set up shop and fast became the life of the village. It was later discovered Sadie was from Iowa and had an English neighbor she loved to visit, therefore picking up on the accent and mannerisms.

A silver and gold mine boom town in the late 1880s, Kingston is still in operation today. (*DB*)

The adage of "hooker with a heart of gold" rang true with Sadie who always took care of her clients and community. When it came to Sadie's attention that the town was lacking a church, she and her girls passed the hat at the saloon. The money for the church was quickly raised by the gifts of gold and silver nuggets from the miners, gold coins from the gamblers, even Sadie and her girls donated numerous diamonds and other jewels to the cause. The church stood for many years until Kingston's silver started to play out and residents began to "borrow" the building materials from the church for their own homes.

Although many of the original buildings are now mere ruins, there are a few of the more spectacular structures still standing. The Percha Bank—constructed of local stone and the only intact building of the silver boom era, serving now as a museum—is opened on special occasions for the public.

Magdalena, New Mexico

Between Socorro and the Very Large Array is a small quaint artist community of Magdalena, New Mexico. Once a mining town, Magdalena is now home to art galleries, rock shops, and saloons. The Magdalena Mountains are part of the Cibola National Forest and contain the Magdalena Fault. The town derived its name from the "Lady on the Mountain" formation on Magdalena Peak, which looked like a woman's profile to the early Spanish explorers. This formation reminded them of the "La Sierra de Maria Magdalena" peak in Spain.

Founded in 1884, Magdalena was known as the "Trails End" of a railroad spur, which ran from Socorro to Magdalena that was used to transport lumber, cattle, and mining ore. Ranching is a big industry in the area, which now includes the raising of

llamas. Huge cattle drives occurred in the fall, with cowboys driving their herds to the railyards in Magdalena for shipment to the east.

When you go to the tiny village, it is hard to imagine that you are only one and half hours from the metropolis of Albuquerque. The laid-back atmosphere is contagious and will have you wishing for the quiet life.

Mesilla, New Mexico

In the 1870s and 1880s, the tiny village of Mesilla, New Mexico, was the largest town between San Antonio, Texas, and San Diego, California. Being on the El Camino Real (The Royal Road), Mesilla was a trading hub between Chihuahua, Mexico, and Santa Fe, New Mexico. Being under Mexican rule until the Gadsden Purchase of 1854, which was signed in the courtyard of what is now the Double Eagle Restaurant, Mesilla was also the center of many border disputes between the U.S. and Mexico, until the U.S. raised their flag over the Plaza of Mesilla on November 16, 1854.

During the Civil War, Confederate Colonel John Baylor claimed Mesilla as the capital of the Confederate Territory of Arizona. At this time, the map of New Mexico and Arizona appeared much different from what we see today. New Mexico and Arizona were divided into two halves, which stretched from California to Texas. The bottom half was Arizona and the top half New Mexico.

The Confederate plan was to march up the Rio Grande, invade Union forts along the way, take Santa Fe, and eventually take over the gold and silver mines of Colorado. This plan led to many Civil War battles being fought in New Mexico, but ultimately, the Union Army was victorious. The Confederate Army retreated to Texas and the Civil War ended shortly afterward.

Mesilla played host to many notables in her day, including William H. Bonney, alias Billy the Kid, who spent time in jail there awaiting execution by hanging in 1881 and was declared a state monument in 1957 due to the historical significance it played in New Mexico and the country. This jail building still stands at the east corner of the Plaza and houses a curio shop. The historical district of which Mesilla is famous was declared in February of 1985.

Billy the Kid Gift Shop: The small pink adobe building at the southeast corner of the Plaza was once the courthouse and jail for Mesilla. Within the 18-inch-thick adobe walls, the outlaw for which the building is now named languished awaiting to be executed after being arrested for the murder of Sheriff William Brady of Lincoln, New Mexico, during the Lincoln County War. The Kid stood accused for a crime of which witnesses stated could have been committed by any one of the men present. The sheriff was ambushed and shot by as many as six different weapons, but the Kid was the only one charged and convicted. The building predates the Civil War and is of typical southwest design and structure, complete with vigas and latillas ceilings; it started life as a general store until it was acquired by Doña Ana County for the courthouse/jail. The outlaw was transferred after his conviction to the Lincoln County Courthouse where he would escape, kill his two captors, and later be killed himself in Fort Sumner, New Mexico, by Sheriff Pat Garrett.

Basilica of San Albino: In the historical district of Mesilla, New Mexico, which radiates out from the central Plaza, you will find the Basilica of San Albino, an adobe church at the north end, which was built in 1855 to replace the primitive church that

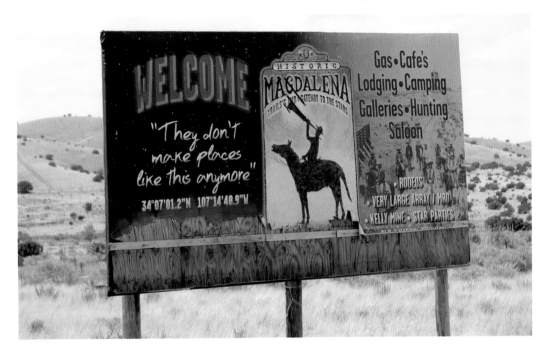

Above: Magdalena is an artist community between Socorro and the Very Large Array. (*DB*)

Right: The historical jail once held the Billy the Kid while he awaited trail, now a gift shop. (*DB*)

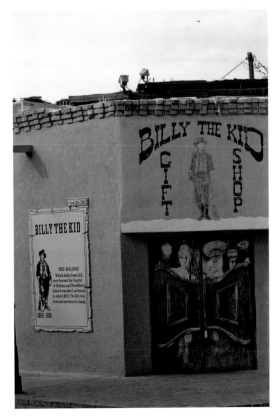

had been built on the south end in 1852; it serves as the anchor of Mesilla today. It is one of the oldest mission churches in the Mesilla Valley and was established by the order of the Mexican government but was transferred to the New Mexico diocese run by Bishop Jean-Baptiste Lamy after the Gadsden Purchase in 1854. Bishop Lamy was not a fan of adobe structures, so the churches he oversaw were built with a French-European influence constructed of fired brick.

Socorro, New Mexico

Established by Spanish settlers in 1598 during the Spanish Entrada, Socorro was one of the earliest settlements in New Mexico. These settlements overtook the original Piro-speaking Teypana Pueblo in the area. Franciscan friars who traveled with Spanish Conquistador Don Juan de Oñate built the San Miguel mission church at the pueblo with the often-unwilling help of the local Indigenous People. After the Pueblo Revolt of 1680 where many of the Spanish settlers were killed or driven from the region, the church remained derelict until the area was resettled in 1815 and the old structure was used as the base for the present-day church.

After silver and lead were discovered in the nearby Magdalena Mountains, Socorro boomed, attracting ruffians and other unsavory characters to her door. During the Civil War era, Socorro also played host to the soldiers stationed at Fort Craig who would

Above left: Silver was so plentiful in the mountains surrounding Socorro that the communion railing at San Miguel Mission church was said to have been solid silver. (*Library of Congress*)

Above right: Socorro, New Mexico's Wheel of History was created in 1998 by artists Claudia de Monte and Ed McGowin. (*DB*)

118

come to the town to let off some steam—this posed its own problems with the soldiers being AWOL or outright deserters.

Truth or Consequences, New Mexico

What kind of name is Truth or Consequences for a town in the middle of the New Mexico desert? Glad you asked. Originally dubbed Hot Springs, New Mexico, in honor of the ancient hot mineral springs in the town, T or C (as it is referred to today) became part of a huge marketing scheme for the 1940s radio show featuring Ralph Emerson, *Truth or Consequences.*

To celebrate the tenth anniversary of the radio show, it was suggested to get a town in America who would be willing to change its name to Truth or Consequences. After an exhaustive search, Hot Springs, New Mexico, was chosen mainly because of the town's reputation for friendliness and processing a desire to help others as well as being the gateway to Elephant Butte Dam. If you want to sit back and enjoy the quiet, yet a bit quirky town, you can do so at one of the many hot spring spas in town, with Riverbend Hot Springs being the most widely known.

Ghost Towns & Frontier Forts

Chloride, New Mexico

One of New Mexico's most interesting ghost towns. Due to the discovery of silver, Chloride became a boom town and was known to have nine saloons, a restaurant, a Chinese laundry, a pharmacy, candy store, millinery, butcher shop, general store, photography studio, a brothel, justice of the peace, bank, and two hotels.

Before all this, there was just a canyon where Army freighter Harry Pye found his Mother Load—which would later be referred to as the "Pye Load" after hiding out in the canyon to avoid Apache raiders. Pye did not immediately inform anyone of his discovery, instead, he finished out his two-year contract with the Army and found two partners to help him mine.

Unfortunately, Pye would not live long after discovering his silver cache, because of a jammed revolver; the three men met their demise at the hands of the Apache who were raiding the area in 1879. By 1880, a tent city filled the entire canyon with miners and prospectors who had heard about the metal lurking in the hills. The first mining town was named Pyetown in Harry's honor, but would be changed to Bromide and eventually Chloride.

When the silver played out and the price of silver bottomed out, Chloride was abandoned and left derelict in 1923 and remained so for seven decades. In 1989, Don Edmund took a wrong turn and ended up traveling down Wall Street in Chloride, becoming completely enthralled by the history behind the tiny town. There are twenty-seven restored buildings in Chloride, including the Pioneer Store Museum, which was closed, boarded up in 1923, lock, stock, and barrel. When it was purchased in 1989, everything remained in the store, so it was turned into a museum.

In the center of town stands a reported 200-year-old Live Oak tree, which was referred to by the locals as "the Hanging Tree." Although no hangings occurred at the tree, locals say that when the cowboys came into town, got drunk, they would be dunked in a stock tank and chained to the tree until they got their senses back.

Today, Chloride is open seven days a week and there are approximately twenty residents. You will find a museum, restaurant, store, and art gallery. It is also possible to rent Harry Pye's cabin as a vacation rental should you so desire.

Directions: To get to Chloride from Truth or Consequences, travel north on Interstate 25 to Exit 83. Take a left on NM-181 and another left on NM-52. Follow the road signs to Winston. In Winston turn left on Chloride Road and travel southwest. Cell phone reception is fine in Chloride, but spotty on the journey between towns

Fort Craig National Monument

During the Civil War, Fort Craig played an integral role in preventing the Confederate Army from advancing on the Colorado gold and silver mines and crucial roles in the Indian Wars. Situated along the Rio Grande in the Jornada del Muerto, Fort Craig is historical reminder of New Mexico's vast history. Home to such notables as Rafael Chacon, Christopher "Kit" Carson, and Captain Jack Crawford, Fort Craig has had tragedy and near tragedy knock on its door and survived.

Home to the famed 9th Cavalry, the 125th and 38th Infantry comprised of Black soldiers who were called the Buffalo Soldiers by the local tribes shared quarters with the mostly Hispanic First New Mexico Volunteers and the New Mexico Militia. Located in a hot, desolate stretch of desert, Fort Craig could be a miserable place in which to be stationed.

Termed as one of the most important forts in the southwest, Fort Craig boasted housing nearly 2,000 men, including members of the Buffalo Soldiers. Abandoned in 1885, remnants of the once proud fort can still be seen and enjoyed. Managed by the Bureau of Land Management, the fort site is manned by knowledgeable volunteers. The museum and gift shop provide visitors with mementos of their travels.

Directions: Fort Craig is about 35 miles south of Socorro. From the north, take Interstate 25 to the San Marcial exit, then east over the Interstate, and south on old Highway 1 for about 11 miles. Then follow the signs to Fort Craig. If traveling from the south on Interstate 25, take exit 115.

Fort Selden Historic Site

Adobe remnants of this historical fort are slowly melting back into the earth from which it was constructed. Preservation efforts are being made to save this Civil War Era fort from disappearing. At one time, Fort Selden was home to the MacArthur family whose son, Douglas, would go on to claim fame as a five-star general. A beautiful location at the foot of the Rebledo Mountains near Radium Springs along the El Camino Real, Fort Selden has seen many transitions during its lifetime. Used as a campground by Confederate troops in 1861, it would not be established as a fort by the U.S. government until 1865 and would be home to the Buffalo Soldiers until it was abandoned in 1891.

A small $5 fee will get you entrance to a fascinating museum, which features a short video that explains the history of the fort and access to the fort ruins.

Directions: Located in Radium Springs, New Mexico, 13 miles north of Las Cruces, New Mexico off Interstate 25 at Exit 19. The Visitor Center is open daily from 8:30 a.m. to 5 p.m., except for Monday and Tuesday. Admission is free to New Mexico residents on the first Sunday of every month with valid I.D. New Mexico foster parents and foster children are admitted free. Address: 1280 Fort Selden Road, Radium Springs, New Mexico 88054. Contact details: (575) 526-8911 and www.nmhistoricsites.org/fortselden.

Fort Bayard was the greatest protection for the settlers during the Civil War and Apache Wars. (*Library of Congress*)

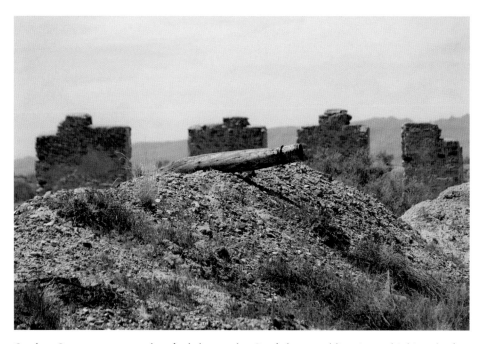

Quaker Cannons were used to fool the nearby Confederate soldiers in to thinking the fort was heavily armed. (*DB*)

Melting from the elements, Fort Selden is in the process of being preserved. (*DB*)

Lake Valley, New Mexico

Whispers of the past are carried in the tall gamma grass surrounding what was once a thriving mining community. The Bridal Chamber Mine (named so since the silver melted right off the ceiling with a candle) produced $2.5 million in silver by the late 1800s, creating a boom town in the high desert. Like the other ghost towns of New Mexico, Lake Valley prospered until the Silver Panic of 1893 when it met its demise. Described by a surveyor in 1883 as "the toughest town I've ever seen. I am convinced a man died with his boots on every night." With a population of 4,000 miners, prospectors and drifters, his estimates may have been spot on.

You can still see the ruins of the town as you cruise through the dirt roads. A stone service station, a few houses, a church, a few graves, and the old school building are all the remains of the once vibrant town. The school serves as a museum today and is manned by volunteers.

Directions: 17 miles south of Hillsboro on State Road 27. Lake Valley is on NM 27, between Nutt and Hillsboro.

Shakespeare, New Mexico

Stroll along the dusty streets of one of New Mexico's most preserved ghost towns, you will truly take a step back into the Old West. The eerie and desolate town is home to numerous tumbleweeds, rattlers, was home to three souls, and is listed on the National Register of Historic Places. Now part of a private ranch, Shakespeare sees little traffic, but is occasionally open to tours. Like many other towns in southwestern New Mexico,

The Bridal Chamber Mine in Lake Valley produced 2.5 million ounces of silver so pure it was sent to the U.S. Mint without being smelted. *(DB)*

Shakespeare boomed with the discovery of silver, which attracted many to the dusty streets of the former stage stop.

Local lore tells of the fate of a cattle rustler, "Russian Bill" Tattenbaum and outlaw Sandy King, who both had connections with the Clanton's of Tombstone fame, being lynched by the town's "Vigilance Committee" in Shakespeare and the bodies were left for several days as a warning to any others who thought about committing the same crime. Town Marshal "Dangerous" Dan Tucker, a famed gunfighter and lawman, took his responsibilities to heart and kept the small Old West town to task during his time as a lawman. As with other lawmen of the New Mexico, Tucker had done his time on the other side of the law, but this is said to have made him a better enforcer.

Unique Annual Events: Great American Duck Race

Deming, New Mexico, is the site of the annual Great American Duck Race held on the fourth weekend in August. A host of festivities occur before the huge wet and dry races held at McKinley Duck Downs in Courthouse Park. The Tournament of Ducks Parade is a creative take on the Tournament of Roses Parade in California, where the Mizkan American Duck Royalty will be revealed, followed by Hot Air Balloon Mass Ascensions, the Great American Tortillas Toss, the Great American Outhouse Race, and the Great American Horseshoe and Washer Tournaments. The Great American Duck

Shakespeare, a ghost town in southwestern New Mexico, is still open for tours. (*Library of Congress*)

Race is all for fun and there are cash prizes for the winners in each category. The entire town of Deming, New Mexico, attends making the spectator rate to over 20,000—almost double the population of Deming.

Quirky Outdoor Art

Cabinetlandia, Deming, New Mexico

Some 10 miles west the town of Deming, New Mexico, is a library of sorts called Cabinetlandia. Developed by the New York-based magazine *Cabinet*, Cabinetlandia is an odd structure in the middle of the desert of southwestern New Mexico, which includes a mailbox, an imbedded file cabinet. The Cabinet National Library is the brainchild of subscriber Matthew Passmore, who claims to be the Cabinet National Librarian. The library originally held every issue of *Cabinet* magazine, a pair of men's boots (size 10), a snack bar, and a guest book. Although the true reason for the development of Cabinetlandia is a mystery, it is a certainly a unique and ponderous site.

Wall of Bottles, Silver City, New Mexico

A wall at a private home across the street from the Grant County Courthouse garners a lot of attention from those who are visiting the historic town of Silver City, New Mexico. What makes this wall so special you may ask; well, it is made from thousands of old wine and other bottles. Each bottle is stuccoed together to form a wall that wraps around the yard and driveway of the home. New Mexico has many resident artists who like to use this medium as artwork as seen in Madrid, Taos, Santa Fe, and Silver City. It is said the light streaming through the bottles at sunrise make for a cheerful and colorful

display on the adjoining walls and sidewalks. The Wall of Bottles ranked a top spot on internet lists of places to see in New Mexico.

Outdoor Adventure

Elephant Butte Lake State Park

Just outside the town of Truth or Consequences is an oasis in the desert, Elephant Butte Dam. A man-made flood diversion dam, Elephant Butte proved to be a saving grace for those who settled along the Rio Grande, which was given to frequent flooding. Named for the elephant-shaped butte in the middle of the lake where a stegomastadon fossil was discovered in 2014, Elephant Butte is the largest state park in New Mexico at 36,000 acres. The site is not only a favorite for New Mexicans and tourists but was also a stomping ground for the fierce Tyrannosaurus Rex as fossils for this mighty giant have also been found. Created in 1916 to help prevent the Rio Grande from flooding, Elephant Butte is a favorite for boaters, campers, and hikers alike, and it hosts world-class bass fishing tournaments.

Address: 101 NM-95, Elephant Butte, New Mexico 87935. Contact number: (575) 744-5421.

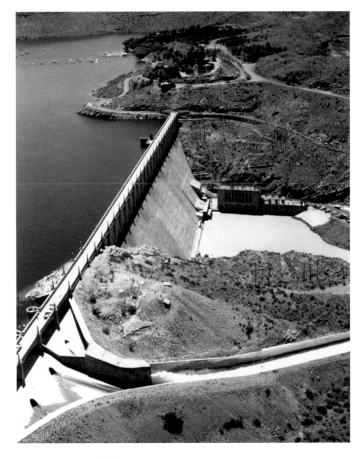

Built for flood control, Elephant Butte is now the largest state park in New Mexico. (*Library of Congress*)

Gila Wilderness and Gila Cliff Dwellings Monument

Surrounded by 2,710,659 acres of the Gila (*He-lah*) National Forest, the Gila Cliff Dwellings are on the edge of the Gila Wilderness, which was the first designated wilderness area in the nation. The stone dwellings now found are believed to have been constructed between A.D. 1276 and 1287 by the Mogollon (*Mug-E-own*) Culture; the Cliff Dwellings mirror those found in Bandolier and Chaco Canyon, although they are the only dwellings built by the Mogollon. There is evidence these alcoves were also used by the Paleo-Indians prior to A.D. 500. Pottery found at the site indicates several cultures utilizing the area.

Starting out small, providing shelter and dwellings for ten to fifteen family units, Gila Cliff Dwelling Monument covers 553 acres. Although the Mogollon people were generally nomadic, they built forty-six rooms separated by flat stones and adobe mortar in the cave system consisting of five alcoves to use for many years. It is not fully known why the Mogollon people left the caves, but it theorized the drought, crop failure, and famine forced them to seek water and shelter elsewhere around 1300.

The Mogollon People were named after the Spanish governor of New Spain from 1712–1715, Don Juan Ignacio Flores Mogollon, yet he had nothing to do with the Mogollon culture. The tribe depended on hunting and gathering until A.D. 900 and began to raise crops in the Gila Wilderness because of the water sources available to them. Cultivated corn, three types of squash, and several bean varieties were grown here.

In more recent years, Apache Chief Geronimo and outlaw Robert LeRoy Parker, otherwise known as Butch Cassidy, used the narrow canyons where the Cliff Dwellings are located as hideouts. The Cliff Dwellings are approximately one-quarter mile, or 200 feet above the canyon floor at the west fork of the Gila River. The Apache's took over the dwellings when the Mogollon moved away and defended the location until late 1870.

In 1899, the McKinley administration develop the Gila River Forest Reserve and pulled land at the headwaters of the Gila River from public use to prevent further homesteading. The archaeological site and 160 surrounding acres were taken from private ownership as looting of the site had already become prevalent. Unfortunately, the Mimbres sites of Chaco Canyon, Mesa Verde, Cliff Palace, and Pueblo Bonito were forgotten about until the 1930s and much damage had already been done.

The Gila Wilderness boasts over 400 miles of hiking trails and a relaxing hot spring. The Gila National Forest is the sixth largest in the nation and enjoys mild weather conditions most of the year, so opportunities for outdoor activities are year-round.

Directions: Travel West on Interstate 10 to Deming bypass to Silver City, New Mexico approximately 95 miles. Visitor Center open 8 a.m. to 4:30 p.m. every day, year round, and the trails are open from 9 a.m. to 4 p.m.; the last visitor in at 4 p.m. must be out by 5 p.m. Address: HC 68, Box 100, Silver City, NM 88061. Contact number: (575) 536-9461.

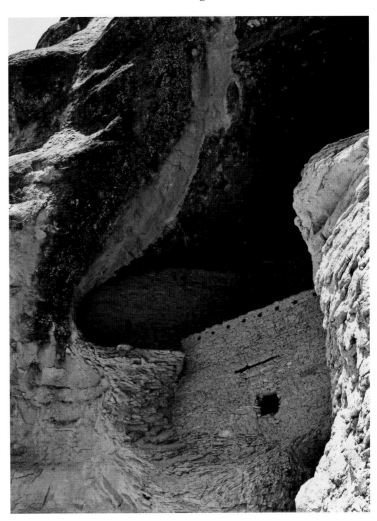

The Gila Wilderness was the nation's first wilderness area. (*Author's collection*)

Stolen Horse Canyon/Outlaw Rock

As part of the Billy the Kid Tour given in September each year, it encompasses Faulkner Canyon, otherwise known as Stolen Horse Canyon. West of Fort Selden, in the Robledo Mountain Wilderness Area, is the canyon that was a favorite haunt of Billy the Kid, who would stash his freshly rustled horses or cattle in the area.

As the soldiers of the fort served as escorts for the Butterfield Stage Line, which ran along the wagon road near the fort, outlaws such as the Kid, his gang members, Charles Bowdre, Tom O'Falliard, as well as "Dangerous Dan" Rudabaugh, and John Kinney would watch their movements from the ancient volcanic plug called Outlaw Rock and left evidence of their presence by scratching initials on the rock outcropping far above the canyon road.

Stolen Horse Canyon and Outlaw Rock are in the Organ Mountains Desert Peaks National Monument.

Not Your Ordinary Museum

Black Range Museum

Housed in the former hotel, home, and restaurant of one of Hillsboro's most famous citizens, the Black Range Museum displays many of its owner's possessions. Sadie Orchard, a lady of the night who took on the persona of an English rose, was the proprietress of the Ocean Grove Hotel and Tom Ying's Restaurant. Ying and Sadie's relationship was said to be volatile at times and she would lock him out of the building and *vice versa*, but, eventually, they would mend the fences and resume business.

The property is now owned by the Hillsboro Historical Society who are renovating the pre-1883 building. Much of Sadie's possessions still reside in the adobe structure. Collections of fine silk dresses, jewelry, business papers, and books reveal the woman Sadie truly was. During the smallpox and influenza epidemics, which ravaged the Kingston and Hillsboro populations, it was Sadie and her girls who would nurse the sick. When tragedy struck and a child passed from the diseases, Sadie would use the silk from her dresses to line the tiny coffins. It was also Sadie who paid for the funerals and supported the orphaned children of Sierra County.

Deming Luna Mimbres Museum

Housed in the first National Guard Armory building built in the state of New Mexico, the Deming Luna Mimbres Museum claims to be New Mexico's largest free museum, with the largest collection of items. Encompassing 25,000 square feet of exhibit space in three buildings, the museum also houses over 100,000 resources in its archives.

In the large, red brick building dating back to 1916, you will find a fascination array of exhibits ranging from gemstones, Native American artifacts, local history, to militaria. Also, on the premises is one of the first homes built in Deming, now a shining example of nineteenth-century life. This home was called the Customs House due to the fact it was it once housed the U.S. Customs Office in part of the home. This is a highly recommended museum, well-worth the time and effort to veer from Interstate 10 on your way to either Arizona or Las Cruces, New Mexico. Although the museum is free, donations are gladly accepted.

Address: 301 S. Silver Avenue, Deming, NM 88030. Contact number: (575) 546-2382.

Atomic Age & Scientific Stops

Spaceport USA

"Be brave. Be Bold. Be Here. Spaceport America beckons a brave and pioneering new breed of commercial space entrepreneur."

Literally in the middle of nowhere, Spaceport America is one of the most interesting sites in New Mexico as the "world's first purpose-built commercial spaceport." Built to increase the accessibility of commercial spaceflight, the spaceport is working in conjunction with Sir Richard Branson of Virgin Galactic, who has moved his entire operations to New Mexico from California to develop safe space travel for businesses and individuals.

Situated in Upham, New Mexico, which is 20 miles southeast of the town of Truth or Consequences, 89 miles north of El Paso, Texas, and 45 miles north of Las Cruces, New Mexico, Spaceport America is on 18,000 acres of uninhabited land with 6,000 square miles of protected airspace, literally in the middle of nowhere. Branson moved his entire California operation to the New Mexico desert to increase the workforce, consolidate, and speed up the process of getting his clients into orbit.

Spaceport America is easy to miss as you travel the narrow two-lane paved road from Interstate 25 North. Situated on the famed Jornada del Muerto (Journey of Death) a much-dreaded section of the New Mexico desert, which was heavily traveled by early settlers. There will be no sign to herald your arrival; in fact, the 12,000-square-foot building blends into the desert landscape so well, you may not notice it at first. In the shape of what could be described as a landlocked manta ray, Spaceport America provides privately run research facilities for scientists who have successfully completed over 200 horizontal and vertical launches from the 12,000-foot runway and is supported by state of the art firefighting equipment and vehicles for safety.

It is highly recommended you take a tour bus to the Spaceport from the Spaceport Visitors' center in Truth or Consequences at 301 Foch, which is open 8:30 a.m. to 4:30 p.m. Due to the extreme remoteness and security of the facility, it is highly discouraged you drive there individually; in fact, those who travel there on their own will not be allowed on the grounds. This is a fact I was unaware of when I traveled to the location: you can take photographs from the guard gate area, but you cannot go any further. When you take the tours given on Saturday and Sunday, please be prepared for it to take at least four hours and arrive at least fifteen minutes early to catch the bus. The road to Upham is a narrow two-lane with many signs warning of road flooding—this is not the place you want to have car trouble or a flat tire, so utilize the tour bus.

A minimum twenty-four-hour notice is required in booking tours since conditions can change rapidly according to Mission Control schedule. The cost of the tours ranged from $59.99 per person when booked online to $24.99 per person for STEM (Science, Technology, Engineering, Math) affiliated groups. Call 1-575-267-8888 to book your tour. Walk ups can be accommodated, but it is not guaranteed you will be able to take the tour.

When you arrive at Spaceport America, you will have the chance to play interactive games, tour Mission Control, and, for the adventurous, experience the G-Force simulator. A tour of the runway will bring the enormity of the facility into perspective—Spaceport America is an exciting opportunity for not only New Mexico, but for those who have already booked their space flights.

Karl G. Jansky Very Large Array

Deep in the flat expanse of the New Mexico desert, 44 miles from Socorro, sits a group of twenty-seven radio antennas in a Y-formation along the San Agustin plains. The Karl G. Jansky Very Large Array (VLA) has been used to observe and listen for possible signs of life in outer space, and this fact alone has whetted the curiosity of all who pass by this stunning display.

Flanked by Cibola National Forest, Gallinas, and Datil Mountains, the key scientific station is crucial to the space industry. Each 82-foot-diameter radio dish is capable of investigating quasars, galaxies, black holes, supernovas, gamma rays, stars, planets, and an assortment of other astronomical objects such as the *Voyager 2.*

Spaceport America sculpture named "Genesis" reaches for the stars. (*DB*)

Spaceport America is the world's first purpose-built Spaceport. (*DB*)

Approval for the VLA was given by Congress in 1972 and the first antenna was placed at the facility in 1975 at the cost of $78.5 million. Since this time, the equipment has been greatly enhanced and expanded to become the largest configuration of radio telescopes in the world. New technology has recently been added to allow 80 percent of the Earth's sky to be surveyed in three full scans. Scientists are expecting to find over 10 million new objects in the survey.

The Karl G. Jansky Very Large Array has garnered the attention of Hollywood as well, which have featured the antennas in the movies *Contact*, starring Jodie Foster and Matthew McConaughey in 1997, and *Cosmos: A Personal Voyage* by Carl Sagan in 1980. The VLA has also played a significant role in the comic book series *G.I. Joe: America's Elite* from 2005–2008, as well as being featured on the 1993 *On the Night* album cover and video for the band Dire Straits.

When you visit the array, you will be in the middle of nowhere, on the St. Agustin plain. Keep a sharp eye out for the pronghorn (antelope) herds that roam in the area. Each time you visit the array, the satellite dishes will most likely be in a different position from your last visit; this is because they are rearranged every four months. Should you want to see the dishes closer together, as seen in the movie *Contact*, you will need to visit on the "D" rotation timeframe.

Tours of the facility will get you an up close and personal view of a functioning radio dish, a maintenance bay, video on the operation of the dishes, information about the supercomputer powering the entire operation, and a highly interesting gift shop.

Contact the Visitor Center for more information at (575) 835-7000 and public.nrao.edu.

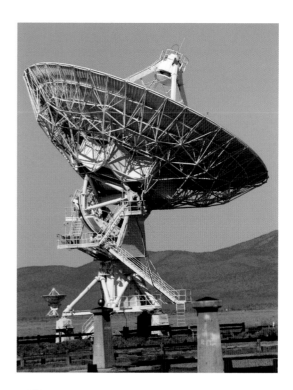

The Very Large Array is one of the world's premiere astronomical radio observatories. (*DB*)

Unique Lodging: Black Range Lodge

In Kingston, tucked off the main road, is the Black Range Lodge, a quaint two-story bed and breakfast that once served the military and gold miners in the late 1800s as the Hole in the Wall Saloon and Pretty Sam's Casino. Some of the remodeled rooms feature heated floors and balconies to give you a cozy stay. The massive rock walls and beamed ceilings were built in the 1930s. You will be thrilled by the amount of wildlife and birds in the vicinity, as well as the proximity to larger towns such as Truth or Consequences. Spa facilities are available so you can let the troubles of the world melt away in the foothills of the Gila National Forest.

Address: 119 Main Street, Kingston, New Mexico 88042. Contact details: (575) 895-5652 and www.blackrangelodge.com.

Built from stone and large log beams, the Black Range Lodge will take you back to the Old West. (*DB*)

6

LAS CRUCES

Historical Background

The southern gateway to New Mexico, Las Cruces is the second largest city in the state and is the home of New Mexico State University. At the foot of the gorgeous Organ Mountains, Las Cruces provides all the amenities of a large city with a hometown feel.

Dripping Springs Natural Area

Some 10 miles off I-25 are the ruins of Van Patten Mountain Camp located at Dripping Springs. Edward Van Patten was a Confederate soldier in the Civil War who wanted to set up a resort in the late 1800s. Unfortunately, he would go bankrupt a couple of decades later, but the building he built would then be used for tubercular patients. "Le Grippe," as it was sometimes known, was rampant in the U.S. and the mild climate of the desert southwest was thought to be the best place for patients to live while recovering from the disease.

Dripping Springs Natural Area is a haven for wildlife with mule deer and coyote often observed. Be cautious, mountain lions have also been seen in the area as well. Camping and picnicking are allowed.

Directions: Approximately 12 miles east of Old Mesilla. Contact number: (575) 525-4300.

Kilbourne Hole

No matter which direction you look in New Mexico, you will see evidence of volcanic activity. Kilbourne Hole, south of Las Cruces, is one such crater. Due to the similarities with the Moon surface, NASA used the crater for lunar training for its Apollo Mission astronauts.

For directions on how to access this unique site, visit the website at www.blm.gov/visit/kilbourne-hole-volcanic-crater.

Organ Mountains Desert Peaks National Monument

In my opinion, the Organ Mountains are some of the most beautiful mountains in the state of New Mexico. Although not exactly "hidden" since they are visible for hundreds of miles, the Organ Mountains are a hiker's dream. Volcanic in origin, the mountain range thrust up from the soil to form the craggy range we are familiar with today, and their distinct similarity to organ pipes in appearance is obvious—hence, the name. The Organ Mountains are often described as the Grand Tetons of New Mexico.

The rhyolite and andesite peaks reign over the 500,000 acres of mountains, grasslands, historic sites, and volcanic craters included in the Organ Mountain Desert Peaks National Monument formed in 2014.

Recycled Roadrunner

As you travel along Interstate 10 East toward Las Cruces, you will see a huge representation of the state bird, a roadrunner at a rest stop to your right. What makes this sculpture unique is the fact it is formed from recycled goods, or more basically trash. Created by Olin Calk in 1992, the roadrunner sculpture was intended to raise awareness of recycling and the enormity of excessive waste.

Originally built in the landfill, the giant roadrunner was later moved to the Interstate 10 rest area where the big bird has become a photo opportunity for those traveling into Las Cruces. Standing 20 feet tall and 40 feet long, the bird is made entirely out of recycled and discarded goods. Feathers are formed from rubber, crutches, car parts,

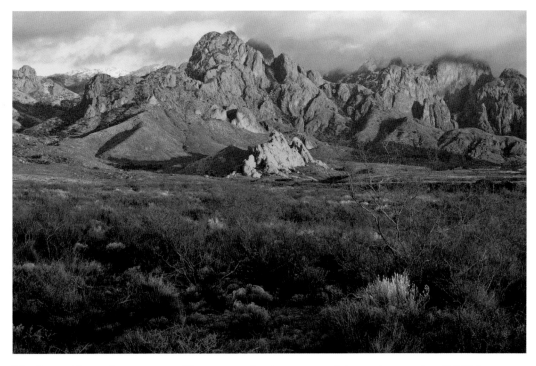

The Organ Mountains are a magnificent range that jets up out of the earth more than 9,000 feet. (*Author's collection*)

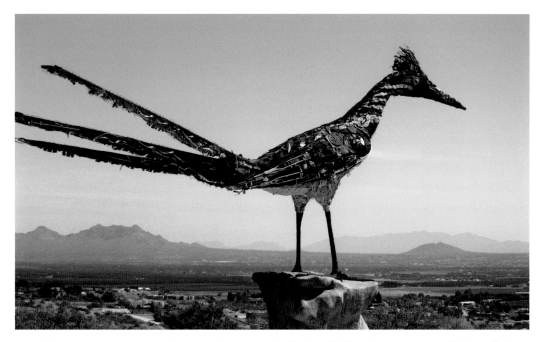

Keeping watch over Las Cruces on Interstate 10, the Recycled Roadrunner is over 20 feet tall. (*DB*)

Crutches, car parts, and shoes make up the feathers of the Recycled Roadrunner. (*DB*)

and computer keyboards, while the underbody boosts flattened tennis shoes, and the eyes are headlights from a Volkswagen car. Constructed on an old tire-covered metal frame, the sculpture had to be rebuilt in 2011 due mainly to natural deterioration and unnatural souvenir seekers. Calk stripped the sculpture down and returned it to his house to await the decision from the city as to the fate of the metal bird.

In 2014, the Recycled Roadrunner was returned, completely re-feathered with junkyard treasures, and it is now perched on "fake" rock, which is hoped will discourage travelers from defrocking the landmark bird once again.

Directions: In a rest area on the south side of Interstate 10, just west of Las Cruces and east of the Picacho Avenue Exit, between mileposts 134 and 135. Only accessible from the eastbound lanes.

Not Your Ordinary Museum: Space Murals Museum

As you travel along Highway 70 in Organ on your way into Las Cruces, you will pass a million plus-gallon water tank with images of the U.S. space program painted on the facade. Be sure to not to pass up the opportunity to experience this fascinating museum.

The Space Murals Museum is home to a vast array of items relating to the space program, much of which was donated by the astronauts and their families—dating back to the beginning of the space program up to the *Challenger* tragedy. With over 6,000 feet of museum space filled to the brim with photographs, space suits, memorabilia, and newspaper articles, you will be sure to be awed by what this hidden gem has to offer. Owner Lou Gariano has been quoted as saying that when the families of the astronauts and NASA workers found out about his museum, they were more than generous with their material donations. Gariano took all donations sent his way. After writing letters to 120 astronauts, the museum received replies in the form of memorabilia that had gone to space and photographs from approximately sixty-five. Therefore, they call the Space Murals Museum "the people's museum."

One of the most heartbreaking displays outside is the 1/8th scale replica—built by Gariano and his team in his garage—of the doomed space shuttle *Challenger*. Those of you who are old enough will never forget that awful, fateful day on January 28, 1986 when the *Challenger* and her brave crew of five astronauts, one payload specialist, and the first teacher in space blasted off to the heavens, never to return.

The 1.2-million-gallon water tank artfully decorated with space murals was built by Gariano's company, Moongate Water Company, in 1993. The idea behind decorating the water tank was to draw attention to the public of the fact that the National Aeronautics and Space Administration (NASA) and White Sands Missile Range were in the area. Gariano likes to point out: "… everything that goes into space, for years, was put together here, flown here and tested here."

Outside, you will be greeted by a coy pond in the shape of the Space Shuttle, a tail section of a V-2 rocket (which coincidently was flown and crashed at nearby White Sands Missile Range), and the Mercury capsule on display was rescued from a salvage yard.

Las Cruces has deep roots with NASA and the Space Murals Museum is adjacent to NASA's White Sand Test Facilities in Organ, New Mexico. Due to Edward's Air Force Base having in climate weather, White Sands Space Harbor Northrup Strip was utilized

in March 1982 for the landing of *Columbia*. It is reported NASA was not happy with using the air strip in the New Mexico desert because it took several months for crews to rid the spacecraft of the white gypsum sand, which had entered the vessel, but it was an unforgettable experience for those who witnessed the landing. The brave crew of seven of the final *Columbia* mission on February 1, 2003, which tragically broke apart during re-entry into the Earth's atmosphere only sixteen minutes before their scheduled landing are also remembered with a touching memorial.

The word astronaut comes from the Greek words *ástron*, which means "star or space," and *nautes*, meaning "sailor," hence "space sailor;" if it were not for these brave adventurers sailing into the great unknown, the world would not have the technology and knowledge we do today. We all owe these explorers a great deal of respect and gratitude.

The Space Murals Museum is free admission and is open Monday through Saturday from 9 a.m. to 5 p.m. There is a great gift shop on the premises where the proceeds help to keep the museum running. Address: 12450 Hwy 70 E, Las Cruces, NM 88052. Contact number: (575) 382-0977.

Above left: Dedicated to the NASA space program, the Space Mural Museum is a must-see! (*DB*)

Above right: The Space Shuttle Challenger crew is immortalized on the 1-million-gallon water tank at the Space Mural Museum. (*DB*)

Quirky Roadside Art

Toth Totem

At the corner of Apodaca Park and North Solano Drive sits a large, carved, wooden totem known as the Toth Totem, which was carved by Hungarian artist, Peter "Wolf" Toth in 1986. The Las Cruces Toth Totem is part of the "Trail of the Whispering Giants." It was the goal of the artist to have on totem in every state in the U.S., a goal he accomplished in 2008 with the completion of the Hawaiian totem.

New Mexico was the recipient of the fifty-seventh totem carved by Toth, who has also placed totems in Canada and Europe. The Toth Totem in Las Cruces is one of his smaller sculptures at 20 feet tall and carved from pine, some range up to 40 feet tall and are carved out of native wood for the area. Using basic hammer and chisel, Toth attempts to carve likenesses of the native people in the states. Apache Chief Geronimo is the inspiration behind New Mexico's creation, the sculpture is named *"Dineh,"* which is a Navajo and Apache word for "human beings" or "the People."

Standing proudly in Solano Park in Las Cruces is one of seventy-four Toth Totems. (*DB*)

Toth requires only room and board and the basic raw materials to create his masterpieces, which have a value of close to a quarter of a million dollars when completed. City crews maintain the wooden sculpture to preserve the work of art. Several of Toth's totems in other states have been destroyed due to adverse weather conditions and a few have been re-carved by the artist.

Directions: Apodaca Park. Northeast corner of North Solano Drive and East Madrid Street. Las Cruces, NM

World's Largest Chile Pepper

What is 47 feet long, fire engine red, and made of 2.5 (5,000 pounds) tons of concrete? Why, the world's largest chile pepper, of course. The enormous red chile sculpture is situated in the front of the Big Chile Inn in Las Cruces, New Mexico, and was built by the owners between the years of 2010 and 2011. Why you ask? The Las Cruces region is known as the Chile Capitol of the World with the largest producer of chile, Hatch, New Mexico, right up the road. The owners thought it would be a great tourist attraction for Las Cruces—as well as their hotel.

The Big Chile has become a bit of a social media darling as more and more people are seen taking selfies with the giant red concrete pepper. The Big Chile Inn is chile themed, with a garden in the back where they grow, you guessed it, chiles! August through October the air in New Mexico smells heavenly when the chile roasters come out to the front of grocery stores, roadside vegetable stands, and even private backyards. The aroma of roasted green chile is like catnip to New Mexicans.

Address: 2160 W. Picacho Ave., Las Cruces, NM.

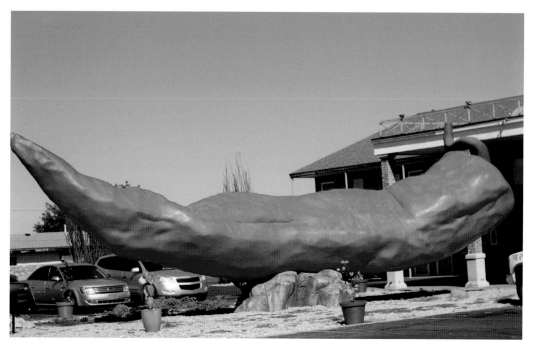

New Mexico is famous for its chile, even the world's largest sculpture as well. (*DB*)

7

SOUTHEASTERN NEW MEXICO REGION

Historical Background

Artesia, New Mexico

Situated between Roswell and Carlsbad, Artesia, New Mexico, is a small, but mighty oil town. Fiercely proud of their Artesia Bulldog teams, the entire town is donned in orange and black on game days. Home also to some of the largest oil industry leaders, Artesia has fantastic community support and give back regularly.

One of the oil magnets in Artesia is the Yates family who have been responsible for donating much of the statuary and art works seen around the town.

Carlsbad, New Mexico

Developed as part of an elaborate plan to bring investors into southeastern New Mexico, Carlsbad started its history as Eddy, New Mexico. It was named for Charles Bishop Eddy, the man who had great visions for the riverbanks along the Pecos River and set out to put them into play. Being blessed with the lifeblood any town needs to survive—water—Carlsbad grew rapidly and saw many tuberculosis treatment facilities open in town due to the perfect climate.

When potash (potassium carbonate, which was left as the ancient seas receded; it is now used for fertilizer for crops) was discovered by accident in 1925 by geologist V. H. McNutt, who was doing core sampling for oil deposits, a sustaining industry was introduced to the farming community. It would be easy to say, up until recently, nearly every family in the basin had a family member who is or was employed by the potash mines. At its highest point, there were seven potash mines operating in the mineral rich soils east of Carlsbad. Today, sadly, it has dwindled to only two. The industry has seen tumultuous times during the history of the mines—rapidly gauging between boom and lean years, but it has certainly been the mainstay of the community and fed many a mouth.

Above: Tularosa Basin Gallery is the largest all photography, all New Mexico gallery in the state. (*DB*)

Right: Burros on Parade decorate the walls outside the Malkerson Gallery 408 in Carrizozo. (*DB*)

Donated by the Forrest Family, the fountain lends an elegant touch to the Pecos River. (*DB*)

Capitan, New Mexico

Home to Smokey the Bear, Capitan is a quiet mountain community with an artistic flair. Smokey is king with the local restaurant and hotel named in his honor. As a long-term ranching community, Capitan is also close to recreational activities such as hunting, fishing, and skiing at Ski Apache. I highly recommend you visit the Capitan Public Library while in town; they are one of two public libraries in Lincoln County that are totally staffed by volunteers. The library thrift store is a great place to find treasures and help the library at the same time. The multiple restaurants and cafes in Capitan have some of the best food in the county, no matter what you are hungry for, the food is great.

Carrizozo, New Mexico

At the crossroads of Highway 54 and Highway 380, Carrizozo is often passed by travelers who are on their way to bigger towns, but they are missing out on a true gem. The historic district on 12th Street will bring you back to a simpler time, one where the telephone number had only two digits.

The pride and joy of Carrizozo are the painted burros, which grace the fronts of businesses and street corners around town. These adorable creatures each have a distinct personality guaranteed to make you smile.

With free admission, the Carrizozo Heritage Museum is a deal as it is chalked full of memorabilia commemorating the town's rich railroad history, as well as one of the best collections of barbed wire anywhere.

Quirky cat art is on the backroad out of Captain. (*DB*)

Cloudcroft, New Mexico

Described as "9,000 feet above stress level," Cloudcroft lives up to the claim. A quaint mountain community nestled in the tall pines in the Sacramento Mountains provides a great deal of family fun and relaxation for those who visit her. Ice skating, festivals, and antiquing are just a few of the activities you will find in this small village.

Hobbs, New Mexico

As one of the fastest growing towns in New Mexico, Hobbs provides residents and visitors alike with every amenity necessary. Evidence remains in Lea County, in which Hobbs is encompassed, being well-traveled by ancient people like the Folsom and Clovis Man who left magnificent spear points behind, also the Apache and Comanche, more recent native people, left pottery and arrowheads much to the delight of the archeologists. Spanish conquistador explorers began their journeys into southeastern New Mexico through the Hobbs region on their way to the fabled Seven Cities of Gold while following the Pecos River.

The decaying ancient marine life left by the shallow inland sea formed over 250 million years ago also resulted in a huge underground aquifer known as the Ogallala in the Llano Estacado, or Staked Plains (named for the many stalks of the yucca plant on the plains), provided not only drinking water for the people who lived on the plains, but also was the source for the immense oil/gas deposits as well. Ranchers soon discovered the vast shallow underground water resources of which the Native Americans in the area kept as a well-guarded secret and developed large cattle ranches.

Aviatrix Amelia Earhart broke speed limit laws on East Broadway in the middle of Hobbs in September 1928 when she landed her out-of-fuel Arvo Avian biplane on the wide dirt street. Earhart was on her first solo U.S. transcontinental flight from New York to California, when she became lost and, eventually, low on fuel. Seeing the empty street below, Earhart used this opportunity to land. Known to pin her navigation (roadmaps) notes to the hem of her skirt since the plane had no instrumentation, the pilot became disoriented when her notes blew out of the open cockpit. "It ruffles your hair, but you get over that in a hurry," she said. "It's like riding in a big convertible. That's why I look like this."

Jal, New Mexico

In the heart of the oil patch in southeastern New Mexico sits a "small town with a big heart." "The Trail Ahead..." a seventeen-piece metal sculpture made from sheet metal by local artist Brian Norwood, stretches for nearly 400 feet along the hilltop depicting a cattle drive featuring the original ranchers in Jal. Some of the silhouettes are over 20 feet tall and run along Highway 18. Follow Highway 18 into town and you will be directed to the JAL Lake Park, which contains a man-made lake forming the initials J.A.L. Although it can be best seen from the air, the park is a great place for family fun. In the historical downtown of Jal, you will notice more metal sculptures by Brian Norwood in the plaza across the street from the Woolworth Library, which is one of the best libraries in the state of New Mexico.

After landing in Hobbs, Amelia Earhart was taken to tour the Carlsbad Caverns. (*Courtesy Southeastern New Mexico Historical Society collection*)

The Trail Ahead..., a metal sculpture by Brian Norwood, casts a life-like silhouette on Highway 176 towards Jal. (*DB*)

Lincoln, New Mexico

Highway 70 west of Roswell is a beautiful drive taking the traveler from the desert landscape through the lush ranches and horse farms of the Hondo Valley and, eventually, to the cool mountains of Ruidoso. Veer off this highway to the right onto Highway 380 for a side trip, and you will be completely transported back into the history of the Old West.

The narrow two-lane road will open into the Lincoln Historical District where Territorial style, adobe, and clapboard homes appear exactly like they were in the 1880s. You are now in Billy the Kid country and traveling down what was once dubbed by President Rutherford Hayes as the "most dangerous street in America." Although it may look extremely close to how it looked during those wilder times, Lincoln has long since lost her dangerous status.

Site of the famed Lincoln County War, the tiny hamlet in the high desert attracts thousands of visitors each year to get a glimpse of history.

Queen, New Mexico

Nestled in the Lincoln National Forest, Queen, New Mexico, is an extremely small, but historical town in the southeastern section of the state. A lone brick chimney is the only historical survivor standing.

The only official building in Queen today is the Queen Café. This tiny café has seen many owners over the years, but the one trait they must all have is the ability to cook

a great green chile cheeseburger. On any given day you can find hikers, motorcyclists, ranchers, and locals eating at the café and loving every bite!

Along your forty-five-minute drive from Carlsbad to Queen, you will notice a stone monument with an airplane propeller, which has been called the most isolated monument in America. This monument is in memory of an important man, Frank Kindel, who was known as "Mr. Carlsbad" by the locals for his community service and enthusiasm. One of the names he acquired was "Paperboy of the Guadalupe's" since he delivered mail and newspapers to the remote rural ranches in the Guadalupe Mountains west of Carlsbad in his Piper airplane.

Directions: North of Carlsbad on U.S. Highway 285 to Highway 127 (Queen Road/ Highway). Turn west and head toward Queen at every fork in the road. The monument is 36 miles west from U.S. Highway 285, inside the Lincoln National Forest, just past the Guadalupe Christian Camp, on the right-hand side.

Above left: A brick chimney at Queen is the only surviving structure left of a once vital town. (*DB*)

Above right: Frank Kindel's death was mourned by the entire town of Carlsbad. (*DB*)

Ruidoso/Ruidoso Downs, New Mexico

In the "cool pines" of Ruidoso, New Mexico, you will find many wonders to explore ranging from art galleries, great live music, museums, wineries/breweries, horse racing, fantastic skiing, horseback riding, bicycling, hiking, off-road trails, theaters, some of the friendliest people in New Mexico. Mixed in with the normal tourist attractions in this mountain village are some rather quirky charms as well.

Billy the Kid Visitors' center: As you enter Ruidoso Downs, New Mexico, you will see an interpretive center that will be a great place to stop and learn the fascinating history of Billy the Kid Country. On the outside of the Visitors' center are mosaics done by local artist, Summer Sarinova of Sarinova's Glass and Mosaics who has also graced many other buildings with her amazing talents. Billy the Kid's Visitor Center is a great spot to start your scenic tour of the Billy the Kid Scenic Byway.

Taiban, New Mexico

On the Eastern Plains, approximately 30 miles from Fort Sumner, New Mexico, is one of the most photographed churches in New Mexico, the First Presbyterian Church of Taiban. On Highway 60 between Fort Sumner and Clovis, New Mexico, a tattered, grey skeleton of a once vibrant church stands off the road. Inside, a tongue-in groove ceiling and ornate light fixtures remain as a reminder of its former glory. Travelers have taken to writing sayings, ditties, and scriptures on the foyer wall as you enter the old sanctuary.

Tularosa, New Mexico

The village of Tularosa is called the City of Roses and garnered its name from the Spanish who saw the red reeds growing along the banks of the Rio Tularosa. As the water source for the region, the Rio Tularosa provided irrigation for the crops grown by the early settlers. Today, pistachio orchards and grape vineyards thrive in the Tularosa Basin and provide good sources of income for the village.

Nearly every home in Tularosa grows roses and when they bloom, the town smells heavenly. The Original Tularosa Townsite District contains the original forty-nine blocks (seven blocks by seven blocks) with a total of 182 historic homes and buildings recorded in the National Register of Historic Places. Many of these structures are of adobe construction and have "rifle" windows, which were used for defense against the Apaches who would conduct raids in the basin.

Cultural Heritage

Bosque Redondo Memorial

Described as one of the worst failed experiments in U.S. history, The Long Walk, forced on the Navajo and Mescalero Apache tribes during the Civil War era by the military, is a tragedy few ancestors of these victims have been able to forget or forgive.

It is hard enough to imagine being expelled from your home by having your dwelling and crops destroyed, but then to have your entire community forced to march nearly 500 miles to a prison in the dead of winter—inconceivable. This is exactly what happened to over 4,000 Native Americans in 1863. Many of the elderly and very young who died along the way were left without a proper burial, and many more found their

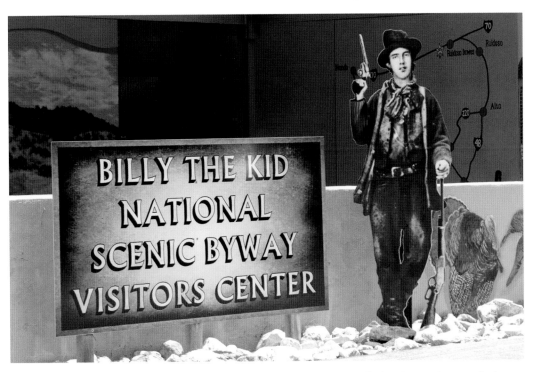

Billy the Kid Visitor Center is faced with detailed pictorial mosaics by local artist Summer Sarinova. (DB)

An abandoned church in Taiban is a huge draw for photographers. (*DB*)

The Bosque Redondo Memorial is a beautiful tribute to a tragic period in New Mexico history. *(DB)*

fates when they arrived in Fort Sumner to find no shelters provided for them from the cold and bitter winds.

Opened in 2005, the Memorial pays homage to both the Navajo and Mescalero Apache tribes, who by the way were mortal enemies before their incarceration. Navajo architect David Sloan designed the memorial by incorporating the Navajo Hogan and the Mescalero Apache teepee with remarkable results. Both tribes were present when the building was dedicated, adding a part of each culture to the grounds. Walk along the trail, under the old cottonwoods—which may have witnessed the suffering—and you will see the starkness of the fort grounds.

The Bosque Redondo Memorial is a strikingly spiritual experience, one can almost feel the presence of the former inhabitants and the pain of which they suffered from greatly. You will be changed by your visit as the reality of what occurred on that land sinks in.

Address: 3647 Billy the Kid Drive, Fort Sumner, New Mexico 88119. Contact number: (575) 355-2573.

Salinas Missions

The location of Gran Quivera Mission is as close to the exact middle of New Mexico as anywhere in the state. No matter which way you are travel to the monuments, you will be amazed by the wide-open spaces that provide views for hundreds of miles and the ever-changing countryside. Be sure to visit all three Missions to get the full effect of the way of life of the Ancient Puebloan, Las Humanas, and Jumano Peoples and seventeenth-century Spanish missionaries. The National Park Service has many knowledgeable Park Rangers who will be happy to convey the rich history of Abo, Gran Quivera, and Quarai Missions through interpretive programs and tours. Famine, drought, and attacks by the local Apache tribes lead to the demise of all three missions in the late 1600s; they would not be settled again until the early 1800s.

While exploring the Salinas Missions, please be mindful of the possibility of rattlesnakes along the trail.

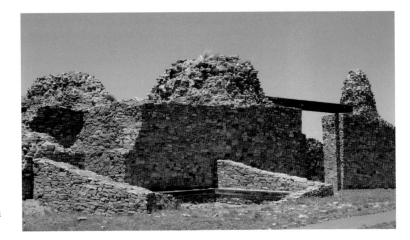

Gran Quivera is the largest of the three Salt Mission Pueblos. (*DB*)

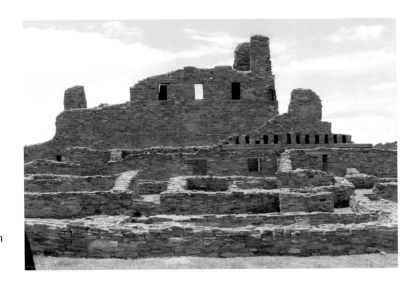

Abo ruins contain a circular Kiva. (*DB*)

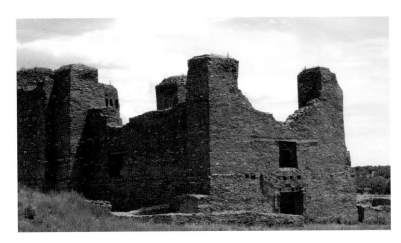

Quarai is riparian with a small creek running south of the ruins. (*DB*)

Three Rivers Petroglyphs

With an astounding 22,000 petroglyphs waiting to be discovered by you, the Three Rivers Petroglyphs is nothing less than awe-inspiring. Only 7 miles off Hwy. 54, you will find a glimpse into a beautiful form of communication left by many cultures centuries ago. Petroglyphs are images etched into stone, by stone. The volcanic boulders along a mile-long ridge in the middle of the vast Tularosa Basin are adorned with images of animals, snakes, people, birds, and ancient symbols. Although no one is positive as to the true meanings behind the drawings, they do present the modern world with an insight into the ancient culture that passed through this rugged region.

Not Your Ordinary Museum

Dalley Windmill Museum, Portales, New Mexico

Said to be one of the largest privately owned collections of windmills in the U.S., the Dalley family have been collecting for over thirty years. With over eighty in the collection, the county decided to allow them to be displayed in a 12,600-square-foot windmill park—prior to this, they were displayed at the Dalley's private home. Windmills are vital to the ranching industry of the late 1800s to today by using wind to pump water from underground to holding tanks to be used by cattle, cowboys, and wildlife in a barren landscape.

Directions: Located at the intersection of U.S. 70 and Lime Street in northeast Portales. The display is visible from U.S. 70.

Hubbard Museum of the American West

Located on the fringes of the Ruidoso Downs Racetrack, the Hubbard Museum of the American West celebrates the western heritage of the region. Located in front of the famed Ruidoso Downs Racetrack, the Hubbard Museum has many exhibits and art pieces that honor the horse, including three gorgeous examples of carved carousel horses. Along with the horses, the exhibits include stunning examples of Native American jewelry, as well as carriages, wagons, and carts from various eras.

Directions: On Highway 70 in Ruidoso Downs, look for the large horse sculptures.

International Space Hall of Fame

A fascinating tribute to the American Space Program is the International Space Hall of Fame located in Alamogordo, New Mexico. The gallery of the museum provides visitors with a stunning view of the Tularosa Basin and the White Sands Missile Range to the west.

Included in the many exhibits featured both outside and inside the building are the gravesite of "Ham," the first space chimp, rare satellite replicas (Sputnik, Gargoyle, and Explorer), a sobering monument to the *Challenger* and *Columbia* astronauts who tragically lost their lives, the Daisy Track, Little Joe II rocket, and, inside, a moon rock.

Directions: Located at the top of Hwy. 2001. Address: Alamogordo, NM 88310. Contact number: (575) 437-2840. Open every day but Tuesday.

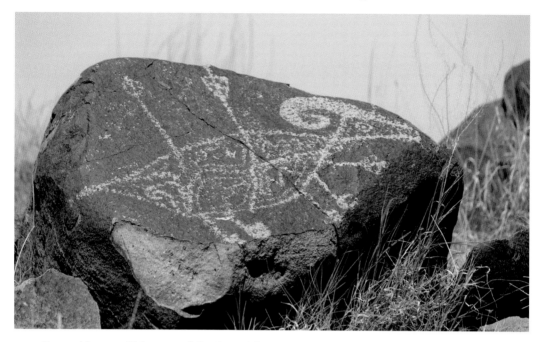

Located between Tularosa and Carrizozo, Three Rivers Petroglyph Site has over 21,000 petroglyphs to show. (*DB*)

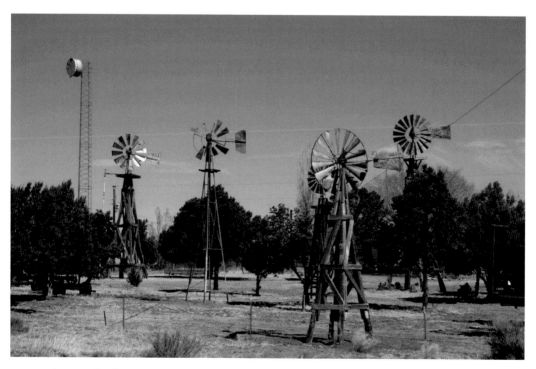

Daley Windmill Museum in Portales preserves a vital part of ranch life. (*Author's collection*)

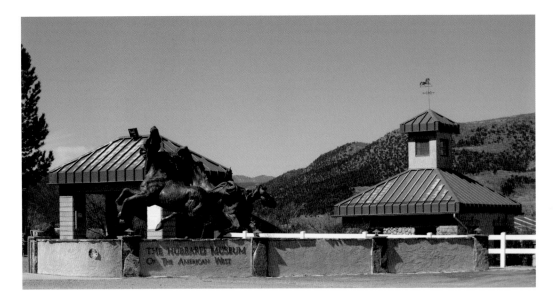

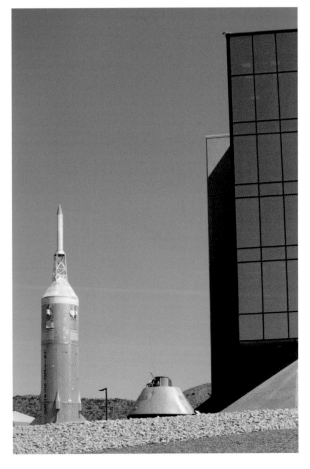

Above: Hubbard Museum of the American West is dedicated to the history of western traditions. (*DB*)

Left: Among the priceless artifacts of the Space Hall of Fame collection is a rare moonrock. (*DB*)

Norman Petty Studios, Clovis, New Mexico

Best known for starting the careers of Buddy Holly and the Crickets, Waylon Jennings and Roy Orbison, the Norman Petty Studios was started by renowned musician Norman Petty who had a lucrative career of his own. Known to have a "golden ear" for talent, Petty created the "Clovis Sound." The Norman and Vi Petty Rock and Roll Museum is like walking into a time capsule of musical history. You can easily imagine Buddy Holly or the Fireballs walking through the doors and any moment. Original sound boards, '50s décor, and soda machines give a nostalgic feel.

Address: 105 East Grand Avenue, Clovis, New Mexico 88101. Contact number: (575) 763-3435.

Smokey Bear Historical Park (Museum)

Hopefully, you have all heard Smokey's message of "only you can prevent forest fires," but do you know anything about the black bear in the ranger hat? Smokey the Bear became an iconic figure in 1950 after he was found as a cub, burned from a forest fire in the Capitan Mountains. The cub was healed and fast became the symbol for fire prevention. After his death in 1976, Smokey was quietly buried in the grounds of the museum. A small carved monument is all that makes the grave of one of the most famous bears in history. The park is also home to many exhibits of the various wilderness zones located around the Capitan Mountains. A small, informative museum gives you a great oversite on the history of the little black bear who grew to be a world-renowned celebrity.

Visit the following websites for more information: www.smokeybearpark.com and www.villageofcapitan.com. Address: 102 Smokey Bear Boulevard, Capitan, New Mexico 88316.

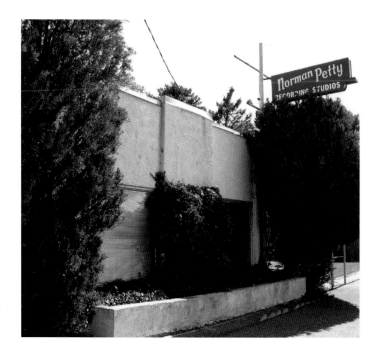

Many greats from the Rock and Roll era got their start at the Norman Petty Studio. (*Author's collection*)

Headstone on the grave of fire prevention mascot Smokey the Bear. (*DB*)

Natural Wonders

Carlsbad Caverns National Park, New Mexico

An observation of a thin column of what was first thought to be smoke led to one of the biggest discoveries of the century. Although others had found the large cavern before him, cowboy Jim White was given the moniker as the "discoverer" of the Big Cave. Completely obsessed with his new discovery, White would work in the guano mines in the cave and give tours on the side. Early visitors were lowered down through the mouth of the cavern via guano bucket and were given lantern tours of the wonders which lay beneath the desert landscape.

When you visit the Carlsbad Caverns one of the first things you will notice about the cave is the darkness of the trail even with modern lighting in place. One can only imagine being one of the first to explore this wonder, in total darkness. With features such as the Bottomless Pit in the cave and your only access was a rickety wood and rope ladder with lantern, it certainly took some bravery to go into the unknown.

In his own words, White described the darkness of the cave: "Standing at the entrance of the tunnel I could see ahead of me a darkness so absolutely black it seemed a solid." While exploring the cave, he said: "It seemed as though a million tons of black wool descended upon me."

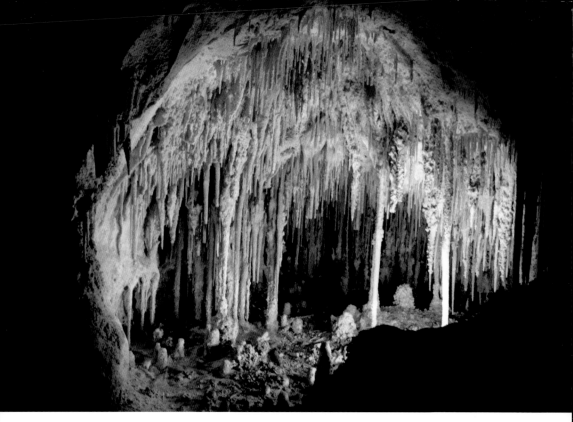

Above: Formations in the Carlsbad Caverns National Park are magical. (*Jerry Birchell*)

Below left: The New York Times advertisement that led to the world discovering this wonder. (*Courtesy Southeastern New Mexico Historical Society collection*)

Below right: Approximately 1 million Mexican Freetail Bats call the Carlsbad Caverns National Park home at any given time. (*Courtesy Southeastern New Mexico Historical Society collection*)

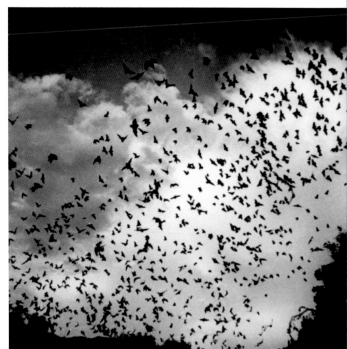

Valley of Fires State Park

As you leave Carrizozo, New Mexico, on U.S. 380 and travel 4 miles west, you will notice a dark line in the distance stretching out across the open landscape, this is the Valley of Fires State Park. The Carrizozo Malpais Lava Flow, originated from the eruption of the Little Black Peak over 5,000 years ago, resulting in a lava flow 4–6 miles wide, 160 feet thick, and 125 miles long.

Valley of Fires is thought to be the youngest lava flow in the continental U.S. Much of the flow is beginning to be covered with vegetation because of the water captured in the many holes created by the cooling of the lava and is home to many animal species, birds, and bats. Bright green prickly pear cactus, yucca, and scrub oak are a great contract against the black ropey flow stones, it is a "grow where you are planted" situation.

Running along the floor of the Tularosa Basin, the Valley of Fires State Park is a quiet refuge for wildlife and campers alike. Campsites, nineteen in all, along a paved road with extremely clean restroom facilities and hot showers provide a serene overview of the lava flow, which is in direct contrast to the activity witnessed several thousand years ago in this spot.

Paved trails throughout the park are fully accessible and provide spectacular venues to watch a legendary New Mexico sunset. You can get up close and personal with the lava waves as you walk the trail or settle into a picnic bench at one of the many overlooks.

Managed by the Bureau of Land Management, the Day Use fee for one person in a vehicle is extremely affordable at only $3—should you have two or more, it jumps up to $5. Tent camping is $7 a day, a campsite with electricity is $18, without $12, a group shelter is $25 per day, tour buses with fifteen or more people are charged $15 per day.

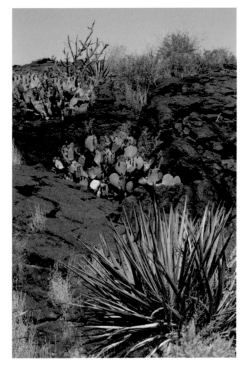

Valley of Fires is one of the youngest lava flows in the U.S. (*DB*)

White Sands National Park

The windswept terrain of the largest gypsum dunes in the world is outer-worldly. Pristine white dunes stretch for miles and provide not only unique photo opportunities, but great family fun. The rangers in the visitors' center will give you an overview of the formation of the dunes, as well as provide you with the opportunity to rent discs to toboggan down the blindingly white sand drifts. Recently White Sands has been given the honor of becoming a National Park on December 20, 2019. The 176,000-acre gypsum dune field has long been a fascinating stop for over 600,000 visitors each year.

White sands and spectacular sunsets create a dream location for any photographer. Due to the intense reflection from the brilliant sands, please be careful of the weather when visiting the National Park in the summer, temperatures can reach over 100 degrees and cause heat exhaustion or stroke quickly. Always take water with you as you frolic in the sands.

Quirky Roadside Art

Eunice, New Mexico

A miniature red, white, and blue Freedom Plane replica of a B-52 bomber sits just off the east side of Highway 18, about 8 miles south of Highway 176 outside Eunice, New Mexico. On private property, the roadside art can be seen from the road as it guards the surrounding pump jacks. The metal cut-out side below the sculpture reads: "Cherish your freedom, it does not come free. Always remember those Americans who sacrificed so much for it." Not much is known about the plane, but it is a somber reminder to not take your freedom for granted.

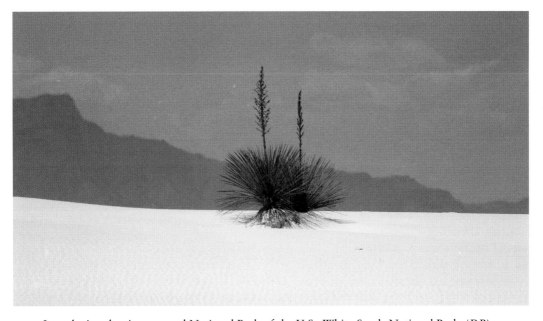

Introducing the sixty-second National Park of the U.S., White Sands National Park. (*DB*)

The Freedom Plane sculpture outside Eunice reminds all that freedom is not free. (*DB*)

Free Spirits at Noisy Water

Eight, one and a half sized, sculpted horses run along an emerald green path in front of the Hubbard Museum of the American West along Hwy. 70 in Ruidoso Downs, New Mexico, within eyeshot of the Ruidoso Downs Racetrack and Billy the Kid Casino. Horse breeds represented by the 1995 Dave McGary sculpture include the Quarter Horse, Thoroughbred, Arabian, Appaloosa, Morgan, Paint (with foal), and Standardbred.

Halagueno Art Park

The front lawn of the Carlsbad Public Library is filled to capacity with sculptures by famed artist Glenna Goodacre and local sculptress, Wren Prater Stroud, as well as numerous examples of public art. Over the span of nearly ten years, the Library Board members have developed a multi-phased plan to transform the library lawn from lightly landscaped space to an art extravaganza. Fountains, sculptures, mural, outdoor performance space, water features, and special lighting adorn the library lawn to become the backdrop for annual community events such as Heritage Days, Harvest Festival, and Night of the Lights.

Heart of the Desert, Alamorosa, New Mexico

At 26 feet tall and 20 feet wide, the Heart of the Desert trademark sign in Alamogordo, New Mexico, has the distinction of being named the largest heart in the world. As the symbol of the Heart of the Desert Winery and Pistachio Farm, the sign beckons all who pass to visit for a wine tasting or pistachio farm tour.

Above: Seven breeds of horses are represented in the Dave McGary sculpture Spirits of Noisy Water. (*DB*)

Below left: Cougar by artist Cynthia Rowland was added to the extensive collection of sculptures on the Carlsbad Public Library lawn in 2019. (DB)

Below right: A mixed-media sculpture by artist Bill Weaver entitled Ball in the Wall; the glass used in the art piece is left over airplane glass. (DB)

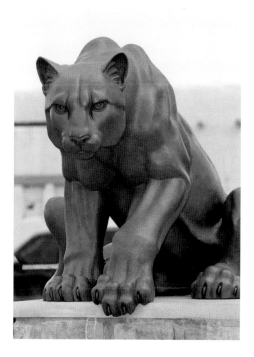

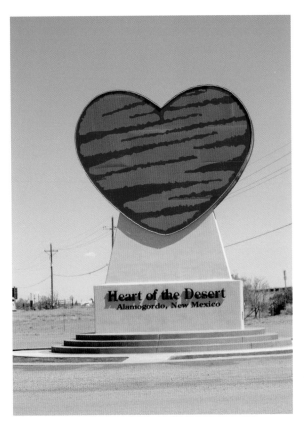

The World's Largest Heart Sign is the trademark of the Heart of the Desert Pistachio Farm. (*DB*)

Jim White Sculpture, Carlsbad, New Mexico

Renowned New Mexico sculptor, Reynaldo "Sonny" Rivera is the artist behind the 14-foot Jim White sculpture at the National Cave & Karst Research Center at the Cascades in Carlsbad. Cowboy Jim White was given credit for discovering the Carlsbad Caverns and was one of the first to explore the enormous cave. Although White was not actually the first to see the cave, he worked tirelessly to promote the cavern.

In the early days of his cave exploration, White was sometimes accompanied by a fifteen-year-old Mexican boy who he called "Pothead." In order not to get lost, the pair would trail a line of string behind them as they descended into the darkness. Their first journey took three days to complete, and they were able to explore much of the same areas that are open to the public today. A recent discovery by park rangers of an inscription in the cave reading "1898 J. White," proves White's exploration of the cave.

Serenade of Burros, Carrizozo, New Mexico

Driving along historic 12th Street in Carrizozo will have you smiling and looking up as you notice the wonderful display of painted burros that decorate the tops of buildings, walls, and store fronts. The colorful herd was a vision by Minnesotan transplants Warren and Joan Malkerson in 2005 who wanted to bring art to the tiny town at the crossroads. Each burro has a different theme and is for sale.

162

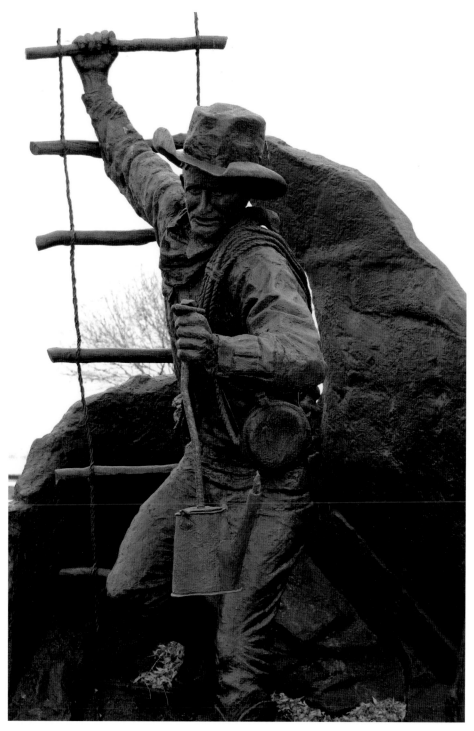

Jim White, an early explorer and promoter of the Carlsbad Caverns National Park, is immortalized in a sculpture. (*DB*)

Painted by local artists, the painted burros are used to decorate local businesses and bring in donations. (*DB*)

World's Largest Pistachio, Alamorosa, New Mexico

The World's Largest Pistachio is located off New Mexico Highway 54 at the famous McGinn's Pistachio Tree Ranch outside of Alamogordo, New Mexico. This huge, 30-foot-tall smiling nut representation is a memorial to the ranch's founder, Tom McGinn, and is made of concrete. To hold this giant pistachio upright, it requires a steel pole anchored in over 9 more feet of concrete at the base.

Outdoor Adventure

Hondo Iris Farm

"One of New Mexico's most beautiful gardens" is the Hondo Iris Farm's claim, and they are correct. With over 1,000 planted Iris pots holding over eighty varieties of the beautiful flower. May, just in time for Mother's Day, is the time to visit this fantasy garden nestled into the countryside off Highway 70, just past the Highway 380 turn off to Historic Lincoln. The garden is ablaze with bright color as rows and rows of Iris'

As the World's Largest Pistachio, this concrete sculpture stands proud at the McGinn Pistachio Farm in Alamogordo. (*DB*)

One example of the hundreds of stunning irises found at the Hondo Iris Farm, which comes to life in May. (*DB*)

show off their vibrant hues. It is nearly impossible to choose only one or two of the bulbs, you will surely be tempted to take home one of every color.

These gardens are a photographer's delight with statuary, glass suncatchers, and fairy gardens scattered throughout the farm. The Irises are not the only stars on the farm, Lilies, high desert botanicals such as the Red Tip Yucca, Mexican Butterfly Bush, Agaves, and Cacti are also available for purchase. The owners encourage you to bring a picnic lunch, relax, and listen to the birds or watch the hummingbird's flit around as you take in the beauty that surrounds you.

A gift shop is also on the premises and features unique items from all around the world like purses, ponchos, ladies clothing, jewelry, and much more. Should you decide you would like to sleep among the Irises, you can rent a cottage on site nightly.

Living Desert Zoo and Gardens State Park, Carlsbad, New Mexico

Overlooking Carlsbad in the Ocotillo Hills is a unique zoo, which features plants and animals indigenous to the Chihuahuan Desert. With over forty species of animals and at least 500 of species of plants represented, the Living Desert Zoo and Gardens State Park provides visitors with an up-close experience with desert life. Broken down into four

zones, which include the Sand Hills, Piñon/Juniper, Gypsum Hills, and Desert Uplands, the park takes you through each environment and features the plants and animals that inhabit these zones. The Living Desert Zoo and Gardens State Park is proud to be accredited by the Association of Zoos and Aquariums.

Most of the animals in the exhibits are injured rescues, or animals who were abandoned by their families, or raised as pets by humans. Since they are imprinted, or injured, they cannot survive in the wild, so this is where the zookeepers of the Living Desert come into play. Their kind care and attention of these animals shows in the longevity of their lives. Also housed at the zoo are endangered species such as the Mexican Grey Wolf.

The first exhibit you will encounter on your 1½-mile walk through the park will be the aviary where golden eagles, owls, hawks, turkey vultures, and roadrunners live. You will also see the gray fox most likely lounging in a tree. The walk-through aviary houses small native birds such as the white-winged dove, sparrows, blue jay, and finches, look closely, they like to hide behind the foliage.

Be sure to visit the nocturnal area, which by the way, is a great spot in the heat of the summer. An exhibit features a larger-than-life representation of a Mexican Freetail Bat, which inhabit the famed Carlsbad Caverns National Park. Close by is the recently constructed Reptile House, which features a gorgeous snake inspired carpeted wall. If you are squeamish about snakes, no worries, these beauties are behind thick panes of glass and cannot harm you. While at the Reptile House, take a moment to go out on to the covered portico and enjoy to panoramic views of not only the city of Carlsbad, but Avalon Lake as well.

One of the celebrities of the Living Desert Zoo is Maggie the Painting Bear. Curator and Maggie's handler, Holly Payne, used paper and non-toxic paint as a form of enrichment for the young Black Bear and it became a hit. Arriving at the zoo as a cub of six months, Maggie was originally kept in a zoo in Georgia as a pet. She outgrew the facility and was removed. Thriving since her arrival, Maggie is the star of the Living Desert and is given a birthday party each year, complete with her favorite nuts and cranberry raisins as presents wrapped up in a fruit leather bow. She is a delight to the children who attend to watch her open her box—usually by sitting on it. The Friends of the Living Desert sell Maggie's masterpieces that help with the upkeep of the zoo. Maggie is truly a great asset to the desert zoo.

Large hoof stock such as elk, pronghorn, and deer can also be seen, but one of the most fascinating exhibits must be the cats. The two mountain lions, Zuzax and Zia, are welcomed additions to the park, but have won the hearts of the staff and visitors alike. Arriving at the Living Desert as kittens, both cats have similar, yet different stories but have bonded with each other and can be seen frolicking in the exhibit.

Do not miss the Greenhouse, which houses succulents from around the world at the end of the trail.

Address: 1504 Miehls Drive, Carlsbad, New Mexico 88220. Contact number: (575) 887-5516.

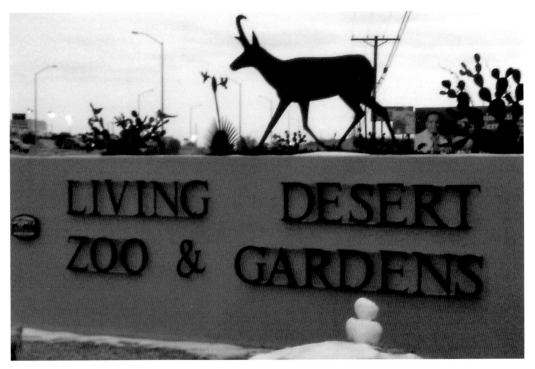

The sign of the Living Desert Zoo and Gardens State Park feature some of the animals and plants that can be found inside. (*DB*)

Zuzax, the male mountain lion, sits on his favorite perch, which overlooks the entire Living Desert park. (*DB*)

Unique Lodging

The Lodge Resort and Spa, Cloudcroft, New Mexico

The tall pines of Cloudcroft hide an historical landmark in the heart of the Sacramento Mountains. As you take the narrow road off Hwy. 82, the Lodge Resort and Spa will appear before you in all her beauty. The imposing Lodge stands proud at the top of the hill, nestled in the Ponderosa Pine trees. Once you walk into the front doors you are transported into the Victorian era. Although the original structure was destroyed in a fire at the turn of the century, the Lodge Resort and Spa has risen out of the ashes to become the premier mountain retreat.

For those of you who love golf, you will be interested in the Lodge's golf course, which is one of America's oldest having been established in 1899. For fifty of those years, it was also the highest course in the country, but it has been topped by three others since then. The elevation of the seventh highest golf course in the world makes this nine-hole course governed by Scottish rules, challenging, yet enjoyable.

One of the most fascinating stories involving the Lodge Resort and Spa is that of Rebecca, who reportedly haunts the Lodge. The legend recalls a blue-eyed, red-headed chamber maid who disappeared from the Lodge in the early 1900s. It is long said Rebecca was a fun-loving girl who was found in the arms of another man by her lumberjack boyfriend, who, it is also said, in a fit of rage, killed them both in the forest near the Lodge. Guests and staff who reported encounters with the fair Rebecca say she is a playful spirit and means no harm. The Lodge Resort and Spa have honored Rebecca by naming their restaurant after her and decorated the lobby with various images of the beautiful ghost.

World-class golf course and fine dining sets The Lodge Resort apart from others in the Sacramento Mountains. (*DB*)

The Trinity Hotel

The stately building on the corner of Fox and Canal Streets in Carlsbad began its service to the town in 1892 as the First National Bank. Over the years, the walls have included Carlsbad's first newspaper, the offices of founder Charles B. Eddy, famed Sheriff Pat Garrett, the Carlsbad Irrigation District, and, for a short time, was a thrift store for the Ladies Auxiliary, which benefitted the hospital.

After the Carlsbad Irrigation District moved their offices, the historical building on the National Register of Historic Places fell into disrepair and was named on the Threatened Historic Sites list for a short time. In 2007, things changed for the better as three partners decided to take on the monumental task of restoring this magnificent building. After adhering to the strict rules of the Historical Society of New Mexico, and several million dollars in renovations, the structure was dubbed the Trinity Hotel and opened as a boutique hotel, winery, and restaurant.

Address: 201 S. Canal Street, Carlsbad, NM 88220. Contact details: (575) 234-9891 and www.thetrinityhotel.com.

Arrowsmith Store, Lincoln, New Mexico

Tucked in the heart of Lincoln, New Mexico, on what was once referred to as "the most dangerous street in the United States," is a charming store run by Murray and Marilyn Arrowsmith. Behind the doors to the store are an eclectic mix of anything Billy the Kid related, antiques, Western memorabilia, historical books, geological specimens, and, of course, Elvis Presley.

Anyone who goes to Lincoln needs to visit Arrowsmith Store. You will be propelled back into the shops of yesteryear as the strains of true Western music from artists such as the Sons of the Pioneers and theme songs from some of the most popular Western television shows and movies fill the air. Novelty items from New Mexico will be a great gift to take back home to make your friends and family jealous, but do not overlook the beautifully stocked display cases of authentic handmade Native American jewelry.

Murray and Marilyn Arrowsmith are extremely knowledgeable of the history of the area and will be more than happy to relay the exciting stories of Billy the Kid, the Regulators, the McSween's, and all of the mayhem, which occurred during the Lincoln County War. Lincoln Days, which features the Billy the Kid Pageant on the first weekend of August, and the Day of the Dead, held the first weekend in November, celebrations are great times to experience Lincoln in full swing. Oh, and do not forget to take a selfie with the full-sized mannequin of the King of Rock and Roll, Elvis, while browsing this unique shop.

Roadside Oddities

Cloudcroft Tunnel, Cloudcroft, New Mexico

Carved out of the side of a mountain that was an obstruction to the completion of Highway 82 is the Cloudcroft Tunnel, the only highway tunnel in southern New Mexico. Built in 1949, the tunnel provides an easier route to connect the towns of Cloudcroft and Alamogordo, New Mexico. Evidence of the strong upheavals of the earth are along both sides of the road, which passes through the tunnels. Be sure to be

Combine wine tasting, a boutique hotel, and the best food in Carlsbad and you will get The Trinity Hotel. (*DB*)

The Arrowsmith Store in Lincoln is a delight for the eye and history buff. (*DB*)

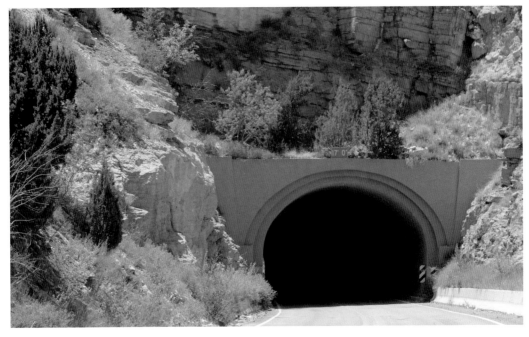

The Cloudcroft Tunnel is the only highway tunnel in New Mexico. (*DB*)

on the lookout for falling rocks as you travel the narrow road. There are three pull-off spots to take photos and a hiking trail that will take you from the top of the road to the bottom of the canyon below.

Cloudcroft Railroad Trestle, Cloudcroft, New Mexico

The Cloud-Climbing Railroad provided a means of transportation for logs and apples in the Sacramento Mountains. The narrow-gauge trestle through Mexican Canyon still stands and is a beautiful example of early engineering and is listed on the National Register of Historic Places since 1979. A lookout provides a wonderful view of the Tularosa Basin below, including White Sands National Park. Hiking and mountain biking trails surround the area and provide trails for every skill level. Dogs are allowed on these trails but must be kept on a leash. At 323 feet long and 52 feet high, the trestle is a sight to behold. In 1907, it cost $3 to ride the train from El Paso, Texas, to Cloudcroft and took nearly three hours to scale the mountain from Alamogordo.

Cowboy Grave, Oscuro, New Mexico

You must look sharp and quickly as you travel along Hwy. 54 between the Three Rivers Petroglyphs and Carrizozo, New Mexico in what is known as Oscuro to see the lonesome grave of a twenty-year-old cowboy.

Legend says, R. L. "Shorty" Lee, a cowboy for the Bar W. Ranch, owned by the first governor of New Mexico, W. C. McDonald, was moving a small herd of cattle in 1907 when he and another cowboy, their horses, and the seven head of cattle were struck and

Spanning Mexican Canyon, the trestle was used by the Cloud-Climbing Railroad for logging. (*DB*)

Lonesome grave of a cowboy on Highway 54. (*DB*)

killed by a lightning strike. Being the tradition at the time, when a person did not have known relatives, they were buried where they died. The landscape in the area is flat and desolate so they were most likely the tallest objects on the plains.

At the time of his death, the place he fell was a cattle trail in the middle of the desert, but as civilization moved into the Oscuro, a new highway was built, which threatened to cover the obscure grave. Through the efforts of W. W. Gallacher, Sr., who was a friend of Lee's, the cowboy's grave remained intact. Gallacher, now a ranch owner, placed a white picket fence around the grave. The fence has long since succumbed to the wind and weather, but a white metal cross still marks the gravesite.

Shorty's cross is not alone anymore, there are two other crosses next to him with the name Ward cut into the metal. These crosses, which appeared in 2009, may be in commemoration of a death site of people who died on Hwy. 54 in the same vicinity as Shorty, the New Mexico Highway Department has no record of giving permission for them to be erected.

Fox Cave, Glencoe, New Mexico

Fox Cave greets the traveler on Hwy. 70 from Roswell as they venture closer to Ruidoso Downs—home of the Ruidoso Downs Racetrack and Casino. The live-sized dinosaur head might catch your eye first as you navigate the corner, or maybe it will be the two disembodied hands reaching up out of the ground, or better yet, the huge cowboy showing you the entrance to Fox Cave and Gem Mine. It was owned by gemologist Arnold Duke, who first settled in the desert community of Las Cruces, New Mexico, southwest of Ruidoso, and found it to be far too hot for his liking, who then made the decision to move a bit north to the mountains where he had a cabin for weekend adventures.

Duke's first acquisition in Ruidoso was the Ruidoso River Museum, which at the time was located at the crossroads of Suddreth and Mechem on the banks of the Rio Ruidoso in the heart of Ruidoso village. Sheriff Pat Garrett's (the man responsible for the death of famed boy outlaw Billy the Kid) badge on display at the museum was Duke's biggest reason for wanting to purchase the building and contents. The museum is now part of the Fox Cave complex, which is constantly under expansion.

Hole in One Gravesite, Ruidoso, New Mexico

Imagine loving the game of golf so much that when you died, you request a putting green be placed over your grave. That is exactly what Richard "Ruff" Jones did when he died in 2004. Forest Hills Cemetery in Ruidoso, New Mexico, is a quiet, peaceful plot of land that is frequented by the local deer herd. Near the back, overlooking the rest of the cemetery is the Hole in One Grave, which is complete with putter and an urn full of golf balls as well as a sign that states, "Let's Play On." Mr. Jones must have had a great sense of humor in life, which he carried on in death.

Old Apple Barn, Mountain Park, New Mexico

Picturesque Mountain Park, New Mexico, in the Sacramento Mountains is home to the Old Apple Barn, which is a fun roadside stop between Cloudcroft and Alamogordo. Built in 1941, the Old Apple Barn is a restored World War II apple processing barn turned fudge factory and pie bakery. Many of the items offered in the shop harken

Tucked into a hillside near Ruidoso Downs, Fox Cave was once a hideout for Billy the Kid. (*DB*)

Imagine loving golf so much you request a putting green placed on your grave. (*DB*)

Standing tall at the Apple Barn is Apple Boy waiting for you to take a selfie. (*DB*)

back to more vintage times. In front of the barn is Apple Boy, sculpted by owner Bill Niffenegger on site, who is waiting to take a selfie with you. Named one of the best roadside attractions to visit in the fall, the Old Apple Barn is a great place to buy fresh apples from the local orchards.

Directions: Highway 82, Mountain Park, New Mexico. Website: www.oldapplebarn. com.

The River That Crosses Itself

As you drive into Carlsbad on Hwy. 285 from Artesia, one of the first structures you will notice is what looks like a Roman aqueduct, which, in fact, it is. As part of a huge irrigation and reclamation project, today's version of the Flume is the third one built on this site. Much like the Three Little Pigs, the first two attempts starting in 1890 were constructed in wood and washed away in the enormous floods that used to plague the area. This concrete Flume has survived since 1903 and has the distinct honor of being mentioned in Ripley's Believe It or Not as "the world's only river which crosses itself" and briefly held the honor as the "world's largest concrete structure." At 425 feet long, 25 feet wide, and 8 feet deep, this modern marvel carries irrigation water from Avalon Lake north of Carlsbad to fields south of the town for crops. Still in use today, the water running across the Flume originated in the Pecos River and crosses the Pecos River on its way south.

The beautiful arches of the Flume are a favorite backdrop for local photographers and provides a restful area to enjoy nature. Also located in the Flume Park is a small rock cabin,

After the original flumes were wiped out by floods, a concrete structure took their place. (*Courtesy Southeastern New Mexico Historical Society collection*)

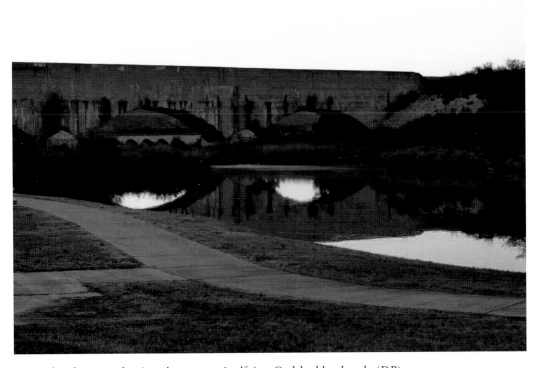

The Flume, or the river that crosses itself, is a Carlsbad landmark. (*DB*)

which was one of the first structures between Roswell, New Mexico, and Pecos, Texas, and served as headquarters for the Eddy Brothers cattle operation. In 1981, the Southeastern New Mexico Historical Society painstakingly dismantled the building stone by stone, numbering them as they went along and reassembled the tiny house in Heritage Park.

Located directly behind the hospital on Callaway Drive, the park is free to the public and gives visitors an idea of the type of structures constructed in the Carlsbad (or as it was known during the time of the cabin—Eddy). It was the hopes of the historical society to instill a bit of the rich history of Carlsbad into the small park. There is a pavilion and three sculptures of New Mexico's state bird, the roadrunner, a small stream, and walking paths on the property as well.

Ghost Towns and Frontier Forts

Fort Stanton National Monument

Walk in the footsteps of military greats such as "Black-Jack" Pershing and Kit Carson, hear the stories of the Buffalo Soldiers and the outlaw Billy the Kid as you tour this pre-Civil War fort, *circa* 1855. Fort Stanton National Monument has been in operation, with little down time for its entire existence. Serving also as a women's prison, Civilian Conservation Corp camp, a German prisoner of war camp, a tuberculosis hospital, a drug rehabilitation center, and now a National Monument. Fort Stanton is a fascinating stop, well worth the short drive from Highway 380 between Capitan and Lincoln, New Mexico. Every third Saturday of the month the Fort Stanton Garrison host living history programs, which illustrate early life at the fort.

Address: 104 Kit Carson Road, Fort Stanton, New Mexico 88323. Website: www. fortstanton.com.

Fort Stanton was ordered to be burned before the Confederates invaded, but nature intervened with a downpour. (*DB*)

Fort Sumner National Monument

Gravesite of one of the most famous outlaws in New Mexico's history, if not the entire U.S., Fort Sumner has a history more diverse than just a haven for a criminal. William H. Bonney (a.k.a. Billy the Kid) enjoyed the friendship of ranch owner Pete Maxwell and was rumored to be in love with Pete's sister, Paulita—this connection would ultimately lead to the Kid's demise in Fort Sumner on July 14, 1881.

Fort Sumner National Monument is also home to the Bosque Redondo Memorial, which illustrates the tragic history of the Navajo Nation and Mescalero Apache members who were forced from their homes to live in the desolation of the eastern plains as a failed humanitarian experiment during the Civil War. The Memorial was created with the blessings of the Navajo Nation and Mescalero Apache leadership. The site is a moving experience as it is hard to fathom the extreme hardships endured by these two tribes and the amount of loss they experienced as a people. Adobe bricks manufactured at the fort are displayed for visitors as are the twig huts constructed by the Navajo's who were forced to live there. Today, very few remnants remain of the Civil War fort along the banks of the Pecos River, but a restored soldier's quarters show how life was for those stationed at the isolated citadel.

You will also find the Billy the Kid Museum in the town of Fort Sumner, which caters to the mystique of Billy the Kid and has a documented rifle once belonging to the boy outlaw on display. With over 60,000 items on display, as well as a replica of Billy the Kid's headstone, the museum is a favorite stop for enthusiasts of the Old West. Nearby the town of Fort Sumner is Fort Sumner Lake State Park, which provides ample opportunities for the fisherman, as well as the boater and swimmer.

Address: 3647 Billy the Kid Road, Fort Sumner, New Mexico. Contact number: (575) 355-2573.

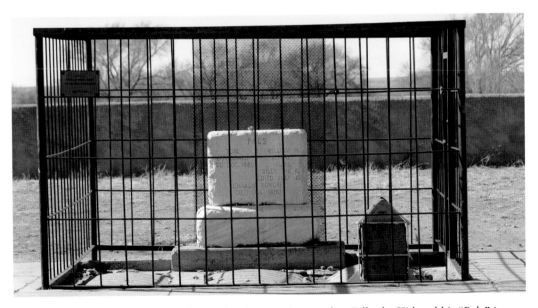

Stolen several times, the headstone for the notorious outlaw Billy the Kid and his "Pals" is now safely enclosed behind chain-linked fencing. (*DB*)

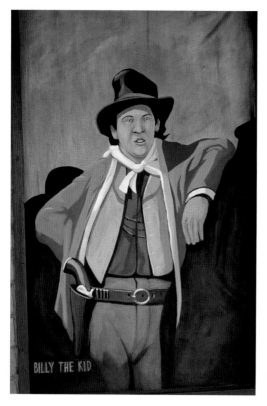

BILLY THE KID

The likeness of outlaw Billy the Kid is everywhere in Fort Sumner, New Mexico. (*DB*)

White Oaks, New Mexico

Hard to believe today, but White Oaks, New Mexico, was once the second largest city in the state. The former mining boom town is now home to artists who are working to revive the tiny village. Surviving eastern-influenced brick structures that once housed schools, private homes, mercantile businesses, and saloons are still accessible today. The four-room schoolhouse, now museum, is one of the finest examples of this architecture in the state today.

Gold and silver were being pulled out of Baxter Mountain in great quantities creating a boom town in the mountains. These riches attracted miners, prospectors, businessmen, outlaws, and shady ladies to tiny village, which quickly blossomed into a true western boom town.

No Scum Allowed Saloon, White Oaks, New Mexico

Have you ever wanted to play poker with Billy the Kid? Have a shot of whiskey with Madam Varnish? Then no trip to White Oaks would be complete without visiting the No Scum Allowed Saloon. Although the historical characters are no longer with us, their spirits are in the deceivingly large saloon in the ghost town of White Oaks. Voted one of the top ten cowboy bars in the U.S. by *American Cowboy* magazine, this 100-year-old brick and adobe structure has been a witness to the many shenanigans of the Old West cowboys.

Belle La Mar, otherwise known as Madam Varnish, was the local shady lady who liked to stir up trouble as much as she liked money. The gold mining boom town of White Oaks was the perfect spot for the sly madam and her "daughters" to take up residence—at least until the gold ran out. During White Oaks heyday, the seedier part of town was known as "Hogtown" where the saloons, brothels, and gambling houses were located. It was in the Little Casino Saloon, which was La Mar's place of business where she dealt faro, poker, and roulette.

The wily madam gained her nickname from the fact the miners said she was "slick as varnish" when she dealt her card games. Even with this reputation, the Little Casino Saloon was the most popular bar in town. Madam Varnish also sold three grades of whiskey at three different price points; it was revealed later that the bottles were filled from the same low-grade whiskey barrel. Remnants of the saloon are still visible.

Today, the No Scum Allowed Saloon is a favorite haunt of motorcyclists, thirsty history buffs, and those who want to sit back and enjoy the beverages, company, dancing, and live music. Starting life in 1884 as an attorney's office and newspaper print shop, the saloon was christened with its moniker by the movie *Young Guns II* about Billy the Kid, in which the town of White Oaks was described as the home of "756 respectable people no scum allowed," locals just call the saloon the White Oaks Bar.

For many years, the bar was run under the honor system, meaning everyone knew which rock the key was under. If the barkeep was not there, it was a serve yourself situation, just leave the money for what you took and be sure to lock up when you were done. Should you be brave enough, ask for the signature Snake Bite whenever you visit—the mixture of liquors is said not to be for the faint of heart. Website: www. whiteoaksnewmexico.com.

The No Scum Allowed Saloon is rated as one of America's Top 10 Cowboy bars. (*DB*)

Nuclear Sites

Project Gnome, Carlsbad, New Mexico

While Project Gnome sounds like a gathering of cute little mythical gnomes running around the desert, this cannot be further from the truth. On December 10, 1961, a 3-kiloton bomb was exploded 1,200 feet below the earth's surface in the desert east of Carlsbad. The idea was innocent enough: could an atomic bomb exploded underground be powerful enough to melt the salt (potash) deposits in the controlled area to create a super-hot salt, which in turn would cause the nearby water source to turn to steam, therefore powering turbines to generate energy?

In the early days of the nuclear industry, there were many unknown factors that were not given too much consideration, such as effects from the radiation on the environment, storage of the irradiated materials, or health issues experienced by the workers who wore no protective clothing to the detonation. Most of the officials donned business suits and the workers who would clean up the area wore a standard uniform of khaki shirts, pants, and steel-toed boots, but they were considered safe because they wore hard hats.

Radioactive steam, dust, and smoke billowed out of the cavity created by the massive blast into the desert landscape. To this day, it is possible to find glass rods in the desert that were fashioned by the atomic heat, much like the ones found around the first nuclear bomb detonation site for the Manhattan Project near White Sands Missile Range, the Trinity Site. These rods are an alien green and are called trinitite and are illegal to gather.

A lonely pedestal, plaque, and plugged hole are all that remain to remind people of the destruction that occurred on that spot so many years ago.

Trinity Site, White Sands Missile Range

The U.S. was embroiled in a terrible war in 1945, against a seemingly unstoppable force—the Japanese Army. Less than one week after the establishment of the White Sands Missile Range (WSMR), the detonation of the first atomic bomb, nicknamed "Gadget," transpired in the range on July 16, 1945. The bomb for the Project Trinity Test was suspended from a 100-foot steel tower. It created a shock and light wave, caused by the mushroom cloud, which rose over 38,000 feet into the New Mexico sky and left an impression in at least a 160-mile radius.

Observers of this power blast were a mere 5.7 miles away and protected only by concrete covered wooden shelters and earthen berms. Protected only by dark glasses, witnesses were nearly blinded by the brilliance of the atomic bomb. The 8-foot-deep impression left by the percussion was a half a mile in diameter and the heat from the explosion produced a dark green glass-like rock, later dubbed as trinitite, which littered the bomb site. Officials would later bulldoze this material into the desert sands and make retrieving the green stones illegal.

The atomic bomb and test were top-secret; therefore, no information would be released about even the existence of such device until it was used as a weapon against Nagasaki.

Today, the Trinity Site is open to the public only two days a year, the first Saturday of April and October. These open houses draw thousands to the isolated site to see Ground Zero for themselves and take a photo next to the rock obelisk, which commemorates the blast heard around the world.

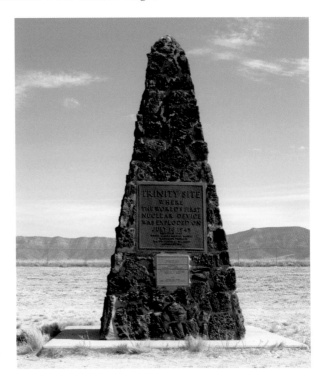

Blast site of the first atomic bomb.
(*Author's collection*)

Annual Events

Bataan Memorial Death March

To honor the fallen and surviving service members of Bataan, the Bataan Memorial Death March is recreated each year at White Sands Missile Range. New Mexico was heavily represented in the Bataan Death March as 1816 members of the 200th Coast Artillery, known as "the Regiment," and the 515th National Guard units (with members from Albuquerque, Santa Fe, Clovis, Carlsbad, Artesia, Roswell, and Deming, New Mexico) were stationed in the Philippines and were said to have fired the first shots in defense of the island. There would be only 987 survivors from these units.

Thousands of participants from all fitness levels walk the 26.2-mile march—some with full rucksacks weighing at least 35 pounds. Family members, military and public groups, and individuals spend a weekend in March to pay homage to the brave 75,000 American and Filipino men who defended the Philippines during World War II and were captured by the Japanese government after a fierce seven-month battle on April 9, 1942. These men were forced to march 65 miles over the course of five days without food, water, and sometimes shoes in horrible heat, swarmed by mosquitos.

Many lost their lives along the route, while survivors were placed in work camps under deplorable conditions. Since the numbers were far greater than the Japanese anticipated, death by starvation, bayonetting, and disease were commonplace to cut down the population, resulting in the deaths of 11,500 soldiers. When the remaining soldiers were rescued three grueling years later by the American and Filipino forces, they were mere

skeletons, some blind, some mute, and they would continue to experience health issues for the rest of their lives because of their treatment. One-third of the rescued soldiers would die of complications when they returned home, related to their horrendous treatment.

On another sad side note is that some of these deaths were unknowingly caused by American forces who sank several unmarked Japanese ships; these ships, known as hell ships, were later revealed to have contained prisoners of war *en route* to Japanese work camps. The Bataan Death March was designated a war crime, and many of the ranking Japanese officers were executed or imprisoned for their role.

Christmas on the Pecos

An enchanting forty-minute boat tour creates a wonderful holiday spirit for all who partake in the adventure. Almost 150 homes along the Pecos River, which bisects Carlsbad, decorate their water-front backyards, boat docks, and islands from Thanksgiving Day to New Year's Eve. Many of the homes are themed with breathtaking light displays, and this is deemed one of the top 100 "must-see events in America." The Carlsbad Navy ferries passengers along the smooth river surface in party barges—two of which are wheelchair accessible. Blankets are provided at the dock, but it is highly suggested that you dress warmly—the river is quite cold at night. Gift shops, hot cocoa, and even ice skating are available on shore. Call early for your tickets as this event sells out fast.

Address: 711 Muscatel Avenue, Carlsbad, New Mexico 88220. Contact details: (575) 628-0952 and christmasonthepecos.com.

Voted one of the Top 100 "Must-see Events in North America," Christmas on the Pecos never fails to delight. (*DB*)

8

ROSWELL

Recognized as the "Alien City" because of the international fame the town received in 1947 when a reported UFO crashed in the desert 30 miles north of the town. Today, this "Roswell Incident" is still a hotly debated subject, with credible reasons on both sides of the issue. Controversy began the day after the sighting was reported to the newspaper when the U.S. Army and Navy became involved in the investigation. Reports were rescinded, witnesses were hushed and threatened, and the entire occurrence was explained off as a crash of a top-secret weather balloon project. Whatever your personal belief on the subject, Roswell is certainly a must see.

Roswell has been called the "prettiest little town west of the Pecos" by Will Rogers.

Roadside Oddities

Alien Donuts?
Towering 22 feet over Main Street Roswell is the ultimate alien sign. Recently built Dunkin Donuts™ has taken the Alien City theme to heart by erecting a large sign resembling a muscular alien made from 2,000 pounds of Styrofoam. The sign has become a hot spot for tourists and locals alike to have their photos taken. Address: 800 N. Main Street, Roswell, NM 88201.

Out of this World Eatery
Alien Culture is alive and flourishing in Roswell. You must hand it to Roswell for taking the alien theme by the horns and running with it, even the local McDonald's™ restaurant is in the shape of a spacecraft. Giving Roswell the bragging rights to having the only spacecraft-shaped McDonald's™ in the world. To further the out-of-this-world experience at the eatery, local artist Larry Welz painted a mural featuring Birdy the Early Bird™ and Ronald McDonald™ flying through space on the side of a building adjacent to the unique structure. Metal and glass form the outer skin of the restaurant, which are highlighted with red neon along the outer ribs to give the building a distinct, outer-worldly glow at night.

Address: 720 N. Main Street, Roswell, NM 88201.

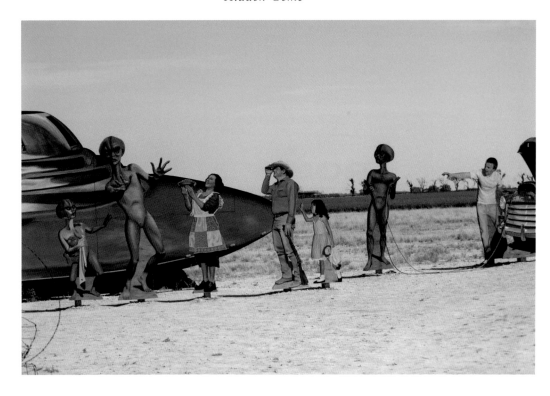

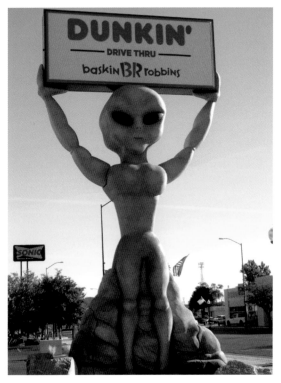

Above: A John Cerney creation of an alien landing draws many travelers off the highway for a photo op. (*DB*)

Left: Keeping with the alien theme, the donut chain erected a unique sign for their Roswell store. (*DB*)

Where else but Roswell could you eat a hamburger in a spacecraft? (*DB*)

Outdoor Adventure: Bottomless Lakes State Park

One of the most asked questions received by rangers and attendants at Bottomless Lakes State Park is "are the lakes really bottomless?" Well, no is the answer, but they do range from 17 to 90 feet in depth. The large sinkholes 14 miles southeast of Roswell provide visitors with hiking, photography, non-motorized boating, swimming, and even scuba diving opportunities. Birdwatching is also a favored pastime for the park visitors and employees.

Address: 545 A Bottomless Lakes Road, Roswell, New Mexico 88201. Contact number: (575) 624-3058.

Not Your Ordinary Museum

Historical Society of Southeastern New Mexico Museum

Located on the corner of Lea Avenue and West Second Street in the historic district of Roswell is a unique museum presented by the Historical Society of Southeastern New Mexico. The museum was once the beautiful home of Mr. and Mrs. James Phelps White, built from the architectural designs developed by Frank Lloyd Wright in the "Prairie or Schooner" style. Wright's architectural style was far before its time, where he incorporated organic elements in his designs. Tours are given each year for the school

The Chavez County Historical Museum has a wonderful archive center, which is open to the public. (*DB*)

children to experience the lifestyle their counterparts lived through in the 1800s. The Historical Society also has a fascinating archive, which is accessible by the public. A must see for everyone.

Address: 200 N. Lea Avenue, Roswell, NM 88210.

International UFO Museum and Research Center

One cannot speak of unusual museums in New Mexico without mentioning the UFO Museum and Research Center in Roswell. This fascinating collection of UFO memorabilia and research of the alleged 1947 flying saucer crash draws thousands of curious visitors each month to experience the alien culture, which has overtaken the city of Roswell. The museum makes a compelling case, but lets the visitor make their own conclusions as whether there is truly life beyond Earth. No matter what you believe, the UFO Museum and Research Center is a must-see and a ton of fun for the entire family.

Started in 1990 by Walter Haut, the public information officer at the Roswell Army Air Field in 1947, the museum has international appeal

Spinning saucers, alien autopsies, newspaper articles, and research facilities are all part of the experience at the museum. As you leave the museum and walk down the main streets of Roswell, you will notice the orange stickers given to the museum attendees stuck on walls, the sidewalk, light posts, alien carving, literally everywhere; unfortunately, people like to leave their mark wherever they go, whether it is right or not.

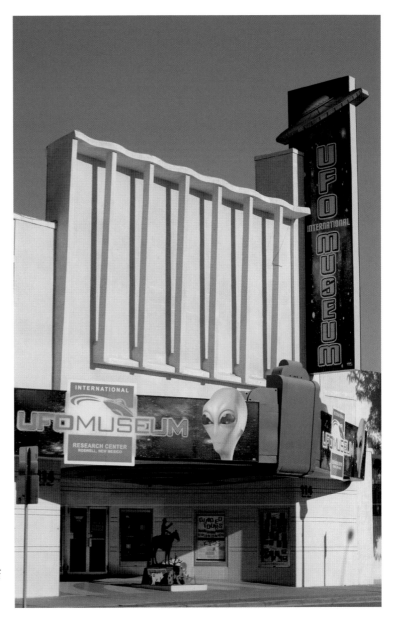

The International
UFO Museum and
Research Center
attracts thousands of
curious visitors each
year. (*DB*)

Outside, you will also notice alien eyes peering at you from the streetlights, "little green and grey men" statues decorating nearly every business in town, alien signage, artwork, murals, and even a spacecraft-shaped McDonald's™ restaurant can be found. It is true to say Roswell has grasped the alien phenomenon by the horns.

Address: 114 North Main Street, Roswell, New Mexico 88203. Contact details: 1-800-822-3545 (Toll Free Worldwide) and www.roswellufomuseum.com. Museum hours: open from 9 a.m. to 5 p.m. seven days per week.

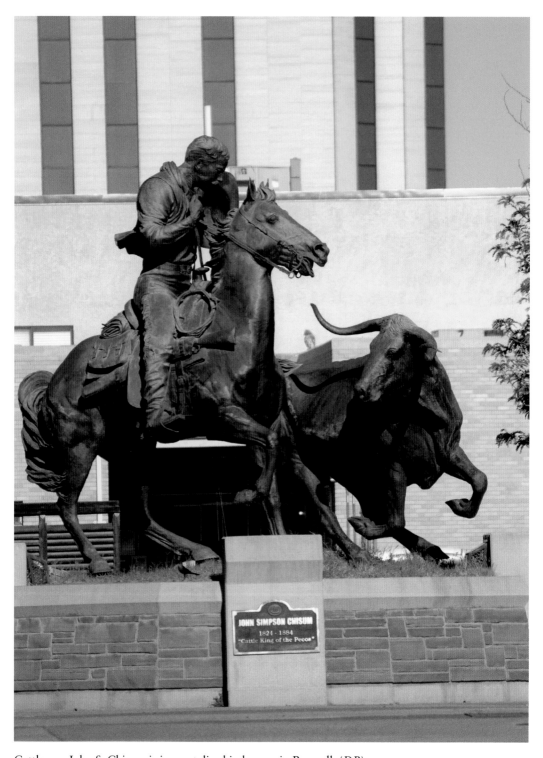

Cattleman John S. Chisum is immortalized in bronze in Roswell. (*DB*)

Roadside Art

John S. Chisum Statue

Prominently featured in the center of Roswell's town plaza is a larger-than-life sculpture depicting John Simpson Chisum, who was known to be one of the largest cattle ranchers in the American West. At one point, his Jingle-Bob Ranch spanned from Fort Sumner to Seven Rivers, New Mexico—making the ranch at least 150 miles on which to run over 100,000 head of cattle.

Tree of Knowledge

Gracing the lawn of the Roswell Public Library is the 17-foot *Tree of Knowledge* sculpture by acclaimed artist Sue Wink, constructed to commemorate the centennial of the library. Ceramic tiles stamped with words and sayings from books are used for the bark of the tree, while metal is used for the branches and leaves. Wink set up a public workshop for patrons to attend and make their own special tiles to show their love for the library and books, these were then incorporated into the design. Some of the metal leaves at the end of the branches are also formed into words for a creative look.

This outstanding artist has also created more works of public art around Roswell, such as the metal and tile work at Reischmann Park in the heart of the town, which features the history of Roswell. Wink's award-winning work can also be found in Albuquerque, Tucson, and across the country.

Address: 301 N. Pennsylvania Avenue, Roswell, NM 88210. Contact number: (575) 627-6179.

Annual Events: UFO Festival

Celebrities, researchers, historians, and the inquisitive have flocked to Roswell over the years, especially in the first weekend of July when Roswell throws an outer worldly party each year to commemorate the alleged crash landing of the 1947 flying saucer in great style. The streets are blocked off as aliens, humans and canine's alike roam freely donned in costumes that are, well, out of this world.

This festival attracts world-wide media attention and cable television celebrity sightings are frequent. Roswell, which has dubbed itself the "UFO Capital of the World," hosts over 20,000 UFO enthusiasts, and the numbers grow continue to grow each year. If you want to attend this fun-filled event, make your hotel reservations far in advance—Roswell has many fine accommodations, but they fill up fast.

Costume contests, seminars, book signings by famous authors (including Roswell's own John LeMay), movies, food vendors, and live music are just a few of the amusing activities that await you in the Alien City on Fourth of July weekend. Website: www. ufofestivalroswell.com.

9

NEW MEXICO CUISINE

Ask anyone from New Mexico, or someone who has visited the state, what is the most unique feature of the state, and they will say the food! The official state question is "Red or Green?" which means, do you want red or green chile sauce on your food, or you can order it "Christmas" style—meaning your food will arrive covered in both red and green chile sauce.

Chile is a staple of the New Mexico diet—and of which the state is famous. And please, it is spelled "chile" not "chili," with the latter being a Tex-Mex condiment for hot dogs or a fare for cook-offs—great food, but it is not chile. If you ever want to ruffle the feathers of a New Mexican, spell chile with an "i," but warning, it will not end well.

Northeastern New Mexico is famous for its red chile, which is the completely ripened chile pod. Chimayó, home to El Santuario de Chimayó, also boasts the best red chile in the state. Seeds for this spicy delight have been handed down through the generations, collected, dried, and planted again in the many small farms and home gardens in the valley. The red chile of Chimayó, also known as landrace or native chile, is smoky in flavor and is rated just above the average jalapeno in zest.

Chile ristras, 5½ feet long, hand strung in the area are dried and then ground into a red chile powder known as *"molido,"* which will supply the ristra owner with enough chile to last the rest of the year. Yes, you can purchase the seeds of the Chimayó chile to grow in your own garden, but the warning that comes with the seeds is that the chile will not taste the same since it was not grown in the rich, red Chimayó soil.

Honors for the best green chile goes to the small town of Hatch in the southwestern region. Chile is the lifeblood of New Mexicans; it is the one ingredient they reach for to include in nearly every dish. When a person moves from New Mexico, chile is what they miss the most since it is not readily found elsewhere in the U.S. Many care packages containing the green gold have been shipped regularly across the country to displaced New Mexicans.

Northern New Mexican is the most authentic style of New Mexican cuisine, with Spanish and Native American influences. You will not find some of the dishes from the north in restaurants anywhere in the state, such as calabacitas. Although you can make this dish made from zucchini and summer squash anywhere, it is most likely found

192

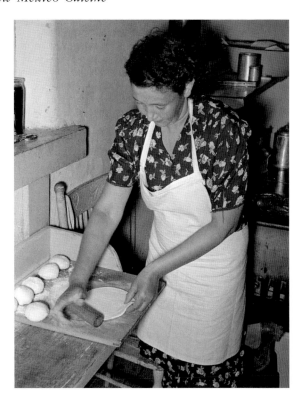

Tortilla making is an art and craft passed down mainly through Hispanic families. (*Library of Congress*)

above Clines Corners. Blue corn tortillas, fry bread, horno bread, piñon empanadas, and posole are also dishes more popular in the north as well.

Staples of New Mexico cuisine are tortillas, both flour and corn, beans (*frijoles*), chile (both red and green), corn, rice, squash (*calabaza*), and potatoes (*pappas*). There are even dishes with all these ingredients mixed with a little onion and garlic to elevate the flavor even more.

Red or Green?

The state question is "Red or Green?" which simply means, do you want red chile or green chile on your food, so do not be surprised and be prepared because when you order New Mexican dishes in our restaurants, you will be asked this question.

So which chile is hotter? Well, that depends. The red chile is the fully ripened, dried chile pod, and is generally more consistence in the heat level, yet it has a more robust taste. Red chiles are generally reconstituted in water to make a delicious red or enchilada sauce. The green chile is picked off the vines before they turn red to be roasted and frozen for the rest of the year. People find the green chile to have the hotter varieties. The green chile is a favorite pizza topping of the locals. One of the hottest green chile varieties was developed by the Chile Pepper Institute of New Mexico State University, dubbed NuMexXX with a Scoville heat index of 60,000–70,000 units.

Other factors also include the amount of rain received during growing season, altitude, the alkaline in the soil, and variety of chile. One of the best-known dishes using the green chile is the Chile Relleno—a roasted green chile traditionally stuffed with cheese, but sometimes meat, battered, and fried. Even the types of batters vary from region to region.

Traditionally, after the chile harvest in northern New Mexico, you can see the terra cotta roofs of the adobe homes covered in red chiles, which have been places there to dry. These pods will be made into chile powder and eventually red sauce. Chile ristras, the long hanging strings of chile pods sometimes decorated with raffia and dried flowers, are also a common means in which to dry the chile. Ristras are found statewide and are sold in roadside stands.

Chile roasting season—August through October—is a highly anticipated time. The aroma of roasted green chile is some of the best perfume in the world, and it will nearly stop a state native in their tracks. There is no better smell than roasted green chile. When the large, metal, propane-fueled tumblers appear on the sidewalks in front of nearly every grocery store in the state, people line up to buy cases of their favorite vegetable to fill the extra freezers located in a great majority of the New Mexico homes. A huge rivalry between Colorado, who is trying to say they have the best green chile, and New Mexico, who already knows they have the best green chile, continues to brew, sparking social media meme wars.

Delicious green chiles are king in New Mexico. (*Library of Congress*)

Holiday Traditions

Thanksgiving through New Year's is a delicious time of year. A steamed dish consisting of a chicken, beef, or cheese filling surrounded with masa and wrapped in a corn husk—otherwise known as a tamale—is the ultimate indication that the holiday season is officially started. Made by the dozens, the tamale is great one its own, or smothered with your choice of sauce. Dessert tamales are also offered as a sweet treat, often filled with pumpkin or apples.

Hatch Chile Festival

The Hatch Chile Festival is celebrated each Labor Day weekend and brings in chile enthusiasts from around the U.S. Red and green chiles are the stars of the two-day event, which brings in 30,000 people to the tiny town in southwestern New Mexico. Festival planners are excited that the Food Network and the BBC are also represented in Hatch.

What are some of the favorite dishes of New Mexicans you ask? My personal favorite is the red chile cheese enchilada (EN-cha-lada), which can be made in a variety of ways—each one delicious. The foundation is generally the same, just the ingredients differ slightly. They are usually corn tortilla based, can be stacked, rolled, or in a

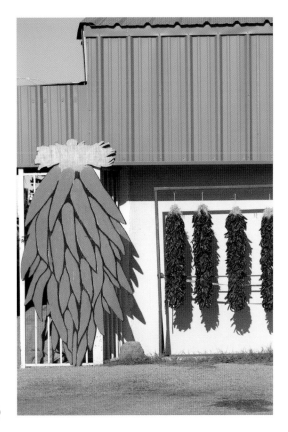

The Hatch Chile Festival is a much-anticipated tasty annual event. (*DB*)

casserole, filled with beef, chicken, or cheese, and topped with the chile of your choice and an extra helping of cheese. Many prefer a softly fried egg gently placed on top of their enchilada stack.

New Mexico is also boasting a state cookie: the biscochito (Bis-CO-cheeto or Bis-CO-Cho) is a traditional cookie used for weddings, holidays, and family gatherings, which were introduced in the state by the Spanish in the sixteenth century. This delicious cookie became official in 1989 to encourage traditional home-cooked foods, making New Mexico the first to recognize an official state cookie symbol.

Official Biscochito Recipe

This is the official recipe for New Mexico's state cookie (compliments of the New Mexico Secretary of State):

Ingredients: 6 C. flour, ¼ Tsp. salt, 3 Tsp. baking powder, 1½ C. sugar, 2 Tsp. anise seeds, 2 eggs, 2 C. manteca (lard), ¼ C. brandy, ¼ C. sugar, 1 Tbsp. cinnamon
Directions: Sift flour with baking powder and salt. In a separate bowl, cream lard with sugar and anise seeds until fluffy. Beat in eggs one at a time. Mix in flour and brandy until well blended. Refrigerate 2–3 hours. Turn dough out on floured board and pat or roll to ¼- or ½-inch thickness. Cut into shapes (the *fleur-de-lis* is traditional) with a cookie cutter. Dust cookie with a mixture of sugar and cinnamon.
Bake 10–12 minutes at 350° or until browned.
Cool on a rack
It is a tasty treat to be lucky enough to receive biscochitos for a gift anytime.

Wine Trail

New Mexico is known for a lot of things, but wine may not be necessarily one of them. We are the oldest wine industry in the U.S. with a recorded starting date of 1629, which places New Mexico 140 years ahead of California. Due to the influence of the Spanish culture into the state, wine was used up to three times a day for the Catholic Mass held in the mission churches scattered across northern New Mexico.

Spain was in total control of the manufacture, shipment, and distribution of wine in the New Spain region, which took nearly three years to get a vat of wine from Spain to New Mexico (New Spain) having to cross treacherous seas, and hundreds of miles in an ox-drawn cart (wagon) from Central Mexico to Santa Fe. The Franciscan Friars, who established the missions, had to ration the wine, and became frustrated with the process. Legend states the friars smuggled their own grape vines from Spain for the sacrament, these grapes would be known as Mission grapes from then on. Planting began in 1626, with the first wine produced in 1629, by the late 1800s, New Mexico was producing over a million gallons of wine annually, which was eventually ruined by prohibition.

Today, the wine industry is flourishing, since a wide variety of micro-climates exist in New Mexico, with each area and winery totally different from the last. New Mexico can produce a wide variety of grapes because of the altitude fluctuations and soil contrasts throughout the state. With over sixty wineries, tasting rooms, and distilleries to choose from, you will not run out of delicious wines to taste.

As with other industries and cultures in the state, the Rio Grande played a prominent part in their success or failure. New Mexico is subject to droughts and great floods. We are told that we can expect a certain amount of rain each year, depending on region, but what generally happens is that it all comes at once during the monsoon season. Wineries are in every section of New Mexico, stretching from the Mesilla Valley in southwestern New Mexico, Pecos Valley in the southeast and along the Interstate 25 corridor to northern New Mexico. The only part of the state without a winery is the far northeastern corner—most likely due to the fridge weather conditions that can occur there.

New Mexico produces award-winning wines that can hold their own with the national and international markets as their many gold, silver, and bronze medals prove. The state has good grape growing soil and given some water, can produce outstanding crops.

The wineries near Santa Fe offer Wine Tours which are a wonderful way to sample all the delicious offerings of the wineries without worrying about driving afterwards.

True to New Mexico, St. Clair Winery has developed green and red chile wines. The combination of roasted, chopped green chile added to a cold white wine produces a spicy, semi-sweet drinking wine, which is popular at local tasting rooms. This wine does not have a "hot" taste, but you can detect the roasted chiles in the aftertaste. Red chile wine is a smokier, spicy wine that can be used as a wonderful marinade for steak or chicken or enjoyed as a wine that pairs beautifully with chocolate desserts.

New Mexico has the oldest wine industry in the U.S. (*DB*)

Tree Martinis

A long-standing tradition in the Taos Ski Valley is Tree Martinis. As the legend is told, in the winter of 1958–1959, a woman was caught in a bad lightning situation while trying to descend the slopes and became too afraid to come down from the mountain. Ski Valley owner and ski instructor Ernie Blake sent his son down the mountain to retrieve a dry martini in a Spanish *porron* (a glass pitcher with a long spout to make drinking easier). After the woman downed several of the martinis, her confidence returned, and she was said to ski down the mountain perfectly.

From that time forward, Blake had several *porron*'s stationed around the slopes to help anxious skiers. At first, the pitchers were nestled in the snow under trees marked with yellow tape, but over the years earned special wooden birdhouse like structures built to keep the containers. Today there are at least four *porron*'s on the ski runs and anyone over the age of twenty-one can partake (they do check I.D.).

Ski magazine dubbed this ski school one of the "elite ski clubs of America," and gave the club the moniker of "HAMS" or "High Altitude Martini Skiers." Membership in HAMS is earned by drinking a martini in an unpressurized environment of at least 11,000 feet in elevation with at least one limb touching the ground. It is highly cautioned to limit your intake of any alcoholic beverage while skiing.

Green Chile Cheeseburger Trail

Nothing says New Mexico cuisine more than the green chile cheeseburger. The Green Chile Cheeseburger Smackdown is held each year at the New Mexico State Fair to determine the best burger in the state. Burger joints, high-end restaurants and food trucks all vie for the title of "Best Green Chile Cheeseburger of New Mexico."

This is a highly coveted prize, which the winner displays proudly; the competition can be fierce because this prestigious title has been known to boost the winner's business tremendously. No matter the official winner, everyone in New Mexico has their own favorite and will fiercely defend their choice. If you have not tasted this mouthwatering delight, it is a crying shame.

Owl Bar & Cafe

The Owl Bar & Cafe in San Antonio, New Mexico, has been at their location since the 1940s and has long been the one to beat. Located at the crossroads of Highway 380 and I-25 between Truth or Consequences and Socorro, this small café and bar has set a high bar in the green chile cheeseburger world. Many may be surprised to learn Conrad Hilton was born in the tiny village, and the bar used in the Owl Bar is originally from his father A. H. Hilton's rooming house in the town. Hilton's rooming house, saloon, and mercantile burned down in 1945, but the front bar was able to be salvaged and is now the shining star of the Owl Bar & Cafe. The 25-foot mahogany bar is now a registered piece of cultural property.

Families, tourists, and wandering souls have all visited the Owl since it opened in 1945 by World War II Navy veteran Frank Chavez and his family, many just to taste

The Owl Café and Bar in San Antonio, New Mexico, is one of the longest-standing green chile cheeseburger winners. (*DB*)

the famous Owl Burger. Among these were a group of men who described themselves as "prospectors." They were atomic scientists who were working at the White Sands Missile Range an hour away. Atomic research was a highly secretive program at the time and this group would be responsible for the research and development of the atomic bomb that was detonated at the Trinity Site on July 16, 1945. They were also responsible for requesting Frank put a grill in the bar—thus allowing the birth of the famous burger.

Today, over 200 eateries from all-around the state includes the delectable burger on their menus.

Culinary Delights

Pie Town, New Mexico
Just past the Very Large Array is a town that is famous for one thing—pie. It is nicknamed "America's Friendliest Little Town." Holding to the pie theme, and please pardon the pun, the motto of the town is "3.14 miles from the middle of nowhere."

In the early 1920s, Clyde Norman started a dried-apple pie business along the desolate highway between Socorro, New Mexico, and the Arizona border. The town's name was derived from The Daily Pie Café, which was the only eating establishment in the region. Everyday life in the small town was immortalized in 1940 by photographer Russell Lee who worked for the Farm Security Administration and documented the residents and called national attention to Pie Town.

Pie Town, New Mexico, holds an annual Pie Festival where attendees can taste some of the best pie in the state served in the three cafes in town. Exotic flavors tempt visitors with delights such as Mango Red Chile, Apple Green Chile, Peach Green Chile, Chocolate Chess with Red Chile, Green Apple with Piñon Nuts, as well as the tried and true standard Cherry, Pecan, Apple, Chocolate Cream, Blueberry, Lemon Meringue, and Peach. Also, at the Pie Festival are antiques, art, pie-making contests, games, music, and jewelry vendors, which make the tiny town with a population of 186 on Highway 60 the place to be on the second Saturday of each September.

Pie is not their only claim to fame, they are also tough competition in the green chile cheeseburger world of New Mexico made at the grill.

Address: 5596 U.S. Pieway 60, Pie Town, New Mexico 87827. Contact number: (575) 772-2700.

Sparky's, Hatch, New Mexico
Owners Teako and Josie Nunn have created a niche for themselves in the "Chile Capital of the World," Hatch, New Mexico. Avid collectors of jukeboxes, video games, larger-than-life-size artwork, and the like, the Nunn's have surrounded their corner restaurant with reminders of the past. A giant Uncle Sam, Statue of Liberty, Burger Boys, chiles, and roosters adorn Sparky's property and draw huge crowds to their doors to taste a New Mexico specialty, the green chile cheeseburger. Across the street, at the Nunn's headquarters, a menacing T-Rex stares at customers standing in line to get into the burger joint.

Pie Town is dedicated to pie of every description. (*Library of Congress*)

A couple of Sparky's fans, legendary rocker Ozzy Osbourne and his son, Jack, stopped in to see what all the hubbub was about during the filming of their television show *Ozzy and Jack's World Detour* in 2018. Teako's massive collection was also featured on *American Pickers* in 2015. Sparky's is also a regular competitor in the Green Chile Cheeseburger Smackdown.

While at Sparky's, quench your thirst with a green chile lemonade, which starts out tart and sweet as with any lemonade, but finishes with a kick from the green chile. A favorite at Sparky's is the New Mexico Shake, which is a delicious, although unconventional, combination of soft serve ice cream and green chiles. Do not knock it until you have tried it

New Mexican Sundae

While in the Mesilla Valley, be sure to try a New Mexican Sundae unique to Las Cruces, New Mexico. At Caliche's Frozen Yogurt, you can get a truly delectable dessert comprising of creamy vanilla yogurt, topped with a green chile sauce and Mesilla Valley salted pecans. There are two locations in Las Cruces and one in Alamogordo, New Mexico, for your enjoyment.

Fry Bread, Navajo Nation and Jemez Pueblo

This delicacy is sought out by locals and tourists alike. Fry Bread is much like a thicker, flattened sopapilla topped with meat, beans, cheese, lettuce, and tomatoes. Typically made in roadside stands along the highways in the northwestern and northeastern sections of New Mexico, this dish also graces the menus of many restaurants in the state.

Many of the roadside stands have been owned by the same families for generations. These booths can be found near Ponderosa, Gallup, Grants, and Farmington, New Mexico.

Fry bread recipe: The Native American culture in northwestern New Mexico has been creating a delicacy known as Fry Bread for hundreds of years. This recipe is the closest to the original used by the Navajo Nation for centuries.

2 Cups All-Purpose flour or Bluebird flour (most widely used brand)
4 Teaspoons Baking Powder
2 Tablespoons Powdered Milk
Shortening or Lard (most widely used – Manteca or John Morrell Snow Cap Lard)
⅔ Cup Warm Water
½ teaspoon salt

1. Combine flour, baking powder, powdered milk, and salt in large bowl.
2. Add warm water to make a smooth, elastic dough.
3. Divide dough into balls of desired size. On lightly floured board, roll out each ball of dough into a one quarter inch thick circle. Cut a hole in the center of each circle – this is an important step.
4. Heat two inches of shortening or lard in a heavy pan (cast iron is recommended) at a medium-high heat. Oil temperature should be 350 degrees.
5. Fry dough in shortening one circle at a time until golden on both sides – turning only once. Drain on a paper towel.

Topping
4 Cups Pinto Beans, cooked and drained
1-pound ground beef, cooked (chicken, pork or turkey can be used as well, but beef is traditional)
1 Cup Green Chile, chopped and added to the beans
1 large Onion, chopped
1 large Tomato, Chopped
Salt and Pepper
Iceberg Lettuce, shredded
Cheddar Cheese, grated
Sour Cream, optional
Salsa, optional
Layer ingredients in this manner: beans, meat, lettuce, onion, cheese, tomato, sour cream, and salsa.

Dessert

Flan and Empanadas

A favorite desert in New Mexico has Mexican roots. The delicious custard-like dish is made traditionally with evaporated milk, eggs, vanilla, and cinnamon poured over a caramel crust and baked to perfection.

Empanadas are little fried pies filled with sweet or savory delights such as hamburger and green chile, apples or pumpkin. Delicious treat to end a meal or start a day.

A delicious custard-like dessert brought to New Mexico by the Spaniards is called flan. (*Author's collection*)

10

ENCHANTED BYWAYS

Judging from the sheer number of scenic byways in New Mexico, it is safe to say the state is truly the Land of Enchantment. Each byway has unique sites and features with a beauty all its own.

Abo Pass Trail Scenic Byway

Known as the byway of connections due to how this byway connects the town of Belen with the Abo Pueblo by means of New Mexico Highway 40 and then Highway 60, this trail also intersects the El Camino Real Scenic Byway to the Salt Missions Scenic Byway.

Billy the Kid National Scenic Byway

Follow along in the footsteps of one of the most famous outlaws of New Mexico as you travel the 84 total miles of the Billy the Kid National Scenic Byway. The Hondo Valley was a favorite haunt of the boy outlaw and when you travel this scenic byway, you will see why. Historic towns, fruit stands, churches, unique museums, art galleries, an iris farm, and all things Billy await you.

Officially beginning in Hondo, New Mexico, the gateway to the Billy the Kid National Scenic Byway, you will find a tranquil valley that was witness to years of turmoil and terror. Today, the valley is dotted with the historical ranches, which were homes to the main players in the Lincoln County War.

Lincoln County was once the largest counties in the U.S., but it has since been divided off into five separate counties, each with rich history attached. If you turn right at the Y of Highways 70 and 380, you will be fast on your way through history with your first stop at the National Historic Landmark of Lincoln, New Mexico. One of the best-preserved examples of an "Old West" town in the country, the two-lane road that bisects the town of Lincoln was once termed as the "most dangerous street in America" due to the amount of deaths that occurred on the dusty path.

Today, Lincoln is home to the Lincoln State Monument and includes the Anderson-Freeman Museum and a fascinating self-guided walking tour of the historical buildings lining the now peaceful street. "Lincoln After Dark" is a popular tour held after the sunset and features members of the historical society giving lantern walking tours of the town while telling tales of murder and mayhem. Call ahead for information on admission fees and special events (505) 563-4372.

Between Lincoln and Capitan is a large boulder that locals and tourists have taken to decorating. The northern part of New Mexico has El Morro, Lincoln County has their boulder. Graphics on the rock change constantly making its discovery fresh and new each time you drive by. Be sure to look on the hillside across from the boulder to the right when traveling to Capitan to see a fascinating rock formation the author has dubbed "skull rock" (the light must be right for the feature to stand out). Be sure to be on the lookout for wildlife along this narrow stretch of road—Barbary sheep, deer, and sometimes elk have been known to cross the road.

Next on stop on Highway 380 is Capitan, New Mexico, whose most famous resident is still the largest advocate for fire safety—Smokey the Bear. Visit Smokey's museum, restaurant and stay at the Smokey the Bear Lodge for the full authentic experience. The Capitan Public Library is a complete delight and run by volunteers who you can tell genuinely love their community. Support for the library is gained by donations and the operation of a thrift store where you will find many unique treasures. The library is located on New Mexico 48 (which will be a left turn off Highway 380 at the Oso Grill). The back road is also home to the Capitan Museum, which is occasionally open. You will also notice a private yard to your left that will contain some of the largest felines you have ever seen.

You will be able to get to Ruidoso from Capitan by taking New Mexico 48, and along this drive you will notice parts of the forest with obvious burn scars, this is the results of the Little Bear Fire in 2007, which nearly devastated the entire forest and threatened the destruction of the town of Ruidoso. Terror ran through the hearts of Capitan, Nogal, and Ruidoso residents as they watched their beloved forests being ravaged by a raging wildfire. Recovery has been slow, but the forest is beginning to revive. An overlook is set up on the side of the winding, narrow road that explains the fire in detail. New Mexico 48 has steep elevations, tight switchback, and a strict speed limit.

Between Lincoln and Capitan is Fort Stanton, which is a short trek up the road and well worth the diversion. Fort Stanton has seen duty since before the Civil War and is still in operation today. A small, but beautifully maintained museum and gift shop is in the visitors' center, which once served as soldiers' barracks in 1855. Ordered burned in 1861 during the Civil War before the fort was seized by Confederate troops, Fort Stanton was lovingly restored by volunteers through a grant from *Save America's Treasures.*

"Fort Stanton Live!" which begins in mid-July, provide visitors with living history tours of the fort with personnel dressed in period-style clothing and featuring storytellers, Buffalo Soldiers, and Mescalero Apache Mountain Spirit dancers. "Fort Stanton After Dark" is an evocative lantern tour of the fort grounds after dark—complete with ghost tales, all for an entry fee of $5, which goes towards the continuous preservation of the historic site. Check the website for dates and times.

Please do not forget to visit the Fort Stanton Merchant Marine Military Cemetery and Fort Stanton State Veteran's Cemetery only a mile further up the road on New Mexico

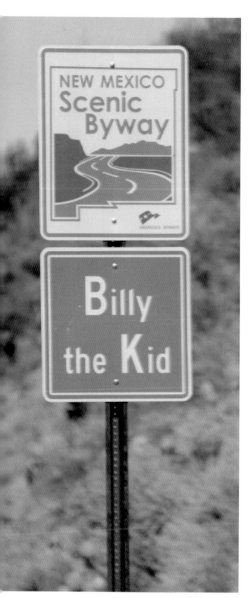

Above left: Billy the Kid Scenic Byway sign near Hondo, New Mexico. (*DB*)

Above right: A likeness of Smokey the Bear standing before the mountains where he was found after the fateful fire. (*DB*)

220. Originally, the cemetery held members of the U.S. Cavalry who were stationed at the fort and later used for those who perished in the hospital from tuberculosis. Fort Stanton State Veteran's Cemetery is the first state-managed cemetery for veterans of New Mexico who have been honorably discharged and their spouses and is separate from the Fort Stanton Merchant Marine Military Cemetery, which you will see first as you enter through the gates.

It is unusual to see a ship anchor in the middle of the high desert, but it was brought to the Fort Stanton Merchant Marine Military Cemetery as part of the Project Liberty Ship. The American Merchant Marine Veterans, Roadrunner Chapter of Albuquerque, New Mexico, placed the anchor at the cemetery, which bears this inscription:

This five-ton anchor taken from the SS *Drake Victory* is a memorial to Merchant Marine Veterans of WWII wherever they are. Their casualty rate of 1 to 32 was one of the highest of all services. Dedicated May 22, 1933.

You may also notice five lonely graves to the left of the main cemetery as you enter, these belong to members of the crew of the SS *Columbia*, who died while interned as a prisoner of war in World War II. Two died from trichinosis, one from suicide and one from murder, and one who requested to be brought here from Germany to be buried after his death. Website: www.fortstanton.com.

Anchor at the Merchant Marine Cemetery at Fort Stanton. (*DB*)

Spencer Theater

Should you decide to remain on New Mexico 220, which takes you to the Fort, you will pass the Ruidoso Airport and the Spencer Theater. The Spencer Theater for the Performing Arts is a seven-story architectural wonder designed by Antoine Predock. "The Spencer," as it is known locally, is also home to a stunning collection of art glass by Seattle glass sculptor Dale Chihuly. The Spencer is open for free guided tours (donations are gladly accepted) on Tuesday and Thursday—except when there is a performance, at 10 a.m. There are performances, many well-known, big name draws, every eleven days year-round. Website: www.spencertheater.com.

The first leg of your tour will be complete in Alto, New Mexico, turn to the left to go into the village of Ruidoso or left to go to Ski Apache. If you choose left, be mindful there is a herd of wild horses in the area, who will sometimes be in the roadway. Be alert as well to deer and elk who also like to play in the streets.

Ruidoso is a quaint mountain community full of friendly, talented people who love to cater to the tourist culture. Art galleries, wineries, clothing, and unique furniture stores, along with restaurants and bars, line the narrow streets of Mechem and Suddreth as they wind through the ski village. Be sure to stop and wander through the shops, you will be guaranteed to find a treasure to commemorate your trip.

As you leave Ruidoso on Highway 70, still following in Billy's footsteps, you will be in Ruidoso Downs, which is famous for horseracing and the "Million Dollar Futurity." Also, in the Downs is the Hubbard Museum of the American West and the Billy the Kid National Scenic Byway Visitor Center. Further down the road is Fox Cave in Glencoe, New Mexico, which is well worth the stop as an interesting side jaunt. These attractions are described in greater detail in the Southeastern New Mexico chapter.

As you travel towards Hondo, originally called La Junta, on Highway 70, you will notice several fruit stands—both active and closed. The Hondo Valley was known for their apple orchards and the fruit along with vegetables from local farms were sold in roadside stands. Sadly, only two remain along the byway. Colorful chile ristras and painted pottery harken the traveler to explore the shops. Inside you will find local honey, piñon nuts, pistachios, candy, and jellies, as well as more artwork, all of which are highly recommended. Another interesting feature on the left side of the road is St. Anne's Church, situated, fittingly enough, at the mouth of Devil's Canyon.

On the way out of the Hondo Valley, you will travel through several villages, such as San Patricio, which was once called Ruidoso, and is the home of the Hurd La Rinconada Gallery, which features the works of local artist Peter Hurd as well as providing wine tasting and lodging.

Hondo, New Mexico, officially marks the end of the Billy the Kid National Scenic Byway. The tiny hamlet has an Allsup's, which is one of the busiest convenience stores in the state since it is the last store before heading into Roswell. Native New Mexicans rave about the Allsup's burritos and tamales that make a great road snack.

The Spencer Theater brings a variety of cultural entertainment to Ruidoso. (*DB*)

Roadside fruit stands in the Hondo Valley provide opportunities to purchase local produce and honey. (*DB*)

Chain of Craters Backcountry Byway

This unpaved byway, County Road 42, travels through the El Malpais National Monument along a 33-mile trek. During your journey, you will be able to explore ancient lava flows in an outer-worldly landscape. You can access this unique road by either NM 53 or NM 117, and it is highly suggested you only attempt this road in good weather conditions with a four-wheel-drive vehicle.

Corrales Road Scenic Byway

Skirting the Rio Grande from Alameda Avenue at the edge of Albuquerque, New Mexico, to Highway 528 in Rio Rancho, New Mexico, the Corrales Road Scenic Byway covers 10 miles and includes 400 acres of prime Bosque land and cottonwood forest. Over 180 species of birds migrate and nest along the river, giving great opportunities for bird watching. Corrales, New Mexico (which is Spanish for "corrals"), is a historical rural village between Albuquerque and Bernalillo and is known for being prime horse country. Originally settled by Spanish colonists during the late 1500s, the quaint village is also home to the Church of San Ysidro, which was built in 1868. Corrales is also home to many artist's galleries, bed and breakfasts, and numerous cafes, many organic,

The scenery at the Chain of Craters Scenic Byway is stunning. (*Author's collection*)

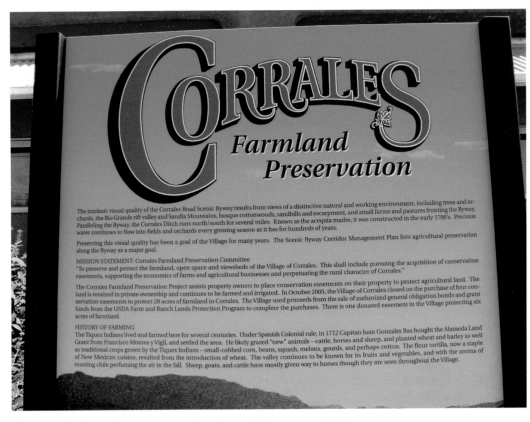

The Corrales Scenic Byway starts at the edge of Albuquerque. (*DB*)

as well as at least five wineries that specialize in wines made of their own varieties of grapes grown on the properties. The fertile Rio Grande Valley is the perfect soil for grape growing, which produce a superior-quality wine. Due to the large number of wineries in the small village, it is said this makes Corrales the "Winery Capital of New Mexico" as well as the oldest wine-growing region in North America. Be sure to watch for bicyclists on the narrow road, which winds through the picturesque countryside to Corrales.

El Camino Real National Scenic Byway

The El Camino Real National Scenic Byway follows along the modern-day Interstate 25 and branches off to Highway 285 between Santa Fe and Española, New Mexico. This 310-mile-long drive follows along the original route of the El Camino Real, which was forged by Spanish explorers and settlers as they first entered New Mexico, or as they knew it, New Spain. The Royal Road was used as the major trade route from Mexico to Colorado, mostly following the Rio Grande.

El Frontera Del Llano Scenic Byway

Cutting through the high plains far northwestern New Mexico is the El Frontera Del Llano Scenic Byway, which provides a beautiful view of the Kiowa and Rita Blanca National Grasslands. Herds of pronghorns (commonly called antelopes) graze in the open fields as you follow from the tiny hamlet of Abbott, New Mexico, to Logan, New Mexico, where Ute Lake State Park is located. Several small villages will dot the route each containing small historic mission churches. Downtown Roy, New Mexico, features the only gas station along the byway, so be sure to stop should you need fuel or refreshments.

Enchanted Circle Scenic Byway

Encircling Mount Wheeler, the highest point in the state at an elevation of 13,159 feet, the 85-mile byway is clearly one of the most stunning drives in New Mexico. National forests, valleys, plains, lakes, mountains, charming village resorts, and mesas are encompassed. This north-central byway includes the towns of Taos, Questa, Eagle Nest, and Red River, as well as the ghost town of Elizabethtown. The narrow two-lane road highways of U.S. 64, Highway 38 and Highway 522 will have you looking up the numbers of local real estate agents so you can purchase your own piece of Heaven.

This beautiful lake at Eagle Nest is part of the Enchanted Circle Scenic Byway. (*DB*)

211

Geronimo Trail National Scenic Byway

This byway was established to protect and show-off the Corridor area for its multi-cultural heritage and natural resources. The 150-mile byway starts and ends at the Gila Wilderness and takes you through forests, deserts, and mountains during your journey. Along the byway, you will see two of the largest lakes in New Mexico, Elephant Butte Lake and Caballo (Horse) Lake as well as several ghost towns.

The Northern Black Range Route will have you passing through the towns of Winston, Cuchillo (Knife), the ghost town of Chloride, Monticello, Beaverhead, and the Continental Divide National Scenic Trail. Chloride is home to a museum that has been described as a time capsule to the past.

The Southern Black Range Route will encompass the ghost towns of Hillsboro, Kingston, and Lake Valley, Emory Pass, and San Lorenzo.

The Rio Grande Route will take you to Elephant Butte Lake, Engle, Truth or Consequences (which is home to the Geronimo Trail National Scenic Byway Visitor Center), Williamsburg, Caballo, and the Percha Dam State Park.

The Geronimo Trail National Scenic Byway encompasses Highway 152, NM 187, Highway 52, and Highway 59. Highway 152 can be a bit treacherous with its many switchbacks and narrow lanes, but the view along the way make up for the feeling in the pit of your stomach.

The Geronimo Trail Scenic Byway encompasses a large variety of landscapes. (*DB*)

212

Travel tips: it is suggested, as always, to begin your journey with a full tank of gas. Although there are many places along the byway to stop, it is always a good idea to start fresh since it covers a lot of miles. Also, please be mindful of cyclists who use the byway to ride. Open range is all along the way, so there will be cattle on the narrow roads. In the Hillsboro and Kingston area, there are narrow bridges passable by only one vehicle at a time, so courtesy is a must.

Guadalupe Back Country Scenic Byway

The oil and gas fields of southeastern New Mexico are the most prominent attractions along this byway. Beginning 12 miles north of Carlsbad, New Mexico, the Guadalupe Back Country Scenic Byway passes deserts covered in prickly pear cactus and sotol (a relative of the yucca, but with thinner petals, and can be distilled much like the mescal), which find any opportunity to grow, even out of the sheer rock faces of the limestone cliffs.

This byway can take you in two directions, first diversion is Sitting Bull Falls, which is an unexpected oasis in the desert featuring a waterfall and recreational facilities, and a more direct route to the Lincoln National Forest where the tiny community of Queen is located. You will pass a monument with an airplane propeller attached, which is dedicated to "the Paperboy of the Guadalupe's." Frank Kindel was a much-beloved member of the community of Carlsbad and would deliver the newspaper to the remote ranches in the Guadalupe Mountains by airplane. One fateful Easter morning after Mr. Kindel was taking the local preacher back to town, he had a heart attack and crashed the plane. The preacher survived, but Mr. Kindel unfortunately perished. This was a dark day for the citizens of Carlsbad since Frank Kindel was known as "Mr. Carlsbad."

At the village of Queen about 3 miles from the monument, you will be able to taste one of the best green chile cheeseburgers in the state at the Queen Café. About a half mile from the café is the Queen Chimney, which is the only remnant of the town of Queen.

While traveling this narrow road, take note that it is an open range and there will be livestock in the road at any given time. This byway is also a favorite for motorcyclists, so be mindful of these other vehicles on the road. This area is also used for hunting, so be extra careful when traveling this byway during hunting season.

High Road to Taos Scenic Byway

Along this byway you will find historic New Mexico churches, art galleries, mountain vistas, and countryside so beautiful your soul will be deeply touched. Take a diversion from traveling only the Interstate from the state's capital of Santa Fe. Head north for 25 miles toward Tesuque and Pojoaque Pueblos on Highway 285 turn right on to Highway 88, which turns into Highway 76 to Chimayo. You will pass the ancient villages of Truchas, Trampas, Chamsal, Penasco, and finally Rancho de Taos. Each of these villages have been immortalized in hundreds of photographs, paintings, and drawings. Every turn of the narrow two-lane road will have an extra-special sight you

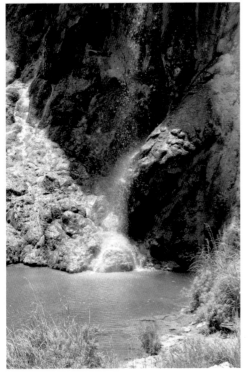

Above: The Guadalupe Backcountry Byway runs 30 miles through the Chihuahuan Desert. (*DB*)

Left: Sitting Bull Falls near Carlsbad is an oasis in the desert. (*DB*)

The High Road to Taos winds through historic and artist villages. (*DB*)

need to stop to enjoy. Colonial-era churches, quaint cemeteries, and fantastic views await you.

You will travel along tree-lined roads, marvel at the wildness of the rugged badlands, trek through the high desert terrain dotted with piñon and junipers, and be able to visit the quaint roadside galleries that are open along the 52 miles of the High Road to Taos Scenic Byway on Highway 76. A short distance off the main highway is Picuris Pueblo, which is one of the oldest in the state and features a museum that has beautiful examples of beadwork and pottery from the pueblo. Permission for photography must granted before taking any image of the pueblo.

Jemez Mountain National Scenic Byway

Unique features along this beautiful byway include the Jemez State Monument, Jemez Falls, Jemez Springs, Soda Dam, and Battleship Rock. NM4, U.S. 550, and NM 126 will provide you with some of the most spectacular views in the state and is said to be one of the most photographed byways in the state. You will be awestruck as to the amount of beauty and hiking opportunities in this 163-mile byway

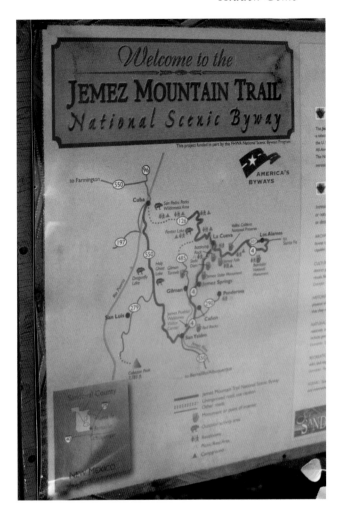

Jemez Mountain Trail National Scenic Byway will leave you breathless from the beauty. (*DB*)

Lake Valley Back Country Byway

Remnants of gold and silver mining communities dot the roadside in the Lake Valley region. The old schoolhouse serves as a museum run by volunteers in the Bureau of Land Management managed and partially restored ghost town. The Bridal Chamber Mine sits proudly on the hillside where it was once the richest producing silver mine in New Mexico. Deep in the heart of the Black Range Mountains, the 48-mile-long Lake Valley Back Country Byway encompasses Lake Caballo, the Caballo, Mimbres Mountains, and Cooke's Range.

Location: NM 27, Hatch, New Mexico 87937. Contact number: (575) 525-4300. Directions: Drive 17 miles west on New Mexico State Highway 152 from Interstate 25 to Hillsboro, where it intersects the Geronimo Trail National Scenic Byway, then turn south on New Mexico State Highway 27 to the ghost town of Lake Valley and then on to Nutt on New Mexico Highway 26.

Ghost towns and mining communities dot the Lake Valley Scenic Byway. (*DB*)

Mesalands Scenic Byway

Mesalands Scenic Byway includes two State Parks, one historic ranch, an historic town, a popular recreational spot, and a dinosaur museum. Depending on which direction you begin your journey, you will eventually travel in a figure-eight configuration. Traveling from the south from Fort Sumner, you will begin at Sumner Lake following along NM 84 to Santa Rosa, New Mexico.

Santa Rosa is a hub on the major thoroughfare, Interstate 40, but is also home to The Blue Hole, which is an 80-foot-deep hole of clear water with a constant temperature of 64 degrees, which draws in tourists and seasoned scuba divers alike. Santa Rosa is known as the City of Natural Lakes—of which it is surrounded by four. Fishing, camping, and picnicking are readily available in the region.

From Santa Rosa, you will travel east and have a choice of going south on NM 91 to Puerto de Luna (Door of the Moon), a small historic village that was once the honeymoon spot in New Mexico of the 1800s. Noted figures such as Pat Garrett who chose this spot to get married and honeymoon and Sally Chisum who also honeymooned in the picturesque hamlet. Outlaw Billy the Kid had many friends in Puerto de Luna and spent what would be his last Christmas in a home owned by local merchant Alexander Grzelachowski.

His visit was commemorated by the townsfolk by the naming of Kid Lane in his honor. Today, Puerto de Luna looks much the same as it did over 100 years ago.

Your other choice is north to the historic 300,000-acre Bell Ranch, which sits 45 miles northwest of Tucumcari, New Mexico. Bell Mountain, which appears to be in the shape of a bell, gave the ranch its name and was the site of many movies and television shows such as *Rawhide* in which a young Clint Eastwood starred. Notably, it is rumored that several of the cowboys who worked on the Bell Ranch were used as models for the "Marlboro Men" campaign, but Bell Ranch is best known for their own brand of cattle, the RedBell. Also located by the historic ranch hacienda is a museum which features artifacts of the Bell Ranch life. It is asked if you want to visit the museum, please know it is part of a working ranch and you should be respectful of the hours. More information can be found at www.bellranch.com.

Conchas Lake State Park is the next stop along the way. With over 60 miles of varied shoreline, Conchas Lake sits on the bank of a 25-mile-long reservoir. The northwestern part of New Mexico was home to many dinosaurs and remnants of their existence can be found along the shores of Conchas Lake in the form of fossils. Remember, Conchas Lake is a state park and any removal of fossils is strictly forbidden. Conchas Lake State Park can be found 34 miles northwest of Tucumcari on NM 104.

J-9 Narrow Gauge Scenic Byway

An isolated dirt road winds 10 miles from mile marker 0 in Dulce, New Mexico, to mile post 9.8 at the Colorado border, following along the Navajo River, was once a route for the J-9 (stands for Jicarilla 9) narrow gauge railroad. Most of the original railway has been removed, but a short section at the junction of U.S. 64 and J-9, which is known to the locals as Narrow Gauge Street, remains. The byway narrows as it travels north through tall pine trees and rock out crops. It is highly suggested this road not be used during rain or very cold weather conditions. The original trail was forged by early settlers and miners who used the route to get from Colorado to New Mexico before the railroad was installed. It is the main link today between the sovereign nations of the Jicarilla Apache in Northern New Mexico and the Ute in Southern Colorado. The Jicarilla Cultural Center have several boxcars from the dismantled Denver and Rio Grande Western Railroad on site.

Old Spanish National Historic Trail

A foot bridge over the Animas River in Aztec, New Mexico, is part of the Old Spanish National Historic Trail that runs between the City of Aztec's Historical District and the Aztec Ruins National Monument. The Old Spanish Trail was the first trade caravan from Santa Fe, New Mexico, to Los Angeles, California, led by Antonio Armijo in 1829. The journey was said to have been so arduous, it was never used again.

The Old Spanish Trail was used by early explorers of what is now New Mexico. *(DB)*

Puye Cliffs Scenic Byway

Near the town of Española, New Mexico, the Puye Cliffs Scenic Byway is one of the shortest byways in the state at only 14 miles long. Towering cliffs will come into view as you pass through four of New Mexico's seven life zones and the Puye Cliff Dwelling National Historic Landmark will become evident as you get closer through the pinon and grama grass covered plains. As once the largest ancestral native settlement on Pajarito Plateau in Santa Clara Canyon, the cliff dwellings are thought to have supported 1,500 people at its height of population and date back to the year 900. Most of the cliff dwelling are carved out of the volcanic rock of the cliffs, and two buildings are at the base of the mesa constructed from the volcanic tuff blocks found on the site like many of the other pueblo sites in the region.

Take Indian Road 565, which is 35 miles north of Santa Fe at Española, New Mexico, which was settled by the Santa Clara Native Americans whose pueblo is nearby. It is said the Santa Claran people refer to this area as a "special place between earth and sky." The Puye Cliffs Scenic Byway is the only scenic byway entirely located within a Native American pueblo. The interpretive center and gift shop at Puye Cliffs were formerly built by Fred Harvey, of the famed Harvey Houses, you will be able to purchase tickets to visit the cliff dwellings as well as food and drinks.

Contact details: (505) 901-0681 and www.puyecliffs.com.

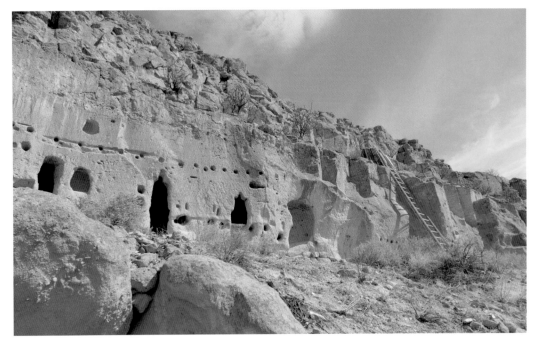

Cliff dwellings on the Puye Cliff Scenic Byway give a glimpse of ancient life. (*Library of Congress*)

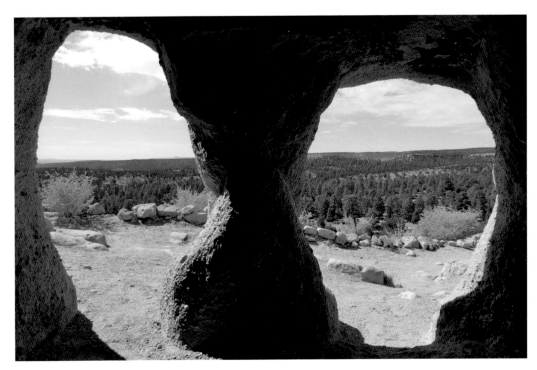

Looking out from the inside of a dwelling at Puye Cliff Dwellings. (*Library of Congress*)

Quebradas Backcountry Scenic Byway

It is suggested to travel this byway located 24 miles east of the town of Socorro, New Mexico, in a truck or four-wheel-drive vehicle. The byway is a well-maintained dirt road can become slippery and eroded by rainstorms, making it difficult for passenger cars to travel securely, the byway can be used for mountain biking and hiking as well. Along the route you will find yourself in a rocky, high desert terrain dotted by pinon and juniper trees. Nestled along the popular Cerrillos del Coyote Loop are natural sinkholes, overhangs, and evidence of Native dwellings.

It is suggested you bring extra water, have a full tank of gasoline, a shovel, spare tire, tire jack, and blanket in your vehicle since it is a remote location.

Directions: the Quebradas Backcountry Scenic Byway can be accessed by two routes depending on which direction you are approaching. If you are traveling down Interstate 25 from Albuquerque, take the Escondida Exit, head east and north for a mile. You will turn right and pass Escondida Lake, then cross the Rio Grande traveling east through Pueblitos. Turn right, or south, on Bosquecito Road and follow the east side of the Rio Grande. You will travel six-tenths of a mile to a dirt road, which will be on your left, or east. Follow this road and the Quebradas Backcountry Byway signs. You will end your trip on Highway 380, east of the town of San Antonio, New Mexico.

Should you be traveling on Highway 380 from Carrizozo, you will turn right on County Road A-135, which will be a dirt road, skirting the Rio Grande and following this route around until you reach Bosquecito Road. You will be able to access Interstate 25 at the end of your journey. This trek will take approximately two to three hours at a moderate speed.

For further information please call (575) 835-0412.

Route 66 National Scenic Byway

Route 66 or the "Mother Road" bisects the state of New Mexico along Interstate 40 from Tucumcari to Gallup and is the best route to "get your kicks." The towns along the route have embraced the spirit of Route 66 with kitschy motels heavily laden with colorful neon signs—a true step back into the past. These motels are still in business, with many receiving modern updates in the interior, which provides the traveler with a sense of how it was in their heyday in the '50s and '60s. Tucumcari, New Mexico, is a prime example, as they have the famous Blue Swallow Motel, teepee-shaped trading posts and diners. From Tucumcari, travel west to Santa Rosa, New Mexico, where you can visit The Blue Hole State Park and enjoy the nostalgic drive through their downtown area.

On to Albuquerque, New Mexico, where you can exit the interstate at Moriarty, New Mexico, and travel along the true Route 66, which is now an access road along the interstate. This road will merge with Central Avenue, which has seen a revitalization of landmarks such as the El Vado Motel, the beautifully ornate Art Deco Kimo Theater, El Camino Motor Hotel, the Tewa Lodge, and the De Anza Motor Lodge. Many sites are close to the Old Town and Nob Hill Districts of Albuquerque, as well as the Albuquerque Bio Park and Zoo. There is public paid parking in Old Town and along

Central Avenue. As with all large cities, it is strongly suggested you put all valuables in your truck, lock your vehicle, and know your surroundings when walking along Central Avenue. This historical route has been used as a backdrop for the popular *Breaking Bad* series, including "The Dog House Drive-In" and the "Crossroads Motel." A staple on Central Avenue, across from the University of New Mexico, is the Frontier Restaurant. Opened in 1971, the Frontier offers a wide variety of American and New Mexican dishes, with the huge, delectable cinnamon rolls a local favorite. Some of the eateries along Route 66 have been featured on many cable cooking channels.

Once you leave Albuquerque, you will continue to travel along Interstate 40 to Grants, New Mexico, in the heart of four Indian Reservations where you can take a side trip to the Pueblo of Acoma, the Bandera Ice Caves and Volcano, the El Malpais National Monument, and the Route 66 Vintage Museum and Double Six Gallery before traveling on to Gallup, New Mexico. As the most populous city between Albuquerque, New Mexico, and Flagstaff, Arizona, Gallup is the county seat of McKinley County and known as the "Indian Capital of the World." Here is an excellent opportunity to shop for authentic Native American jewelry, rugs, blankets, baskets, and fry bread.

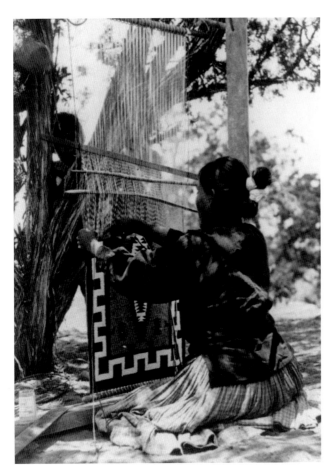

Navajo rugs have long been a prized purchase along Route 66. (*Library of Congress*)

222

Right: The Mother Road, Route 66, crossed New Mexico from Tucumcari to Gallup. (*Library of Congress*)

Below: One of the most iconic hotels along Route 66 in Tucumcari, New Mexico. (*Author's collection*)

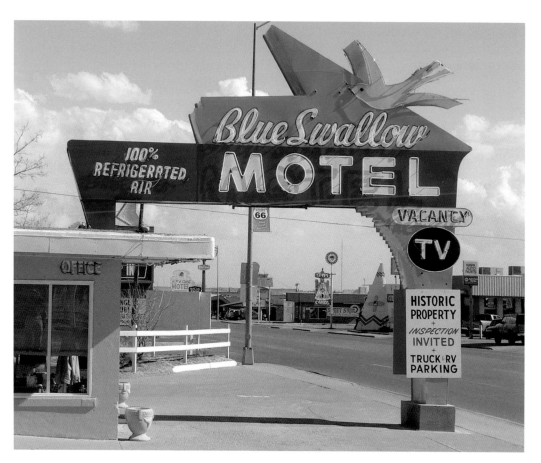

Salt Missions Scenic Byway

Travel south from Tijeras on NM55 and you will encounter quaint land grant communities dotted along the narrow two-lane highway. Be sure not to spend too much time looking away from the road enjoying the beautiful scenery as there will be bicycle riders, hikers, and runners along the roadside also utilizing this route. The towns of Tajique, Torreon, Manzano, and Punta de Agua are picturesque and welcoming, but the Pueblo of Chillili is a private village that does not want visitors—please be respectful of their wishes. If you enjoy old churches, cemeteries, and abandoned buildings, you will find it difficult not to stop many times to snap photos along your route. (Please note, photography is not allowed in Chillili.)

Once you reach Puerto de Aqua, you will be within a mile of Quarai Mission, one of the three Salinas Missions in the vicinity, and the smallest of the three, but was thought to be much larger before the arrival of the Spaniards in 1598. Located in the heart of New Mexico, the Salt Missions were once home to the Tiwa, Tompiro, and Humana Puebloan People and thrived due to their proximity to Zapato Creek. Due to later drought, famine, and attacks by the Apache, all three of the missions were abandoned. Quarai Pueblo and Abo Pueblo are made from distinctive red stones quarried in the area, while Gran Quivera is constructed from much lighter stones and is almost hidden from view. The precision of the stonework will astound you.

The Salt Missions trail is over 140 miles and stretches from Tijeras Canyon to Abo Mission and loops around to Mountainair, Estancia, and finally Moriarty where you can access Interstate 40 once again. The rolling hills and mountains of the scenic byway are a sight to behold, the villages are quaint and historical and make for an eventful day trip.

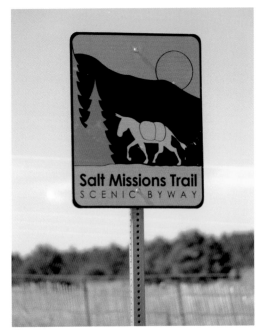

The Salt Missions Scenic Byways sign near Gran Quivera. (*DB*)

Sandia Crest National Scenic Byway

Known as the highest scenic byway in the southwest, the Sandia Crest National Scenic Byway, located in the Cibola National Forest, offers spectacular views. You will be a mile above the valley below and 2 miles above sea level. The Sandia Crest Highway, or NM 536, is a paved, well-maintained highway that zigzags through the Sandia Mountains with an elevation gain of nearly 4,000 feet. You are cautioned to be aware of the possibility of dirt being on the corners of the switchbacks, which could cause traction issues.

About halfway up the byway is County Road 156, where evidence has been found during excavations of ancient human inhabitants in the area dating back 12,000 years ago. This road through La Hurtas Canyon is dirt, yet well-traveled by other vehicles. Along the route is the Sandia Cave trailhead, which leads to a man-made metal staircase leading to a cave high on the face of the canyon wall. You will be able to explore this cave if you are up to the steep hike. The cave is undeveloped, so headlamps, caving equipment, head gear, and flashlights are strongly suggested. Should you want to continue down County Road 156 you will immerge on the village of Placitas, which is part of the Albuquerque Metropolis, although it is located approximately 15 miles to the north. Known for their wild horses and aversion to signs, Placitas, which was once a poor farming community, which became home to the hippie communes of the 1960s and 1970s, is now a wealthy suburb within a short drive of any amenity desired.

At the end of the Sandia Crest National Scenic Byway, where you may be lucky enough to encounter forms of wildlife such as deer, bighorn sheep, or even bear, you will be gifted with some jaw-dropping vistas of the city and surrounding mountain ranges below. If you plan to stay in this location a while, there is a daily $3 parking fee—please deposit the exact change in the drop box. At the top, you will also find the Sandia House restaurant and gift shop. Be sure to look for the Rosy Finch who are known to migrate to the Sandia Mountains from October to March. Chipmunks and grey squirrels will also be scurrying around the crest—great subjects for those candid shots.

The top of Sandia Crest is where some locals go to decompress from the hustle and bustle of city living. Photography opportunities are endless at the top as well as the entire trip. Since Sandia Crest is 10,000 feet above the city, please know the weather conditions are at times completely different with a likely 20-degree temperature drop; because of this, you may encounter fog or even snow. The byway will close during times of in climate weather, so please call ahead of your trip. Once again, fall is probably the most breathtaking time to experience the 14 miles of the Sandia Crest National Scenic Byway as it will be ablaze with color. Hiking trailheads dot the road along the road, dogs are allowed on these trails if they are on a leash.

Directions: To access Highway 536, turn west off the Turquoise Trail or Highway 14 at Cedar Crest. Along your route you will encounter a curious museum called Tinkertown as well as the Museum of Archaeology and Material Culture—each one totally different from the other and both worth a stop. Sandia Peak is also the stopping place for the Sandia Peak Tramway, which is accessible from Albuquerque. You will also encounter mountain bikers and motorcyclists on this road, so use caution.

Above: Sandia Crest National Scenic Byway has many outlooks to enjoy the valley below. (*DB*)

Left: Wildlife is prevalent along the Sandia Crest road so use caution. (*DB*)

Santa Fe National Forest Scenic Byway

Originating at the Palace of the Governors oldest building in the Santa Fe, also known as the City Different, the Santa Fe National Forest Scenic Byway includes 15 miles of some of the most beautiful scenic views in the state. Begin your journey by shopping the unique wares of the Native American vendors set up on the portico of the Palace of the Governors building located on the Plaza—you will be sure to find a treasure to bring home as a memory of your time in Santa Fe.

Your route out of Santa Fe on Washington Avenue will take you by the Santa Fe Public Library, which is another great place to spend a lazy afternoon reading about the rich history of New Mexico. When you get to the intersection of Washington and Paseo de Peralta, you will continue straight up a slight hill into a residential section that will be known as Bishop's Lodge Road for a short time. Turn right on to Artist Road or also known as NM 475 and follow along out of the city to the heart of the gorgeous Sangre de Cristo mountains.

This narrow two-lane road will take you on a steady incline through the Santa Fe National Forest. Depending on the time of year you make your journey, you will see forests of Aspens blanket the steep mountainsides—which turn a glorious gold in the fall. The road gets progressively narrower with many switchbacks, so take your time as you ascend into the beauty. Be aware, there will also be bicyclists along this route as well. Do not be surprised to see patches of snow in the shady parts of the higher elevations, even into the late spring or early summer.

Cottonwoods live among the huge roadside boulders alongside Blue Spruce and Evergreens, bump-outs along the way give many photographic and scenic view opportunities of the valley Santa Fe Valley and the Arroyo Seco Badlands below. There are many hiking trails dotted along the way as well, and some include camping

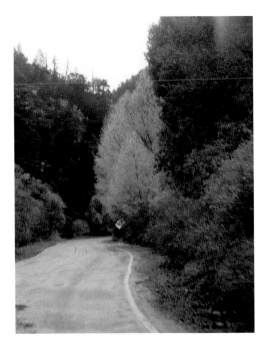

Santa Fe National Forest Scenic Byway provides gorgeous views along the way to the top. (*DB*)

spots. Hyde Park State Park boasts over fifty camping sites alone. The stunning Old World-style Hyde Park Hunting Lodge is available for weddings, receptions, family reunions, and the like.

As you continue your ascent, there will be the Vista Grande Overlook Observation Site on the left-hand side of the road from which you can see Santa Fe, Taos, and into Colorado; this will be a good place to stop on your way back down. At the end of the scenic byway is the groomed slopes of Ski Santa Fe on Mount Baldy, elevation at the base is 10,350 feet. You can hop a ride on a ski lift, which will take you to the top of Tesuque Peak, elevation over 12,000 feet. With an average of 225 inches of snow per year and eighty-three trails, Ski Santa Fe is a skier and snowboarder's dream.

For more information call Ski Santa Fe at (505) 982-4429.

Socorro Historic District Scenic Byway

The San Miguel Mission is said to be the cornerstone of the Socorro Historic District Scenic Byway as its oldest structure. This 3-mile long district is the only one in New Mexico to be named a scenic byway. Roundabouts dot the historic district of Socorro and could provide a challenge to drivers who have not used them. Included in the historic district along with San Miguel Church is the Wheel of History sculpture, the Hammel Museum, the Capital Bar, and the Opera House. The historical society states that although you can drive the short distance of the district, it is far better to park and walk the historical streets to get the most out of the experience.

Socorro, established in 1598 by the Spanish Explorers who followed Don Juan Oñate, is located at the end of the Jornada del Muerto (Journey of Death) and the El Camino Real where the early travelers to New Mexico were finally able to stop, water their livestock and relax after the taxing trip north from Mexico. Rich in mining history as well, Socorro is home to New Mexico Tech, which provides undergraduate and graduate courses on advanced science, astrophysics, hydrology, geophysics, explosive research, information technology, and mining. Some of the most brilliant minds in New Mexico graduated from this institution.

Due to the discovery of lead and silver in the nearby Magdalena Mountains, Socorro became a boomtown that brought with it the good and the bad. A walking tour of the town's historical plaza will introduce you to both. Website: www.socorronm.org.

Sunspot Scenic Byway

Perched 9,200 feet above sea level, Sunspot Observatory provides not only jaw-dropping vistas of the surrounding countryside, but an expanded view into the surrounding galaxies. Follow Highway 130 and Highway 6563 for 16 miles where you will be rewarded with spectacular views of the Tularosa Basin below. Along the climb to the National Solar Observatory in Sunspot is Apache Point Observatory, which is perched high in the Sacramento Mountains and provides an opportunity to get out and walk around the buildings, which unfortunately are closed to the public; there are no restrooms, but the views are worth the side trip.

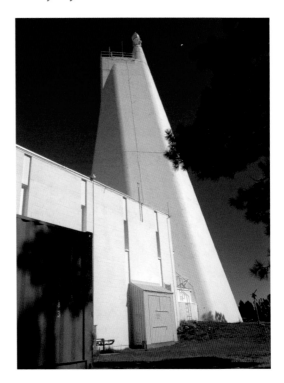

Sunspot Observatory is designed for study of the sun. (*Author's collection*)

Continue only one more mile up the road and you will arrive at the National Solar Observatory, which opened its doors in 1997. The observatory has been studying the many aspects of the sun and how magnetic fields influence solar activity for over fifty years. Through new funding, the National Solar Observatory will continue their amazing work and be able to educate the public on their findings. Open to the public from dawn until dusk, visitors can do self-guided tours and wander the observatory grounds. Be prepared for the altitude as the National Solar Observatory is generally 10 to 20 degrees cooler than the Tularosa Basin (Alamogordo, Tularosa, White Sands) and is subject to quick and sometimes severe weather changes. During the monsoon season in the summer, storms form fast and will engulf the observatory in rain with lightning; in the winter, it will receive large amounts of snow. Always call ahead before traveling to the site to make sure the conditions are good. The observatory has a gift shop, educational exhibits, and restrooms.

Contact details: (575) 434-7000 and www.nso.edu.

Trail of the Ancients Scenic Byway

The Trail of the Ancients snakes through a small part of the Navajo Nation and reveals some of the most breathtaking scenery in the state. Sandstone bluffs jet out of the barren landscape, striped flat-topped mesas, and a moon-like plain dot the trail, making you feel you have landed in an alien world. This trail originates at Four Corners, New Mexico, but is entirely located in Colorado and Utah.

Trail of the Mountain Spirits Scenic Byway

Starting in Silver City, New Mexico, this 95-mile scenic byway will take you approximately three hours to drive or six to eight hours to experience. You will follow the trail taken by Native Americans, Spanish explorers, miners, homesteaders, and mountain men before you. The Trail of the Mountain Spirits is known locally as the Inner Loop since it serves as a route for the grueling Tour of the Gila bike race. Along the route you will cross six climate zones and have ample opportunity for bird and wildlife observations.

Along the Trail of the Mountain Spirits you will be able to drive by or explore frontier fort, cross the Continental Divide, and marvel at the scenery of the first National Wilderness Area in the U.S. One of the most interesting stops along the byway is the Gila Cliff Dwellings and Gila Hot Springs, both are a little off the main route, but far worth the extra drive.

As you make your way back to Silver City, you should take the time to explore the old mining town/ghost town of Piños Altos, which was founded in 1860 and is just off Highway 15. In its heyday, Piños Altos was a raucous town filled with gold miners, saloons, brothels, an opera house, and a church, which was paid for by George Hearst, the father of William Randolph Hearst.

Today, there is the wonderful Piños Altos Historical Museum and bookstore, the Buckhorn Saloon, which is a great place to have a steak a three-quarter replica of a frontier fort, as well as the ruins of the Old West and mining ways of life.

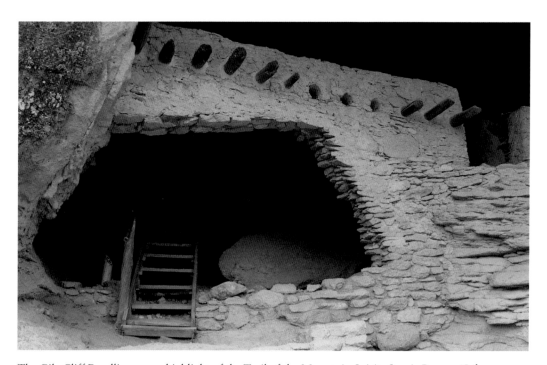

The Gila Cliff Dwellings are a highlight of the Trail of the Mountain Spirits Scenic Byway. (*Library of Congress*)

Turquoise Trail National Scenic Byway

Along the two-lane Highway 14 from Santa Fe to Albuquerque, you will pass historical mining towns that served the miners and local farmers located in 15,000 miles of historic and scenic Central New Mexico. The Turquoise Trail was a route also used sadly by frontiersman Christopher "Kit" Carson to move the Navajo Tribe from their ancestral home in northwestern New Mexico 500 miles to the Bosque Redondo at Fort Sumner in southeastern New Mexico on what is called "The Long Walk" in the years between 1863 and 1868. Due to the remoteness of the area, the Turquoise Trail saw a high influx of residency by outlaws, as well as Confederate soldiers during the Civil War.

Cerrillos

Your first stop along the Turquoise Trail from Santa Fe will be the village of Cerrillos, which, with its large deposits of galena, or lead, and turquoise, was the oldest mining districts in the southwest. The miners were pulling not only turquoise and lead from the surrounding peaks, but silver, gold, and zinc as well. The mining operations of the late 1880s were a boon to the local economy, which had twenty-one saloons and four hotels.

Today, the quaint village still sports dirt streets and has the 1855 Black Bird Saloon, which is a favorite watering hole frequented by locals and visitors alike. The movie *Young Guns* was filmed in Cerrillos in 1988, and you can still see "Wortley Hotel" painted on one of the buildings on Main Street; the tiny town has also played well as a backdrop in other cinematic works, such as John Carpenter's *Vampires*. You will find the Cerrillos Hills State Park, Casa Grande Trading Post, and the Cerrillos Turquoise Mining Museum and Petting Zoo to be of great interest during your visit to the Old West town. Turquoise Mine tours are also available for a fee and can be booked by calling proprietors Todd and Patricia Brown at (505) 438-3008.

Golden

Do not blink or you might miss the once thriving mining village of Golden. As the site of the first gold rush west of the Mississippi in 1825, Golden was originally named Real de San Francisco (St. Francis Way), but when the big gold mining companies moved in in the late 1880s, it was changed. Golden did not last due to small yields from the surrounding mines and was eventually abandoned by the companies leaving only a few residents to populate the hills.

One of the most photographed churches in New Mexico resides atop a hill to the left as you come into Golden—San Francisco de Assis Church. Be on the lookout since there are no signs indicating the church location. A festival is held at San Francisco de Assis Church each year on the first Saturday of October. This festival celebrates the rich Hispanic heritage of the region and a blessing of the church and cemetery is performed.

The saloon in Cerrillos has starred in many films over the years, including Young Guns. (*DB*)

San Francisco de Assis Church sits on a hillside outside the village of Golden. (*DB*)

While in Golden, visit the Henderson Store, which has been run by members of the same family since 1918. Inside you will find many Native American treasures such as rugs, jewelry, and pottery. There are also many art galleries, unique shops, and cafes along the Turquoise Trail for your enjoyment and purchasing pleasure. Take a little bit of New Mexico home with you.

Madrid

Although the name appears to have the same spelling as Madrid, Spain, the pronunciation is quite different. The town's name is Mad-Rid. Founded in the early 1800s to support the burgeoning coal-mining industry in the area, Madrid became famous for being one of only two locations in the world where hard and soft coal was mined in shafts as deep as 2,500 feet. As with the other towns along the Turquoise Trail, when the need for coal declined, so did the town, which turned into a ghost town for many years.

Today, Madrid has gained notoriety as a thriving, eclectic artist community, which was used as a setting for the 2007 movie *Wild Hogs*. The Great Madrid Gift Emporium and Maggie's Diner has memorabilia in support of the film and is a great place to get t-shirts and other mementos. (Please note, Maggie's Diner does not actually serve food—it was a prop for the movie.) On any given day you will find tourists, motorcyclists, and bicyclists all mingling in the large array of wonderful shops, galleries, and studios that offer one-of-a-kind merchandise for purchase. The tiny town blossoms with activity every day and can be a bit tricky to get around in—or find a parking spot, so if you see a spot, grab it quick or someone else surely will. You will see rows and rows of beautiful, shiny motorcycles in town, so be sure not to gawk at them too much and rear-end the car in front of you.

As you travel south on Highway 14 in Madrid, you will find the historic Mine Shaft Tavern perched proudly at the end of town, which now features a heated deck and has a great view that overlooks the town. Live music is featured on the weekends at the tavern as well as their award-winning Mad Chile green chile cheeseburger served every day. The movie *Paul* was filmed at the Mine Shaft Tavern, and their bar was featured in the series *Longmire*. Famous country music stars have also discovered the Mine Shaft Tavern, acts like the legendary Willie Nelson and Toby Keith—who filmed their video for "Beer for My Horses" at the tavern. Some say that people have liked going to the Mine Shaft Tavern so much, they stay—in ghost form. Yes, the tavern is rumored to be haunted, but after seeing how much fun everyone has, you will not want to leave either.

Residents of Madrid sure know how to have fun. The town is notorious for their Fourth of July parade, Christmas celebrations every weekend in December, as well as the Coal Mining Museum, theater performances, open-air concerts, and baseball. What more could you ask for?

Once you leave Madrid, you are at the end of the historic part of the Turquoise Trail, which then becomes the Sandia Crest National Scenic Byway, also part of the Turquoise Trail. Just off the Turquoise Trail is the San Juan/Lone Butte Area, which consists mainly of a gas station, art galleries, and cafes. This high plateau was once used for farming and pottery making until the Pueblo Revolt of 1680 when the Spanish settlers in the area were forced out. Today, the scenic area also near two large ranches that have been used to film over 100 films.

With a starring role in Wild Hogs, Maggie's Diner is a t-shirt shop in Madrid. (*DB*)

Directions: From Interstate 40 West take the turn off Interstate 40 on to Highway 14 at the Tijeras/Cedar Crest exit to experience a few of New Mexico's most eclectic communities. From Santa Fe take Interstate 25 towards Albuquerque and take exit at the Historic Byway Signs stating Madrid (there will be two opportunities). Travel south on Highway 14, which is the Turquoise Trail.

Wild Rivers Backcountry Byway

Some 13 miles off a closed loop road, Wild Rivers Backcountry Byway provides stunning views of the Taos backcountry. Some 26 miles north of the village of Taos and 17 miles south of the state of Colorado, the byway's main feature is the Rio Grande Gorge, which you can look 500–700 feet down into as the byway follows alongside. You will have a 40-mile view in all directions, which will reveal New Mexico's tallest mountain, Mount Wheeler, volcanic cones, sagebrush covered plains, and the magnificent Sangre de Cristo Mountains.

The drive is gorgeous, but there are spots to pull off the road and picnic or hike. Several overlooks provide you with photo opportunities galore as you view the confluence of Red River and the Rio Grande.

Directions: To access the Wild Rivers Backcountry Byway, turn west on to NM 378 from NM 522, which is approximately 2 miles north of the town of Questa. The byway is an extension of NM 378 into the Bureau of Land Management's Wild Rivers Recreation Area. Open year round and maintained during the winter months, poor weather conditions may limit or restrict access.

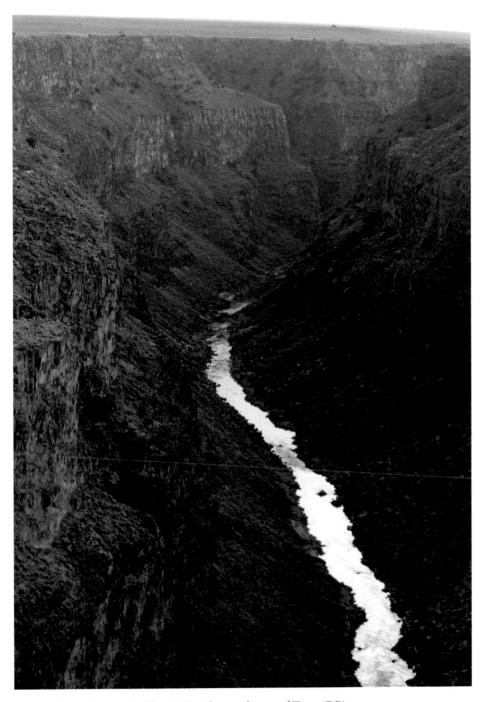

The Rio Grande Gorge Bridge is 12 miles northwest of Taos. (DB)

BIBLIOGRAPHY

Aragon, R., *Enchanted Legends and Lore of New Mexico*. (Charleston, SC: The History Press, 2012)

Baxter, W., *Gold and the Ortiz Mine Grant: A New Mexico History and Reference Guide*. (Santa Fe, NM: Lone Butte Press, 2014)

Beck, W., *New Mexico: A History of Four Centuries*. (Norman, OK: University of Oklahoma Press, 1963)

Birchell, D., *Carlsbad and Carlsbad Caverns*. (Charleston, SC: Images of America, Arcadia Publishing, 2010); *Eddy County*. (Charleston, SC: Images of America, Arcadia Publishing, 2011); *New Mexico Wine: An Enchanting History*. (Charleston, SC: American Palate, The History Press, 2013); *Wicked Women of New Mexico*. (Charleston, SC: The History Press, 2014); *Hidden History of Southeast New Mexico*. (Charleston, SC: The History Press, 2017); *Haunted Hotels and Ghostly Getaways of New Mexico*. (Charleston, SC: The History Press, 2018); *Frontier Forts and Outposts of New Mexico*. (Charleston, SC: The History Press, 2019)

Caiar, R., *One Man's Dream: The Story of Jim White, Discoverer and Explorer of the Carlsbad Caverns*, n.p., 1957.

Caldwell, C., *John Simpson Chisum: The Cattle Kind of the Pecos Revisited*. (Santa Fe, NM: Sandstone Press, 2010)

Conant, J., *109 East Palace: Robert Oppenheimer and the Secret City of Los Alamos*. (New York, NY: Simon and Schuster, 2006)

Davis. C., and Humble, T., *Silver City*. (Charleston, SC: Images of America, Arcadia Publishing, 2013)

Dunn, N., and Florez, N., and the Artesia Historical Museum & Art Center. *Artesia*. (Charleston, SC: Images of America, Arcadia Publishing, 2011)

Eidenbach, P., *Alamogordo*. (Charleston, SC: Images of America, Arcadia Publishing, 2010)

Explore New Mexico: Insider's Guide: Getaways in the Land of Enchantment. (Santa Fe, NM: The New Mexico Magazine, 1989)

Fisher, P., *Los Alamos Experience*. (Tokyo: Japan Publications, Inc., 1985)

Frantz, L., *The Turquoise Trail*. (Charleston, SC: Images of America, Arcadia Publishing, 2013)

Hillsboro Historical Society, *Around Hillsboro*. (Charleston, SC: Images of America, Arcadia Publishing, 2011)

Jenkins, M., and Schroeder, A., *A Brief History of New Mexico*. (Albuquerque, NM: University of New Mexico Press, 1974)

Johnson, B., and Dauner, R., and Pausewang, J. *Old Town, Albuquerque, New Mexico: A Guide To Its History and Architecture*. (Albuquerque, NM: The City of Albuquerque, 1980)